THE MUSEUM
OF THE MIND

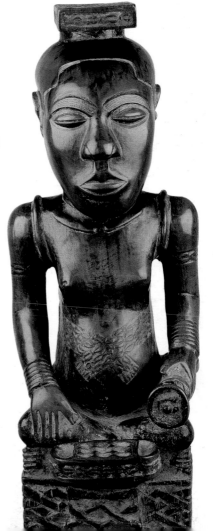

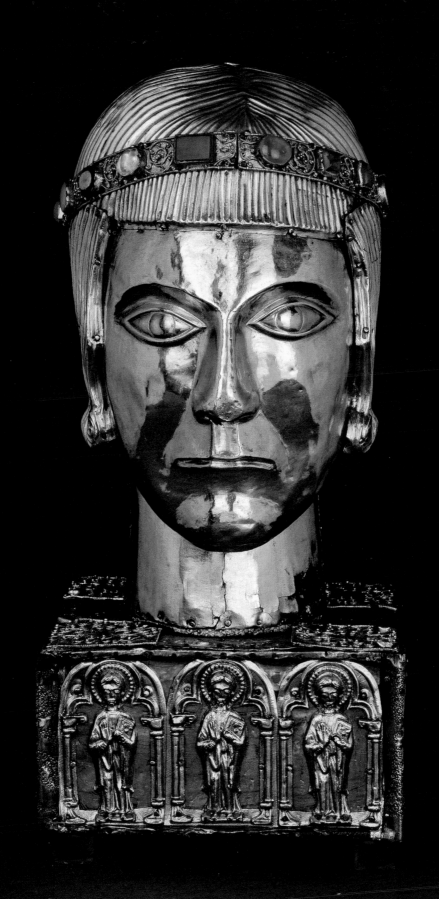

ART AND MEMORY IN WORLD CULTURES

THE MUSEUM
OF THE MIND

JOHN MACK

THE BRITISH MUSEUM PRESS

First published in 2003 by The British Museum Press
A division of The British Museum Company Ltd
46 Bloomsbury Street, London WC1B 3QQ

A catalogue record for this book
is available from the British Library

ISBN 0 7141 2637 3

Designed by Harry Green
Typeset in Gill
Printed in Spain by Mateu Cromo, S.A. Pinto (Madrid)

Front cover
James Stephanoff, 'An Assemblage
of Works of Art in Sculpture and Painting' (fig. 1).

Back cover (clockwise, from left)
Visitors to the British Museum in front
of a sculpted head by Igor Mitoraj (fig. 89).

Copper-alloy and enamelled reliquary
depicting the Adoration of the Magi (fig. 98).

Painted papier mâché skeleton from Mexico (fig. 62).

Guillaume Dupré's medal of the Venetian
doge Marcantonio Memmo (see p. 55).

Wood coffin in the shape of a Mercedes from
Ghana (see p. 98).

Page one Wood figure (*ndop*) of Shyaam-a-Mbul
Ngwoong, founder of the Kuba kingdom in
Central Africa (fig. 20).

Frontispiece Silver-gilt reliquary head, with its wooden core.
Reliquaries often assumed a form to reflect the nature
of the relics they contained. In this instance, the reliquary
was believed to hold fragments of the skull of St Eustace.
Probably made in Germany or Switzerland. *c.* 1210. H. 32 cm.
Department of Medieval and Modern Europe.

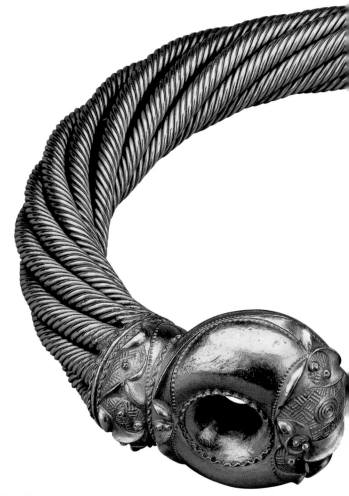

Above Gold torc found
at the site of Snettisham in Norfolk,
England. c. 70 BC (see p. 92).

Contents

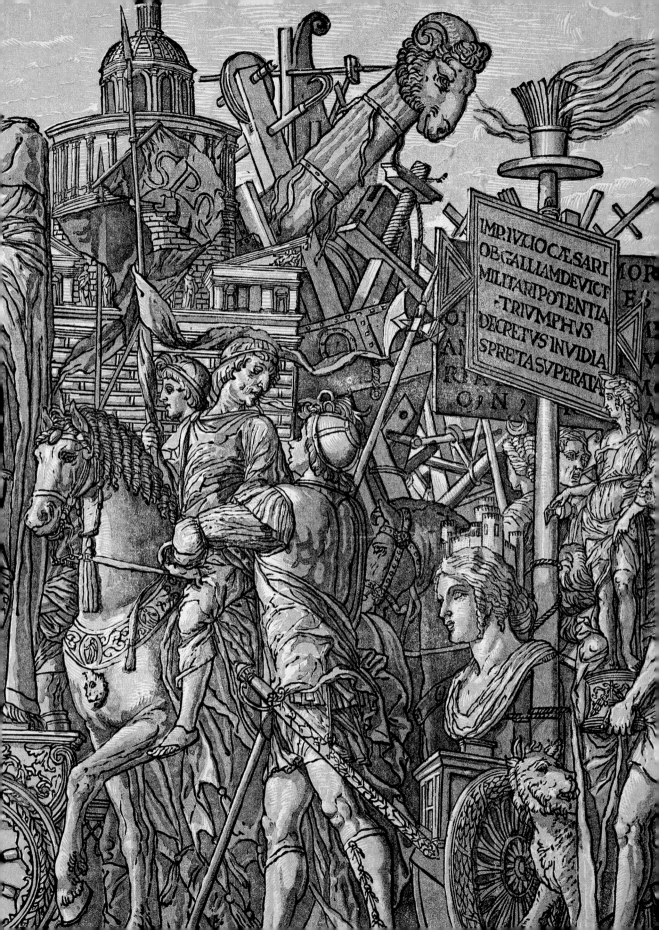

IMP·IVLIO·CÆSARI
OB·GALLIAM·DEVICT
MILITARI·POTENTIA
·TRIVMPHVS·
DECRETVS·INVIDIA
SPRETA·SVPERATA

Acknowledgements

Detail of fig. 79: Andrea Andeani, chiaroscuro woodcut of 'The Triumph of Caesar', after Andrea Mantegna.

What follows is a reflective essay. I am keenly aware that its subject – the relations between the production of art, of objects, and the production of memory – is a vast and fundamental one. It is tied up with some of the most crucial and definitive of human questions: a sense of being, issues of identity, of relationships and community, and of posterity. A study of this topic, which seeks its evidence cross-culturally, could easily run to many volumes. It is a subject for a polymath of Renaissance proportions. I am certainly not that. I do, however, have the good fortune to work in an institution which collectively assumes a closer approximation to universal range. My colleagues have been unfailingly generous in suggesting routes to be followed, in helping with sources and, most memorably, in discussing the objects in their care. Indeed I am aware how many of the articles and books produced by the Museum's staff explore this theme, explicitly or implicitly, testament to the fundamental place of memory in human culture and individual development.

At one level what follows is the act of an amanuensis. To acknowledge those who have contributed would be to produce a significant proportion of the curatorial phone directory of the British Museum. Much direct discussion took place. My links to the curatorial Departments were: Sheila Canby, Frances Carey, Tim Clark, Aileen Dawson, Julie Hudson, Richard Parkinson, Thorsten Opper, Jonathon Tubb, Gill Varndell, Helen Wang. All were extremely helpful. Beyond that I benefited greatly from detailed advice in areas in which I can claim no special expertise. The most substantial help was provided by Silke Ackermann, Richard Blurton, John Cherry, Christopher Date, Caroline Malone, Stuart Needham, Michael O'Hanlon, Luke Syson, John Taylor and Jonathan Williams. Daily support was unfailingly provided by Sophie Mew and Julia Walton, and I am indebted to the staff of the Ethnography and Central Libraries for much assistance in tracking down a wide range of, sometimes obscure, sources. Katy Mack and Lucy Douglas helped check aspects of the section on pilgrimage. Tom Jenkins and Ian Jenkins have been constant guides to unusual additional avenues to be explored. The book has been significantly improved by the efforts of colleagues in the British Museum Press, and in particular Laura Brockbank who has been an excellent editor.

In such circumstances it is conventional for the author to absolve correspondents from responsibility for errors of omission and commission. I am more than usually aware of the failings that can befall a discursive treatment of an encyclopaedic subject. There is a clear case here to blame the messenger.

A book on the subject of memory can hardly escape recognition of its own generation. I would like especially to acknowledge Caroline, Katy and Sam who helped hugely in seeing through the process of its writing in otherwise difficult circumstances.

Preface

For individuals, as for communities, it may be said that memory is identity. At the very least it is an essential part of it. To lose your memory is, quite literally, no longer to know who you are, and we have all witnessed the consequences both in individuals and in communities. For both, a life without memories is so diminished as hardly to count as life.

All societies have therefore devised systems and structures, objects and rituals to help them remember those things that are needful if the community is to be strong – the individuals and the moments that have shaped the past, the beliefs and the habits which should determine the future. These monuments and aides-memoires point not only to what we were, but to what we want to be.

On the simpler level of daily life, mnemonics must be devised to help us remember the facts we need to know to cope with the world – wooden models of wave patterns in Oceania to help sea-farers navigate huge and dangerous distances; rosaries and relics in medieval Europe to guide the believer through the no less hazardous paths of earthly existence.

The British Museum, to mark its 250th anniversary and crystallise its own memory, is mounting a series of exhibitions. The exhibition that this book accompanies is drawn from the Museum's collection of objects from all over the world, designed to help the different parts of mankind to remember. Arms against oblivion.

In 1753, the British Museum was founded as a universal museum. It is an incomparable collection of humanly-created artefacts covering all time and all places; they are displayed, uniquely amongst the museums of the world, in a single building accessible free to visitors seven days a week.

An anniversary such as this is an appropriate moment at which to ask what the contemporary virtues of this Enlightenment vision are. This book represents, we hope, part of the answer. It focuses only on objects in the British Museum, and it

discusses the extent to which the Museum itself is a site or 'theatre' of memory. It takes this particular institution as a laboratory to test the universalising concept. As the text notes, the Museum has been in existence for longer than most nation states. It has thereby acquired its own cargo of memories, and persists in the memory of its vast numbers of annual visitors, for many of whom it is a place of pilgrimage. Memory is not, however, a static, nostalgic condition, but an active and ongoing dynamic, and museums must respond to its perpetual reverberations. Accommodating and responding to memory is a central, but rarely articulated responsibility of contemporary cultural institutions.

Making meaningful comparisons across cultural and linguistic boundaries is a hazardous activity. As anthropologists and ethnographers tell us, there is sometimes little to reassure us that we are comparing like with like. In tackling memory and its concretisation in objects as its subject, this book looks to examine the British Museum's collection and the cultures from which they come in a fundamental and common perspective, one of those basic and shared elements in human experience which can, we believe, fruitfully sustain cross-cultural investigation.

The theme of memory is thus central to the anniversary events of an institution like the British Museum, to the proper study of the objects in its care, and beyond that to the nature of our common human existence. To raise questions such as these is one of the central justifications for the existence of universal collections, for understanding what occurs across and between cultures is fundamental to reassessing and more completely understanding what we are.

Neil MacGregor
Director
The British Museum

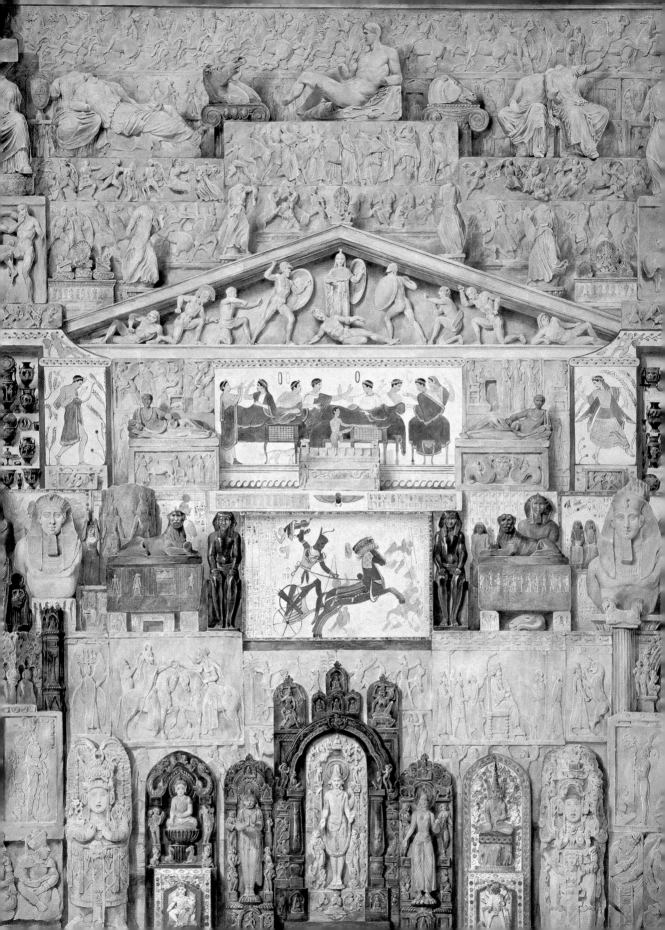

The British Museum and Other Theatres of Memory

1 James Stephanoff, 'An Assemblage of Works of Art in Sculpture and Painting'. Watercolour, first exhibited in 1845. The work shows sculptures from the antiquity of different parts of the world in the British Museum collection, arranged in a broadly architectural register. British. H. 74.3 cm, w. 64.6 cm. See p. 18. National Art Collections Fund. Department of Prints and Drawings.

In the 1950s a small row of houses at the bottom of the village of Killyleagh, situated on the shores of Strangford Lough in Northern Ireland, was open on its southern side to the breeze and the elements. It was in the harbour here that my father anchored a small yacht, and subsequently where we launched our home-made motor cruiser suited to fishing for mackerel, an activity which dominated the summer weekends of my youth. Sloane's Emporium, a Killyleagh shop of the late twentieth century, claimed no descent from a great son of County Down, Sir Hans Sloane, founder of the British Museum, born here in 1660. His house in Frederick Street bore no identifying plaque, and has now been demolished. A small brass plate placed outside the local castle with a short explanatory text, was the only acknowledgement of him. Virtually no one would have been aware of who he was or of his association with this quiet place.

On a blustery afternoon in April 2002 a statue of Sir Hans was unveiled by HRH the Duke of York in Killyleagh. The statue is a copy of a sculpture commissioned by the Apothecaries Society from John Michael Rysbrack in 1737. The original was first installed in the Chelsea Physic Garden, London, but moved in 1985 to the British Museum to protect it from erosion. The new copy stands in a complex of colourful modern town houses in what was the harbour that I remember well, but now an enclosed area called, appropriately, Hans Sloane Square (fig. 2). The renamed Square and the duplicate statue are, thus, a reclaiming of memory.

There are other copies of the Rysbrack sculpture on public view. A copy has been retained in the Physic Garden and a further example has in recent years been put up in Sloane Square, London – it, like nearby Hans Crescent, also named after the notable Irishman. He is renowned, of course, for a singular act of benefaction. His generosity led to the creation of the British Museum in 1753 which then incorporated the now separate Natural History Museum and the British Library. In Chelsea, Sloane leased the land from 1722 to the Apothecaries for their garden. A bronze medal bust of Sloane by Jacques-Antoine Dassier was struck in 1744 to commemorate his distinguished and lengthy presidency of the Royal Society (fig. 3); there is a portrait attributed to John Vanderbank and an engraving by John Faber junior after a painting executed by Thomas Murray in 1728. Sloane is thus much commemorated and his memory widely distributed at institutions in London, and now also in the village of his birth. His memory is thereby preserved through the deployment of his name and the display of his portrait at the many sites with which he is associated.

This book is published in the 250th anniversary year of the founding of the British

Museum. Its subject, however, is not the story of the British Museum itself which is well dealt with elsewhere.[1] The event of a major anniversary, and the memorialising which has already occurred in Killyleagh and elsewhere to ensure the acknowledgement of Sloane's legacy, raise underlying questions of how and why we commemorate, indeed how and why we remember. The focus here, then, is on the themes of memory and commemoration, and how these relate to the production of objects and images. The perspective is more anthropological than strictly historical, consistent with my own background as a social anthropologist. It is also selective in the examples it chooses for more detailed discussion. My own specialist interest has been in sub-Saharan Africa, though in more recent years I have had responsibility for coordinating work across a broader curatorial field in a museum context, and this is reflected in the approach adopted here.

The subject of memory is potentially a vast undertaking. In a literary context, Tristram Shandy took a full year to recount merely the events of the first day of his life. But it is not just a question of individual acts of memory, for it is arguable that shared memory is a defining characteristic of cultures and societies, as it is of families. Common heritage is asserted by such varied events as engagement in remembrance for the war dead, attendance at political rallies or sporting events, religious gatherings, voting, the wearing of badges, and, of course, the unveiling of statues to honoured local citizens. These are potentially cross-cutting sets of allegiances. Those who have together engaged in the defence of the nation may in another context be conservative or radical by political inclination, Catholic, Protestant, Muslim or Jew, and so forth. Ultimately, memory is tied up with the equally complex question of identity, personal identity and social or cultural identity. As the surrealist film-maker Luis Buñuel wrote: 'You have to begin to lose your memory, if only in bits and pieces, to realise that memory is what makes our lives. Life without memory is no life at all.'[2] The subject is one which could easily fill many large volumes. Some restriction of the field is clearly necessary. This book is not an encyclopaedic treatment of the topic of memory in culture, but rather an

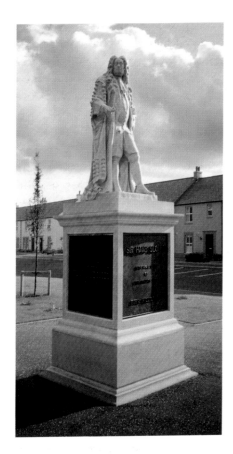

2 Copy portrait statue of Sir Hans Sloane in Hans Sloane Square, Killyleagh – his home village in Northern Ireland. The original, dating from 1737, by John Michael Rysbrack, is on display in the British Museum which he was instrumental in founding by his will in 1753.

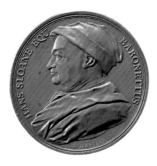

3 Bronze medal of Sir Hans Sloane by Jacques-Antoine Dassier, one of a series of studies of illustrious figures of his time. British. 1744. D. 55 mm. Department of Coins and Medals.

essay which reflects on some of the ways in which memory works in different societies. Here the topic is largely limited by attention to the issues as they arise in a single institution and in a consideration of its collections. Admittedly, when the institution is 250 years old, currently has 10 curatorial departments, covers nearly 14 acres and has approaching 8 million objects in its care, this is hardly a restrictive limitation.

So what follows is a survey of a particular theme, occasioned by an anniversary, the discussion itself inspired by the unique world-wide and temporal depth of the British Museum collections. In the next chapter, we will look at the ways in which memory is conceived as functioning, at the processes of memory and how an understanding of these processes is expressed and evaluated in different cultural contexts. Chapter 3 moves on to look at the mechanics of memory, at mnemonic systems and the objects that are created to facilitate remembering. If Chapter 3 is largely about the recollection of knowledge, Chapter 4 brings us to the question of how people are remembered, or indeed how the subjects and participants in history have sought to influence the ways in which they are to be remembered. This leads on to the large topic of portraiture and the representation of political and religious figures in a range of media, from prints and paintings, to sculpture, religious icons, coinage and banknotes. Chapter 5 looks at what happens after death, at methods of commemoration, memorialisation and monuments. This is not all morbid territory, however. Amongst the cultural forms considered is the role of festivals and fiesta, of remembering and honouring the dead through entertaining them. The greatest risk of being forgotten, of course, occurs when a person is no longer in charge of the mechanisms of their own remembrance. Remembering also implies forgetting, not just by being feather-brained, but as a deliberate attempt to erase the details of someone's existence or of past events, the memory of which is often hurtful or demeaning. This linkage between remembering and forgetting is explored in Chapter 6. The final chapter discusses memorabilia – objects which are brought back from physical journeys of various kinds, from the mementos of pilgrimage to the collecting activities of those on the Grand Tour, to souvenirs, photographs and objects attracting nostalgic emotions.

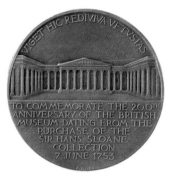

4 Medal commissioned from Paul Vincze to celebrate the British Museum's 200th anniversary. Sloane is shown on the obverse and the front portico of the British Museum on the reverse. British. 1953. D. 57 mm. Department of Coins and Medals.

The British Museum

We begin, however, in the British Museum itself for, even if there were no specific anniversary to be celebrated, museums are themselves instruments of memory. The huge world-wide interest in creating museums, and related phenomena such as Heritage Centres, was such a notable feature of the later twentieth century that it suggests museums have become allied to the functioning of collective memory in

new and significantly enhanced ways. Indeed in recent decades the interest in memory as a topic of historical and ethnographic interest has developed a burgeoning bibliography.

Beyond its collections, an institution of the age of the British Museum has necessarily itself become a place of memory, from its architecture to the naming of its parts, and even reported sightings of the ghosts of former members of its staff said still to stalk its backwaters. You enter it from the south through a neo-Classical frontage with, above, a pediment interpreting 'The Progress of Civilisation' by Sir Richard Westmacott. This combination of elements has been described as a 'magnificent essay in the adaptation and integration of antique sources', a reverent architectural quotation from the past.[3] The portico through which you pass contains a memorial to staff fallen in two World Wars (fig. 5). Beyond lies the former entrance hall, now renamed the Weston Hall in memory of one of the most generous of recent supporters of the Museum. The nearby donor boards record generosity stretching back to the Museum's foundation, and the names of the patrons of the recently created Great Court are carved in the stone encasing the round Reading Room. In the Reading Room itself the most frequently asked question concerns the location of the desk at which Karl Marx sat on his daily visits to the place over a period of thirty years in the nineteenth century (fig. 6).

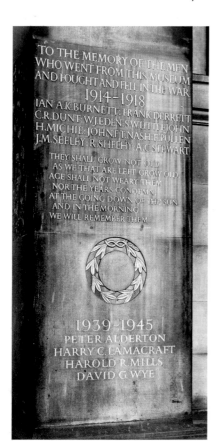

Entering from the north, you come through the King Edward building, named to record the laying of the foundation stone by Edward VII in 1907 – reminding us of the unfortunate fact that it was completed and opened in 1914, with the King recently deceased and the country on the brink of the First World War. Edward's bust stands in the north entrance. Finally, if you leave again through the front gates, on the inside of the low-railinged wall, the pitted marks left by shrapnel from a bomb which fell on the Museum in the Second World War can still be seen.

Many spaces within the building retain their original names despite subsequent changes of use. The King's Library remains the King's Library, even after the removal of King George III's books to the new British Library in 1998. Nearby are the Banksian Rooms and the Cracherode Room (associated with, respectively, Sir Joseph Banks, an influential Trustee and early benefactor, and the Reverend Clayton Mordaunt Cracherode, a major eighteenth-century donor). In the Museum's Board Room are assembled the painted or sculpted portraits of its former Directors (fig. 7). Elsewhere are brought together the photographs of recent Chairmen of the Trustees – the distinction between the medium in which the portraits of Directors and Trustees are executed being rigorously observed, though any deeper underlying rationale is difficult to detect.

Those institutions devoted to collections of cultural (as opposed to natural) objects also provide extensive insight into the ways in which memory operates in a wide variety of different social and historical circumstances. Commemorative items

5 War memorial beside the front entrance to the British Museum, originally designed by Eric Gill in 1921 to commemorate Museum staff lost in the First World War, and with text subsequently added to commemorate those who also fell in the Second World War. The famous poem 'They shall not grow old ...' was written by Laurence Binyon, a member of the curatorial staff.

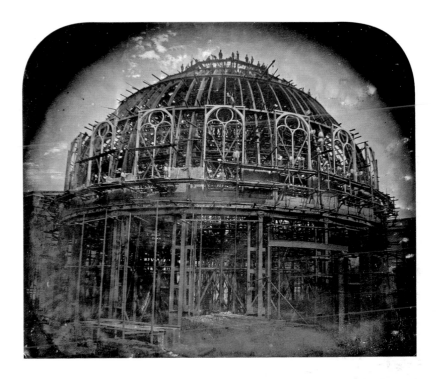

6 The round Reading Room under construction. Photograph by William Lake Price. 1855. British Museum Archives.

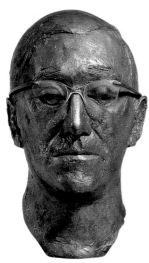

7 Life-size bronze portrait head of Sir John Pope-Hennessy (Director of the British Museum 1974–6) by Elisabeth Frink, DBE, RA. British. 1977. H. 35 cm. Department of Medieval and Modern Europe.

of one sort or another are their very stock-in-trade: painted or sculpted portraits, medals, coins and banknotes, sepulchres, inscriptions of various kinds, souvenirs and memorabilia, photographs and archives, and diaries. The fundamental questions to be addressed here concern the linkage between the creation of objects and the creation of memory as an aspect of human culture in general. This may be a direct relationship, as in the making of mnemonic devices of various kinds, or it may be more a matter of creating mechanisms by which individuals, and indeed whole cultures, commemorate and recollect.

Theatres of Memory

There is in Western culture a well-established tradition of theatres of memory. This is at one level a very precise reference to actual physical theatres, or models of them. It is also a reference to how questions of identity are shaped and negotiated.[4] We turn now to take the metaphor of the theatre and the question of identity into a museum setting.

Our introductory remarks have largely pointed to questions of how memory functions, and of the role of art and artefacts in that process. One can, however, also ask the question of where memory is fostered, in those specially constructed spaces in which the aim is often explicitly that of the encouragement and incubation of memory. The architects of contemporary museum buildings and memorials have been deeply conscious of this role in the designs they have created, from Daniel Libeskind's Jewish Museum in Berlin to Renzo Piano's Kanak cultural centre in New

Caledonia, or Maya Lin's Vietnam memorial in Washington DC. Libeskind has been quoted as saying that it is 'the destiny of architecture to communicate and to evoke the conditions of memory'.[5] His museum building in Berlin presents three alternative options to the visitor – a dead end, a path to exile and a steep staircase, each deeply evocative for all those profoundly aware, in the German capital, above all, of the historical events to be remembered in the building and expressed in its architectural conception.

In creating places of memory, present-day architects participate in a notable Western tradition. We return below to consider the roots of memory theory in Classical thought and practice and its use of 'imagined' architectural spaces to enhance the ability to remember things. For now, it is worth noting that in sixteenth-century Italy this imagined architecture took on physical shape in the form of one of the most famous, yet one of the most mysterious, artefacts of the century. This was the creation of a sometime professor at the University of Bologna, Giulio Camillo, and took the form of a wooden structure large enough to be entered by two people at the same time. Inside was the physical realisation of human knowledge so arranged within the space, as Classical theory prescribed, as to be completely capable of being committed to memory. We do not know what it looked like, as neither it, nor a copy commissioned from Camillo by Francis I of France, has survived, and an anticipated book to explain his marvellous design never appeared. But it promised great things. A correspondent of Erasmus wrote in 1532: 'They say that this man has constructed a certain Amphitheatre, a work of wonderful skill into which whoever is admitted as spectator will be able to discourse on any subject no less fluently than Cicero. It is said that this Architect has drawn up in certain places whatever about anything is found in Cicero.... Certain orders or grades of figures are disposed ... with stupendous and divine skill.'[6] Camillo's theatre of the memory was more than a mnemonic device on an architectural scale. Within, it was averred, was to be found an ordering of all knowledge, a kind of epistemological planetarium displayed so as to be recollected through the visual presentation of their organic linkages. Camillo's theatre afforded in effect a glimpse of the eternal verities, a life-changing revelation. No need here for Ophelia's memory-enhancing infusion of rosemary to strengthen the capacity for recollection. The genius that led to this wonder of the Renaissance world earned Camillo, as other great exponents of the art of memory, the accolade of greatness at the time: 'divine'.

This was memory theatre on the scale of a large wooden crate. At about the same time, however, other developments in this spatial understanding of memory were in development on a grander scale. Two stand out. In 1566, Duke Albrecht V of Bavaria set about acquiring a large series of busts and full statues, many obtained from earlier Italian cabinets on his behalf by the notorious dealer Jacopo Strada. The focus on portraiture, and the preponderance of Roman examples, recalls the displays set up in temples and private villas in ancient Rome itself, many including Roman marble copies of Greek originals. The fact of such Roman copying in antiquity is itself an indication of the early and explicit memorialising habit in Western

culture. Duke Albrecht had his collection brought together in a so-called 'Antiquarium' purpose-built in Munich, his capital. Strada was closely involved in both the acquisition of the collection and its arrangement in the large central hall on the ground floor (the upper floor containing an associated library). Later displays in the space brought the portraits together in a strict chronological sequence expressing, as the lost Camillo memory theatre had reputedly done for knowledge itself, a set of connections between the great figures of the past there assembled.

Another important project of the sixteenth century was Paolo Giovio's villa of portraits by Lake Como. He chose his site deliberately. Giovio built on the ruins of what was presumed to be Pliny's famous villa at Borgo Vico.[7] Alert to the fact that many of the portraits in circulation, especially those purporting to represent the ancients, were unlikely to be portraits done from life, Giovio took great care to seek as far as possible 'authentic' portraits. He did not restrict himself to any single type of portrayal, or indeed any particular type of subject. The images were found in a wide variety of media: on coins and medals, drawings and paintings, woodcuts, sculpture and busts. Each was identified in his displays and a short biography of the subject attached. The displays were arranged in rooms with particular themes – pagan deities, Fame and Honour, for example. A large hall overlooking the lake itself was decorated with images of Apollo and the Muses, leading Giovio to describe the complex as a 'Museum'. As Haskell, who discusses the project,[8] remarks, visitors found the result 'miraculous' – a similar vocabulary, of course, to that used in descriptions of Camillo's memory theatre.

The British Museum was established in the age of the Enlightenment, the era when optimism about the possibilities of assembling all knowledge in an accessible form led to grand schemes for creating encyclopaedias and large assemblages of objects, natural history specimens and books. This approach to universalism underlies the great expansion of the institution and has from the start provided the rationale for its existence. It has, therefore, all the potential to fulfil the role of Camillo's 'theatre', Duke Albrecht's 'Antiquarium' and Giovio's 'Museum' writ large, and is seen by visitors as in a sense the keeper of the world's memory. The hundred or so galleries of the British Museum as we now see them are the result of a long series of curatorial decisions, opportunities and historical circumstances which make the task of telling a connected story of human history in similar terms difficult. Nineteenth-century ideas of the evolution of cultures led to some ordering of the collections to explore historical and cultural connectedness.[9] Chronological sequence is still a guiding principle, but it is difficult to superimpose clear cultural connections on today's higgledy-piggledy disposition of galleries. It represents a considerable curatorial (and funding) challenge to render the relationships coherent, as well as a belief in some master narrative that sits ill with contemporary approaches. The floor plan of the galleries will not convey the Great Chain of Being without some rewelding, though happily modern electronic presentation of the collections enables many different forms of linkage to be easily explored.

If we are to seek a succinct image by which to convey the Museum's collections

in terms of an ordering of cultural knowledge, it is perhaps to the nineteenth-century watercolourist James Stephanoff that we might best turn. Stephanoff was the creator of a series of six watercolour paintings inspired by the Classical collections of the British Museum.[10] One is a painting first exhibited in 1845 which brings together in a single architectural image a collage of such diverse objects as Indian and Far Eastern sculpture, Maya reliefs, tomb reliefs from Xanthos, Etruscan sarcophagi, Achaemenid reliefs, Egyptian figures and the Parthenon sculptures (see fig. 1). There is certainly an element of universalist theories of the rise of civilisation in Stephanoff's image: at the base are shown Hindu, Javanese and Maya sculptures ascending to the Panathenaic procession of the Temple of Minerva at the top. But he is not slavishly following any single academic thesis; rather he portrays a synthesis of objects in a register given broadly architectural form by the inclusion of a pediment which itself reminds us of Westmacott's Progress of Civilisation on the outside of the British Museum building. No one would want to say that Stephanoff was necessarily aware of Cicero or the Rhetorica ad Herennium, the memory primer most widely referred to in the Middle Ages and the Renaissance.[11] None the less, his image is reminiscent of everything we know of the theatre of memory tradition. It has architectural reference and it brings together otherwise disconnected images in a visual ordering of knowledge equivalent in a single frame to what the modern museum seeks to achieve in its series of galleries. Although formally entitled 'An assemblage of Works of Art in Sculpture and Painting, from the earliest period to the time of Phydias' – hardly any clues there to intellectual inspiration – it might stand as a theatrical allusion to the British Museum as the world's most prominent museum of archaeology and antiquity. It distils human history in a visual collage reminiscent of the celebrated Camillo memory theatre.

Beyond the discussion of the Antiquarium and the villa of portraits, a considerable contemporary literature has built up which explores the concept of the museum as a place of 'living' memory in today's multi-faceted world. This was strikingly expressed in the nineteenth century by the French historian Jules Michelet who talked of his boyhood visits to the Musée des Monuments Français. Passing through the dark vaults, encountering epoch after epoch, he found himself 'not altogether certain that they were not alive, all those marble sleepers, stretched out on their tombs'. 'And', he continues, 'when I moved from the sumptuous monuments of the sixteenth century, glowing with alabaster, to the low room of the Merovingians, in which was to be found the sword of Dagobert, I felt it was possible that I would suddenly see Chilpéric and Fredégonde raise themselves and sit up.'[12]

Many of those who advocate that museums promote an active engagement with their collections as opposed to limiting visitors to passive acts of looking, invoke a similar idea: that of stimulating memory as a means to breathing life into inanimate objects. It is as if Stanley Spencer had resited Cookham churchyard to the local museum where, instead of the dead arising from their coffins, it is the objects which come to life in their glass cases. In a local museum context

this can work well. The museum itself becomes a kind of communal 'dream space'[13] in which objects are reunited with stories of the past, a significant exercise in reinventing the institution of a museum or cultural centre as a vehicle for promoting popular memory rather than simply as an instrument of historical preservation. The collection of oral accounts of the past becomes as important a fragment of history as the objects in the museum's collection; and many museums, not just in the Western world, see their role as 'collecting' memory with the tape recorder. Memory, thereby, gains a voice, and a capacity not just to inform but to move emotionally.

This agenda is more difficult for larger metropolitan museums, which are often bequeathed responsibility by local or national authorities for promoting multicultural sentiment. One option is to translate this aspiration into exhibitions and activities designed to express the cultural memory of selected individual sectors of ethnically mixed communities on a participative basis; and this most such institutions successfully achieve. Where museum audiences are international, however, the difference these activities makes is not easy to gauge. In a local context much works by a recognition of common rootedness and the possibility of shared nostalgia that this implies. However, nostalgia is not itself a multi-cultural sentiment. It is difficult to feel nostalgic for someone else's cultural past where there is otherwise no touchstone for a sense of belonging.

For international museums, especially those with well-established historical collections, the challenge and the opportunities are of a wholly different order. For one thing, they have been around long enough to be producers of memory – and even, for some visitors, nostalgia – in their own right. After all, institutions whose foundation goes back to the nineteenth century and beyond have been in existence for longer than most modern nation states, and their own memory deserves recognition. Secondly, they have survived many changes in intellectual direction and are still capable of contributing to the development of new approaches and insight. In a post-colonial era much attention is quite properly accorded the memory and histories of individual cultures; the intra-cultural is out of fashion. Many attempts by anthropologists and others to describe phenomena across cultures run up against the charge that they are not comparing like with like, that their basic vocabulary is often misplaced. Terms like 'religion', deriving from a Western monotheistic context, may carry inappropriate assumptions when applied across the belief systems of a wide variety of other cultures.

But, if the vocabulary is sometimes troublesome to present-day commentators, the original eighteenth-century ideal of comprising a conspectus of human cultures under one roof remains to be rediscovered and exploited. The starting point in this book is the contention that what is common across different cultures is not the details of cultural forms as such, but what underlies them. *The Museum of the Mind* reflects on this idea through the theme of memory, a characteristic which is integral to the definition of all cultures as of individuals. In drawing directly on the resources of one of the oldest established and most wide-ranging museums in the world it

seeks to explore the ideal of cross-cultural perspectives for the modern reader, without, however, drawing on the developmental assumptions of eighteenth- and nineteenth-century models of universality.

Identity and Memory

Memory is profoundly implicated in questions of identity, both personal and social or cultural. The point is well made in numerous literary and scientific contexts. The neurologist and writer Oliver Sacks discusses the cases of patients suffering confabulatory delirium, who through severe memory loss have to make up their identity and that of those around them every minute. 'We have, each of us,' Sacks reflects, 'a life-story, an inner narrative – whose continuity, whose sense, *is* our lives. It might be said that each of us constructs and lives, a "narrative", and that narrative *is* us, our identities.'[14] This narrative is, in effect, memory, the mechanism by which we recollect ourselves in that continuous inner drama which constitutes our sense of uniqueness in the face of the facts of biological similarity. Gabriel García Márquez makes a similar point in talking of a gradual decline of memory that will be familiar to many witnessing (or living with) what is now widely identified as a disease, Alzheimer's: firstly 'the recollection of his childhood began to be erased from his memory, then the name and notion of things, and finally the identity of people, and even the awareness of his own being . . . until he sank into a kind of idiocy that had no past'.[15] Kavanagh invites us to imagine ourselves loose in a world without the support of experience, or in the present context without memory.[16] 'Imagine,' she says, 'waking up one day not knowing how to boil water in a kettle, and not being able to recognize a life partner. We literally *remember* ourselves in all our conscious acts. . . . Every time we repeat an action or bring something to mind (however small) we are underlining, reinforcing and buttressing the subjective sense of self.' At the level of existential perception this makes clear the crucial part played by memory in our most fundamental sense of being. As far as Western understanding of the matter is concerned, we grow into memory at the point of birth, and we relinquish it, at least as far as knowable experiential criteria are concerned, at death. Memory is essential to a sense of being.

In a social context, shared memory promotes coherent communities. In the modern world the estimable aims of modern multi-culturalism are confronted by divergent, potentially fracturing, assertions of separate memory until common cause produces common remembrance. Wars, and the commemoration of those who fell in them, are amongst the most dramatic contributors to sustained common cause. Remembrance days, the creation of memorials, the wearing of signs of remembrance fabricate a common narrative of the past. Without the construction of such common remembrance, past events often have no clearly recognised closure. To give one contemporary example from the field of international affairs, it has been argued that in Zimbabwe the lack of full acknowledgement of the part of all those involved in the struggle for independence has created a sense of forgetting, or disregarding, rather than of honourable recollection. Even before the issues of War Veterans

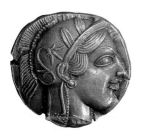

8 Silver tetradrachm showing a profile image of the goddess Athena in an archaic pre-Classical style. Greek. Fifth century BC. D. 24.5 mm. Department of Coins and Medals.

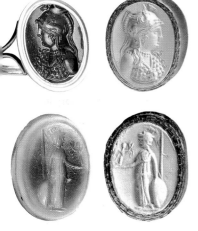

9–10 Two gems of Athena Parthenos (the statue of Athena that stood in the Parthenon), one showing a detail of the Pegasus helmet with which she is associated, the other presenting her general pose. Roman. Second century AD. H. 16 mm, W. 13 mm (both). Department of Greek and Roman Antiquities.

became an international concern in Zimbabwe in 2001 it was suggested by at least one anthropologist[17] that the War Memorial in Harare had failed appropriately to commemorate the contribution of ordinary people to the independence movement. Leaders of the movement and civil servants prominent in the post-Independence government were commemorated in Heroes Acre, but not those who had actually fought the wars on the ground. Without commemoration and appropriate acknowledgement, the hostilities of the period lacked resolution and, as indeed subsequently occurred, were potentially set to continue in one form or another.[18] For the great majority the ignominy of the death of colleagues, the painful remembrance of a war which, though won, had its individual moments of loss and grief, remained untransformed from apparent futility into heroic memory. Thus, in a sense it is incomplete, it has yet to be committed to common memory.

The repatriation debates which engage contemporary museums often have to do with negotiating questions of unresolved identity. Indeed, from the point of view of creating common memory amongst claimants, the negotiation and debate over the ultimate ownership of objects not only transforms the museum's holdings into icons, but – in a political context – also creates common cause in what is seen to be the reclaiming, in several senses, of a common history. The debate is at least as important from the political perspective as a successful outcome, for it is about internalising in the form of subjective memory the otherwise 'objective' facts of documentary history. Absence, exile – as it is portrayed – at a place of pilgrimage in a foreign museum, lends memory its potency.

This is not the place to reopen or conduct such debates. However, questions of repatriation are linked to a reclaiming of the past, and thereby to questions of what is remembered (and, as a corollary, what is forgotten or overlooked) in cases like these; and this is a further sense in which contemporary museums are embroiled in questions of memory. The most celebrated repatriation case of all is that of the sculptures of the Parthenon, the so-called Elgin Marbles. It has often been pointed out by opponents of the case for return that the Parthenon sculptures have been implicated in a great number of architectural and cultural contextualisations since their original creation. The founding of the modern Greek state in 1832 succeeded the removal of the sculptures by Lord Elgin's team and their acquisition by the British Museum in 1816. Until that point, as Mary Beard has recently observed,[19] the Parthenon had itself had a colourful cultural history. It began life in the fifth century BC as a grand building on the Acropolis dedicated to the goddess Athena (figs 8–10). The space was not the bare rocky outcrop it is today, but a sacred space in which the Parthenon would have been surrounded by other shrines, sculptures and memorials to mythic and civic achievements of other sorts. Inside stood the giant statue in ivory and gold of Athena herself. On the outside of the building the frontage was composed of a pediment supported on vast columns of marble with a set of metopes or panels inset beneath. Inside this forest of columns, high up on the outside of the walls of Athena's place of dwelling and difficult to see, was a continuous marble frieze.[20] The pedimental sculpture and that on the metopes concentrated on

the world of myth – the birth of Athena, her contest with Poseidon over control of Athens and various themes of conflict.

The frieze itself, 160 metres in extent, could not be seen as a continuous whole. What it shows is a procession of horsemen and chariots, elders, musicians, pitcher-bearers, girls with vessels for pouring libations and sacrificial sheep and goats.[21] There are also male figures in conversation and groups of gods separated by figures with folded cloth. The reference is generally held to be to the festival celebrating Athena, which on every fourth year was especially resplendent, and for which a large cloth was woven for the statue of Athena. One interpretation suggests that the frieze recalled for visitors to the site during intervening periods the major festival they might otherwise have been able to see had they timed it differently. The frieze is therefore seen as a form of memorialising which imbued the site with a continuing significance as a place of pilgrimage outside of the specific schedule of festival.[22] This pagan assemblage may, or may not, have been a 'temple': there is no ancient source to settle the matter. That it was a temple of some kind seems the obvious answer. But it appears not to have had an altar, which has led some to wonder if it was rather a grand treasury dedicated to Athena, the warrior goddess who helped defeat the Persians.[23]

Subsequent use added to its sacred status. By the Middle Ages, Athens was little more than a large village numbering no more than a few thousand citizens and, by then, its magnificent Classical building had undergone the first of several transformations. It had become a cathedral, its statue of Athena long gone, and now dedicated to a different lady, the Virgin Mary, Our Lady of Athens, with a resident archbishop appointed from Constantinople, the capital of the Byzantine Empire. The change to Christian use may date from the sixth century. One story tells of how Dionysus was on the Parthenon the day of Christ's crucifixion. From the colonnade he witnessed the earth shake and, to mark the far-off act of crucifixion whose significance he understood, is said to have inscribed the sign of the cross on the columns. Thus, a pagan function and Christian memory are succinctly run together. From Our Lady of Athens, a Burgundian takeover led to a French archbishop being installed and Our Lady became, briefly, Notre Dame d'Athènes. Catalan and Florentine influence brought archbishops of yet other nationalities and, as Beard describes, Our Lady became variously Seu de Santa Maria de Cetinas and then Sta Maria di Atene – all refashioning the original Parthenon to the celebration of different hues of the Christian faith.

In the early 1460s, the Parthenon became a mosque. It had, as Beard points out, by that time been a Christian cathedral for a similar length of time to its first incarnation as a pagan temple (assuming that is what it was). The church bell tower built to accommodate its function as a cathedral had a minaret added, the furnishings were changed, and the Christian decoration was to an extent painted out; thus the Parthenon re-emerged as 'the finest mosque in the world'.[24] For at least a thousand years the Parthenon was indeed a truly pantheistic architectural triumph, a space capable of encapsulating a series of separate dedications, and assembling a variety of potential communal and religious memories. Each successive use adapted or eradicated the previous. The most dramatic of these eradications occurred in the seventeenth century

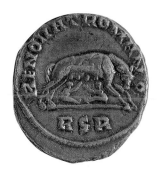

11 Silver coin showing Romulus and Remus suckled by a she-wolf, a reference to the mythical origins of the city of Rome and of the Roman people. It was made in the reign of the usurper Emperor Carausius (AD 286–93), probably in Britain. By this time all free inhabitants of the empire were Roman citizens and regarded themselves as Roman, whatever their place of origin. D. 18 mm. Department of Coins and Medals.

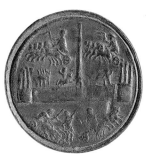

and effectively took the Parthenon into a further redefinition: this time as a ruin. When the Ottoman Turks in Athens came under attack in 1687 by Venetian forces of a Holy League, the Parthenon was being used to store ammunition. The inevitable happened and a huge explosion occurred destroying much of the building. The Parthenon as we see it today is a reconstruction of the early twentieth century using blocks that remained at the site after centuries of removing bits for other purposes. It sought, like Sir Arthur Evans did at Knossos on nearby Crete, to reconstruct what was imagined to have once been there. Later accretions – the Christian and Islamic foundations – were destroyed. Currently, the Greek archaeological authorities are in the midst of a painstaking refurbishment which will seek to acknowledge all these moments in the long history of recontextualisation to which the Parthenon has been subject. They are, however, obliged to do so by bringing together in one moment of time a series of refits which never existed simultaneously. And this, of course, is precisely the same challenge which museums with displays of world-wide collections deriving from different historical eras and cultural circumstances also face.

This extended discussion is intended to make a fundamental point: that remembering is also forgetting, and the further back one goes to seek for a common source, the more accretions of history need to be blanked out. Too patinated a history embellished with unpredicted twists and turns threatens to overwhelm popular memory and make it untenable, especially when filling out the story implicates other people's histories. Questions of repatriation are at one level not just about objects but about a sense of identity in search of memorialisation.

Memory and multiple identities are, as hinted at above, strange bedfellows unless united in a common cause which itself creates a sense of shared experience. For museums with large international collections, the 'sharing' is in one sense the specific experience of a particular collection displayed in a particular disposition of galleries in a museum building. Alternatively it is at a higher level of abstraction than subjective memory ever has to confront – it affords an apprehension of common humanity, something Camillo's theatre of memory and like experiments sought to express. This is a vision that the eighteenth century, which gave birth to the British Museum, found a more compatible aspiration than have the late twentieth and early twenty-first centuries. Perhaps the true challenge facing large international museums is that of embracing the implications of their functions as places with, simultaneously, a memory of their own, and a role as keepers of memory. And this is a dynamic situation, for when we define the essence of museum activity as 'memory-work', we acknowledge it is an active ongoing mechanism of creating and expressing contemporary identities, and not simply an impassive cataloguing of diverse historical cultures.

12–13 Roman medallions depicting the Circus Maximus in Rome. Buildings and monuments on coins and medallions reminded viewers of their benefactors, and of the antiquity and greatness of Rome and the Roman people. Fourth century AD. D. 37.8 mm (top), D. 38.9 mm (bottom). Department of Coins and Medals.

In the Mind's Eye

14 Osi Audu, 'Monoprint ("Juju")'.
Graphite, safety pins, wool and
plaited hair. A contemporary
evocation of Yoruba (Nigerian)
conceptions of the inner head.
1998. H. 153 cm, W. 122 cm.
Department of Ethnography.

The Nigerian artist Osi Audu, in describing a work acquired in the context of a new British Museum permanent gallery of Africa, has spoken of creating objects as containers of memory.[1] He has in mind the idea that a sense of self is constructed through memory; the self is a projection forward of remembered experience into present time. Each of us derives our selfhood from our ability to remember. However, all is not as it seems to Western ways of thinking. Audu's inspiration is the Yoruba idea, which he encountered as part of his own education, that just before birth every *ori* (a word that can mean both 'consciousness' and 'head') comes to an understanding with God (Olorun) as to the trajectory of their future lives. With birth the detail of this agreement is erased from conscious thought and concealed in the interior of the mind within the inner head (*ori-inu*). Life is a struggle to recapture the original plan and bring it back into consciousness as a memory that can be worked towards achievement. Any deviation from this agreed charter might result in illness and the solution might lie in a process of divination to retrieve an accurate memory of the pre-natal scheme and effect a realignment with destiny. What is envisaged is not unlike aspects of Freud's descriptions of memory in which experience leaves marks or traces in the unconscious whose recollection is triggered or energised long afterwards by appropriate stimuli returning as a dream. Freud talks in his 'Note on the mystic writing pad' (1925) of a film laid over a wax block. The written inscription on the film may be removed but its trace is registered on the wax beneath.

In Audu's work these themes emerge strongly. As he says[2] in explaining his own sources of inspiration:

> Part of the process of remembering usually involves the installation of a shrine to the inner head (i.e. Juju) in the corner of the room of the house. It is believed that the memory of the agreement reached with Olorun (God) is locked within the *ori-inu* (inner head). Installing a Juju in the house is a means of attuning with the memory of the original agreement with God in order to ensure that destiny is achieved. This was the inspiration behind my making of the Juju work.

> The resulting artwork (fig. 14) is a monoprint, the central element of which is a rectangular box, a metaphor of the head as a container of consciousness. It has a blackened graphite surface suggestive of the hardness of the skull, plaited hair, and safety pins which Audu sees as a metaphor for 'the ubiquitous eyes of consciousness'.[3] Yoruba conception, let us note, is quite profligate with notions of time: a clear case of 'back to the future'.

16 *Opposite* Painted scroll of turtles, an iconographic reference of longevity. The first image (top) was painted by Mōri Shūhō, the senior member of a group of Osaka-based artists (aged seventy-seven at the time of the painting). Subsequent images of turtles have been added in his honour by other younger artists. Japanese. Edo period, AD 1815. L. 122 cm, W. 36 cm. Department of Japanese Antiquities.

In this chapter we begin our investigation into the place of memory in different cultural settings by examining first of all the importance it is accorded in the pantheon of intellectual activity by different peoples. Archaeologists, as we shall see later, work with the idea of memory to interpret aspects of the distribution of artefacts in depositions, and they see evidence of its directive presence in the landscape, in mounds and commemorative sites dating to the earliest times. There is a strong and largely unquestioned presumption that the concept which we would term memory was at work in prehistory – certainly cultures in later antiquity for which we have more elaborate written or visual records all appear to accord memory a privileged place. But memory, if anything, plays an even more prominent role in cultures that have no systems of writing than in those which do. And this is without considering the impact in the contemporary world of access to electronic means of record which make the role of the remembrancers of old – esteemed figures in many cultures – to an extent ornamental or redundant. We begin, however, by looking at the words used to describe 'memory' in different languages and their semantic implications.

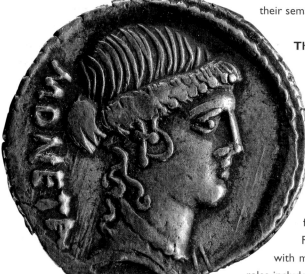

15 Denarius bearing the image of Juno Moneta. Roman. 47 BC. D. 18 mm. Department of Coins and Medals.

The Vocabulary of Memory

In Greek mythology, memory holds a high place. The personification of memory was the goddess Mnemosyne who, after nine nights of coupling with Zeus, gave birth to the Muses. The Muses are perhaps best known as divine singers whose music delighted the gods. They also, however, held sway over thought in all its forms. Thus, in the Greek world memory is the progenitor of knowledge, history, mathematics, astronomy, eloquence and the arts of persuasion. It is a fundamental, god-given and god-like attribute.

For the Romans, the goddess most closely associated with memory was Moneta (one of the names of Juno) whose roles included those of reminding, warning and advising (fig. 15). Her temple was that of Juno Moneta, one of the most prominent on the Capitol in Rome. As has been pointed out,[4] the temple is associated with validating standards of weights and measures, the minting of Roman coinage, and keeping the historical records known as the *libri lintei*, the linen rolls on which were listed the names of magistrates. In this guise Moneta is the goddess who remembers and certifies the accuracy of records and measures. 'Common to all these controversial areas of public interest is the need to be reliable, impartial and constant, a requirement which Moneta served as the divine trustee.'[5] So in both the Greek and Roman traditions memory is identified with a spectrum of laudable and basic human and civic virtues: knowledge, learning, constancy, reliability.

It is interesting that Greek mythology has spawned the modern English word 'memory' whilst Roman mythology is responsible for the word 'money'. From the

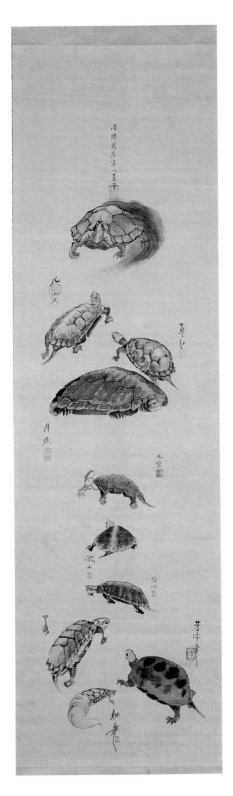

ancient Greek (via, the dictionary etymologists say, Old French) come related English words which carry different semantic burdens: memory, remembering, memorial, memorabilia, mnemonic, memorandum, memoir, aide-memoire. The clustering of terms, each with slightly different emphasis and shades of meaning, acknowledges the importance of memory as a mental attribute in Western cultures – it is, as Samuel Johnson put it, the 'primary and fundamental power without which there can be no other intellectual operations'.[6]

Many other languages have similar clusters of meaning and display an emphasis on carefully crafted distinctions of vocabulary. However, there are languages in which the meaning is dispersed in a range of alternatives with apparently independent derivations, rather than being brought together linguistically in a single clustering. The distinctions are none the less often finely drawn. Thus, in Japanese the word *kinen* covers much of the meaning of the English word memorial – memory in its physical context as a commemorative object. It means souvenir in one context, but has a deeper sense when applied to major life events. So it is a trinket, yet it is also a memorial plaque, a gift or a tree planted to mark a life-changing event. Since we are mostly concerned here with the place of objects in the construction of memory, this is the term which arises most readily below in discussing Japanese culture. But, in Japanese there is a range of alternative terms with their own subtleties and nuances. *Omiyage*, literally 'local products', also refers to souvenirs brought back from a journey, often as a gift to those remaining behind.[7] *Kioku* is a term used most familiarly in association with systems of mnemonics and artificial memory; *omoide* has reference to childhood memories and recollections; *tsuiso* or *tsuioku* has the sense of retrospection, of an afterthought or reminiscence; *tsuitō* refers to mourning and to *in memoriam* writing or poems; whilst a word with more ancient etymology, *tsuizen*, refers to a memorial ritual, what in Christian culture would be called a mass or requiem.

In Congo, Luba concepts of memory are embedded in a complex etymology which Nooter Roberts and Roberts have sought to unravel.[8] They notice, firstly, that the term in European languages has what they call a fan of meanings and usage for Luba, and that, taken together, these point to a transactional sense of the concept. It is about disputes which remain unsettled and to which one returns, unfulfilled debts, exchanges that are incomplete. The concept of memory, then, is most readily encountered in ideas of relationships and connections. Other terms link memory to the activities of wandering, strolling or simply lounging about, which suggests both the establishment of relationships of visitor to visited, but also a habit of mind which dodges around until it alights on a topic and begins to make

connections. This notion of memory as an outcome of random reflection is further endorsed by a semantic liaison between memory and the verb for 'to set', 'spread out' or 'extend', suggestive of hunting nets and game traps set to catch passing prey. Beyond that, the idea of remembrance incorporates the sense of repetition, whilst that of forgetting draws in ideas of neglect and disruption.

In Malagasy, the language of the island of Madagascar, the link between memory and consciousness is also asserted. A series of terms conveys this sense. In Richardson's classic dictionary of Malagasy (1885) the verb *mahatsiaro* has the meaning of 'to remember, to awake, to be conscious' and likewise the noun *arika*, memory, may also be glossed as 'imagination', 'idea', 'thought'. There is therefore a recognition in the etymology of the fundamental link between memory and a whole series of other mental processes broadly identified with consciousness and with a sense of self. To forget or to be oblivious of something is to possess *maty arika*, literally a 'dead memory'. However, as amongst the Luba, memory has an active transactional or relational aspect. Thus, something remembered or recollected is *tadidy*, a word which also means 'a tale', 'a story', 'a fable'. It is something in oral culture; *matadidy* is 'to speak in public', 'to deliver a public message', 'to express one's thoughts in public'. The relational sense of memory is embraced in the connection of the speaker to an audience of listeners. And this is not a loose piece of semantic linkage, for the immediate oppositional term to *tadidy* is *tantara*. *Tantara* refers to history in the form of a written account of successive events. The best known example is the *Tantara ny Andriana*, a three-volume history of the Merina aristocracy, written down and published in 1873 by Père Callet. In its oral form it was *tadidy*, as written history it has become *tantara*. In other words, *tadidy* is history as memory, *tantara* is history as archive.[9] In the context of the present discussion the distinction might be drawn up slightly differently. *Tadidy*, orally transmitted stories, retain memory as an active and vital part of culture which by repetition are transmitted from person to person and across generations. *Tantara*, the written version, has become referential.

The distinction made in Malagasy also resonates with Classical thinking. For the Greeks, as we have just seen, memory was the progenitor of knowledge, and thus of history. In a Western context, the relation between memory and history is a large topic in itself. Some modern historians have felt happier to talk of memory as their subject where other generations might have found the evidence of memory insubstantial and perhaps even unworthy: Raphael Samuel's *Theatres of Memory* (1994, 1998) or Simon Schama's *Landscape and Memory* (1996), for instance, for all that they take in an imaginative sweep of history rather than a restricted vista, could hardly be imagined emerging from the pen of a Gibbon or a Macaulay. In Samuel's writing, the case for attention to memory is not that it is differentiated from history in terms of the passive role of the one and the active process of interpretation of the other. Both are products of their time; they are constantly revised, changing their emphasis depending on the demands of the moment. Likewise, an otherwise instinctive distinction between memory as largely subjective and history as objective

seems to be flawed. They are seen, instead, as convergent methods of constructing historical knowledge. Memory, however, is not concerned with binding in incidental evidence to create a single rising tide of master narrative; rather, it cheerfully invokes the eccentric or sensational without any attempt to give the past a didactic developmental sense. In the study of memory, history becomes ethnography: it is about oral traditions and popular culture rather than official archived sources of evidence. Here the very sense of the past and its importance to those living in the present is a proper point of departure for historical thinking, rather than just the official accounts of what occurred.

Memory in Oral and Literate Contexts

In the traditional court system of the Kuba peoples living deep in the Equatorial forest of the Congo, a leading court title is that of the *bulaam*. This is accorded the person charged with two crucial, but otherwise apparently unrelated, tasks. The first is that of recounting the king lists which are central to establishing royal descent from the founder of the kingdom, Shyaam-a-Mbul Ngwoong. The *bulaam*, with his command of what was formerly an oral archive of kingly history, is thus a vital component in affirming the credentials of an incumbent ruler and establishing the rights to succession of potential heirs to the kingdom. This concern with order and propriety recalls the continuing role of the office of the Remembrancer in the Corporation of London who is charged with determining matters of protocol. The second role of the *bulaam* is that of dance master, for it is also the *bulaam* who teaches female members of the court and royal household the movements which they are to reproduce in ceremonial performance.[10] In this sense the *bulaam* has the dual function of committing to memory on behalf of the court both a particular sequence of historical events in time and a predetermined pattern of physical movement in space.

In both dimensions, the act of memory which the *bulaam* is required to perform is related to the process of creating an order to events. In reciting oral tradition the structure is largely narrative but, as the historian of the Kuba, Jan Vansina, tells us, there is great admiration for being able, in the course of story-telling, to rattle off long lists of genealogies, titleholders within the court, place names and so forth.[11] Immense prestige is accorded those able to perform such acts of memory, and to do so in ways which locate sequences of events in the evolution of Kuba society.

Here, we will consider a range of cultures, from those in antiquity to those in more recent history which utilised writing, and many that did not. Is there any significant divergence in the functioning of memory in such different cultural contexts? Oral cultures rely heavily on memory, on the recounting of stories and histories to create a shared and coherent account of social and cultural identity. Where in literate cultures a society's expectations of behaviour are codified in written laws, in oral circumstances much depends on memory. The legitimacy of claims to individual power and authority cannot be sustained without remembrance of genealogy. Kinship, marriage regulations, the annual cycle of domestic or

agricultural activity and many other familiar points of reference in literate culture – all require organised recollection of past experience and precedent in an oral context. At a fundamental level it can be argued (though it is difficult for a literate author, or indeed the reader, to imagine purely oral circumstances), that thought which is not organised and rendered mnemonic through deliberate means is little more than amnesiac day-dreaming. Unless retrievable in some way by presentation in a repeatable formula, it is simply lost. In oral cultures, knowledge is remembered recoverable experience.

Without texts, more complex analytical thought has no clear locus within which to be retrieved and through which to develop a sustained argument. This does not mean it does not happen; however, as Ong points out, argument is developed not in isolation but is fundamentally tied to oral communication.[12] Hence patterns of speech become significant: 'Your thought must come into being in heavily rhythmic, balanced patterns, in repetitions or antithesis, in alliterations and assonances, in epithetic and other formulary expressions, in standard thematic settings . . . in proverbs . . . or in other mnemonic form.'[13] Thought must be specifically encoded in memorable form, often a narrative form, otherwise it will simply be forgotten, for it has no other medium of record. Carruthers insists that the distinction between the place of memory in oral and literate contexts is generally overdrawn and that the crucial question concerns the place of rhetoric in particular cultures (which may be associated with either scenario).[14] The point is well made, though we might say that rhetorical traditions which are embedded in largely literate cultures in fact retain characteristics in terms of the use of language which are otherwise associated with orality. Medieval libraries, as we know, were not the quiet contemplative spaces we find today. Readers then mouthed the words in front of them or read aloud, for literacy had not overcome vocalisation and the need for communication as the primary means of lodging ideas in the mind so as to ensure future recall. Memory still baulks large.

Orality is deeply embedded in our traditions of literature. The Classical tradition of poetry, of course, was largely oral. Homer's verse survived through repetition over centuries before it was transcribed. Longfellow sought to suggest something similar was happening in his popular *Song of Hiawatha*; he tried to give it the feel of oral poetry by turning to a translation (in German) of the Finnish oral epic *Kelevala* in search of an appropriate meter – not altogether successfully, given the difficulties of fitting Minehaha, Pau-Pak-Keewis and Mushkodasa conveniently into a line of verse without occupying too much of it. Poets have often been performers. Byron had Coleridge recite Kubla Khan. Once we have heard Auden, Dylan Thomas or Betjeman read their own poetry it is impossible to read it ourselves without recalling the rhythms of their recitations. Poetry is often memorised so it can be repeated; it trails with it its oral origins. Likewise, plays are written to be performed. Indeed the script in printed form often emerged from prompt copies or actors repeating their lines – witness the complex debates over the sources of Shakespeare's plays. Similarly the fifth-century BC Athenian playwright Euripides (fig. 17) interpreted the great

17 Marble portrait of the Athenian dramatist Euripides (c. 484–406 BC). Roman version. Second century AD. H. 47.5 cm. Department of Greek and Roman Antiquities.

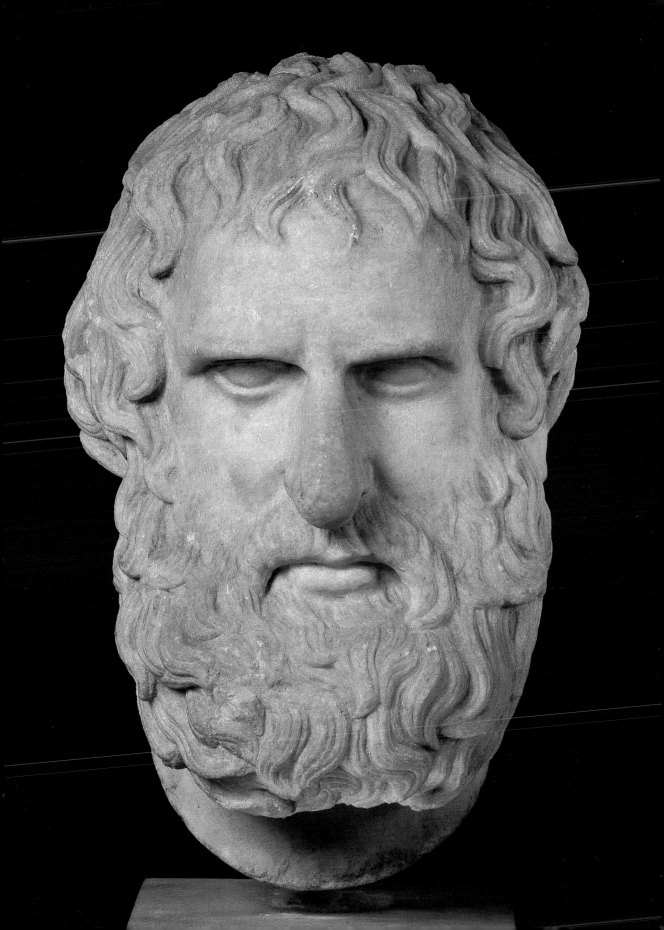

18 The Buddha shown in paradise with Bodhisattvas, attendants and musicians. Two devotees are pictured arriving by boat. They are thought to be the patrons responsible for donating an associated manuscript to a temple – creating at once a textual memory and a pictorial recollection of the donation. Japanese. c. AD 1200. H. (of image) 26 cm, W. 25 cm. Department of Japanese Antiquities.

military and political events of his day through placing them in a mythical context. He conceived his plays as unique occasions to be performed only once. That they have come down to us at all is due to the fact that written versions were commissioned a century later.

Much recent anthropology has wrestled with these issues of orality and literacy. Goody originally drew attention to the possible differential functioning of memory in oral and literate contexts, seeing them as embodying two versions of a process by which memory is transmitted across the generations, two models of a kind of cultural genetics.[15] Küchler and others have broken this model down and suggested other distinctions broadly consistent with our remarks above.[16] Thus, the methods of memory-recall may be redrawn as a comparison between 'repetition', where the thing remembered becomes the subject of formulaic recitation or visualisation, and 'duration', where it is always potentially present as a stimulus to recollection. Clearly two overlapping conceptions of time are at work here, one cyclical the other linear. The distinction is further made explicit by referring to the former as 'inscription' and the latter as 'incorporation'. The one achieves its aims by returning to a template or formula and

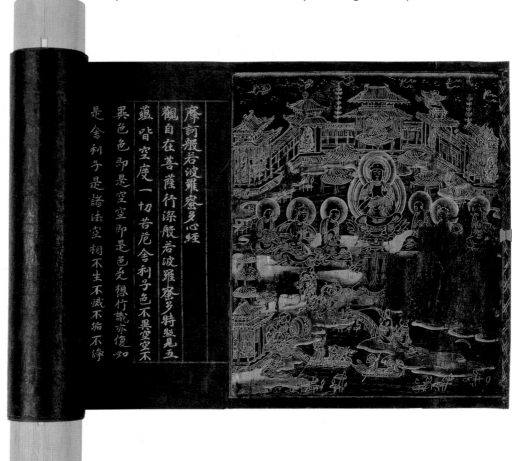

creating meaning from it (as in much ritual action), the other has an enduring authority which requires no repetition or exegesis for its transmission (as in the creation of monuments).

Innovation is also involved, for inscription implies the production of multiple successive versions of an original with inherent possibilities of variation. We have already remarked that the dynamic of remembering some things often implies forgetting others. Erasing memory is integral to creating memory. This may seem to return us to the distinction questioned above between history, as an objective form of report of the past, and memory, as a subjective and potentially unreliable accounting. Memory, of course, stands in direct contrast to forgetting; and it is not supposed to be innovative. But from one point of view it is irrelevant whether it is or not. As a means of cultural transmission it is about the recognition of constancy, whether illusory or accurate. The social memory discussed here is not concerned with fastidious acts of accounting, or with exactitude in repetition. Repetitive 'inscribed' acts of memory, we might say, assert constancy, whereas enduring incorporated ones simply are constant. And if that is so, then we are led to see memory as integral to history rather than as a faulty accounting of the past.

So, it is suggested here that the distinction between the place of memory in systems of orality and of literacy needs further elaboration. People muttering in medieval libraries is one instance; the addition of a written inscription to a portrait bust in ancient Egypt is another – reading it aloud was intended to be the means of investing memory with an ongoing value. We will be concerned in later sections largely with visual imagery. In these terms we might see our distinction as located in the difference between the ephemeral, where reproduction of an image is essential to its ability to act as a touchstone of recollection, and the memorial, the enduring end of the spectrum.

Feats of Memory

Against this background let us turn to consider in more detail some concrete examples of the cross-cultural understanding of the place of memory in mental activity. Recollection without reference to texts has always been held in high regard. Theatrical feats of recollection (like the Mr Memory of the musical hall, capable of remembering vast reams of facts in answer to the random questions of the audience) or technical acts of memory (such as those of several British Museum warders capable of remembering accurately from which hook to retrieve the security keys of approximately 1,000 staff) are modern and secular examples of awesome powers of recollection.

But historically, much cultivated memory has been in the service of the sacred. A prime example is the Koran. In the Islamic world, knowledge of the Koran has not just been a trick of memorising, but a spiritual duty. In many ways the oral recitation of the Koran is regarded as superior to its written form and is independent of it. Indeed some have argued that the fact that early written versions are unpointed (that is, they lack diacritical markings) suggests that it was intended to

be known by heart and did not require to be written in formal Arabic. When the 'standard' Egyptian version was being prepared in the 1920s, it was largely oral versions which gave the text its authority. In Arabic the word Koran (Qur'an) means 'recitation', and its basis is the recitation chanted by Muhammad to his followers over a period of twenty years. These revelations were committed to memory and the entire Koran maintained through the centuries in this oral form by professional reciters (Qurra), with followers only memorising those parts required for daily prayer.[17]

In India, similar memorising as a sacred duty seems to underlie the survival of the Vedas, a large collection of hymns and songs which date back to the first millennium BC. Ong discusses whether these have a primary oral or written form, and comes to the conclusion that their formulaic and thematic structure, so suited to remembrance, suggests that their first context was in oral performance and recitation.[18]

The Western tradition is similarly replete with accounts of unfailing admiration accorded those able to perform prodigious feats of memory, both secular and sacred. The Roman general Publius Scipio was reputed to have been able to remember the names and identify all of the 35,000 men under his command. In similar vein, Augustine describes the accomplishments of a schoolfriend called Simplicius, whose memory belied any implication his name might convey of a lack of mental ability. According to Augustine, Simplicius had so completely committed to memory the works of Virgil that, if asked to repeat the penultimate verse of each book, he could do so quickly without reference to the books themselves. Or, if challenged, he could produce an apt quotation to any given situation without hesitation. Likewise he knew much of Cicero's orations and could similarly manipulate the sequence of his prose backwards and forwards to a remarkable extent. For Augustine it is not simply the act of learning by rote which is remarkable, but the fact that it has been so completely performed that elements can be dislodged from the sequences in which they originally appeared and reconstructed to fit other circumstances. 'When we wondered [about his abilities], he testified that he had not known God could do this before the proof from experience.'[19]

Other divines were likewise credited with phenomenal powers of retentive memory. Thomas Aquinas is said to have been capable of remembering everything he was taught whilst at school in Naples. We are told that later, when composing a collection of utterances of the Church Fathers on the content of the Four Gospels, he was able to do so from what he had seen and committed to memory, rather than from copying it down from other books. Frances Yates, in recounting this feat, concludes that Cicero himself 'would have called such a memory "almost divine"'.[20]

Not everyone was unambiguously sold on the virtues of a trained and burgeoning memory for detail. Writing in the 1530s, the era of Camillo's theatre of memory, Rabelais describes how the fictional Gargantua is taught to learn the most complicated of grammatical treatises together with a succession of detailed commentaries by such learned worthies as Bangbreeze, Scallywag and Claptrap. Rabelais reports that Gargantua had a remarkable aptitude to repeat all he had

learned backwards as well as forwards, totally by heart. However, he goes on rue-fully, if it came to asking a question on the significance of all that Gargantua had so impressively committed to memory, it was like extracting blood from a stone – or in Rabelais' more colourful language, 'it was no more possible to draw a word from him than a fart from a dead donkey'.

Most of Rabelais' contemporaries, however, saw in memory the accumulation of knowledge such that ever more informed, ever wiser, judgement can be exercised. Memory is the equivalent of experience, of lessons learned, recollected and applied. With the Enlightenment thinking of the eighteenth century, things were to change. On the brink of this shift of emphasis the philosopher John Locke could still describe the mind as like a piece of white paper. But, unlike the Ancients, he did not regard memory as a straightforward matter of inscribing impressions, and then retrieving them so they could be brought to bear on particular situations. Whereas the attribution of genius had formerly been associated with prodigious memory, it was to become instead an attribute of creative and imaginative ability. Yet memory was still relevant. On Locke's virginal white paper, sensation and reflection were imprinted, and their combination was seen as leading to perception. Memory of indi-vidual events would summon in ideas in ever more complex networks of associa-tion, which would produce further abstract thought, and ultimately notions of beauty, order, and, in the moral and political vocabulary of the Enlightenment, liberty. Phrenologists in the nineteenth century allocated memory its sphere in the human brain;[21] but where the Ancients saw memory as the underlay of sound judgement, the modern European mind came to resite it as a structuring mechanism from which creative thinking can proceed.

A special place is accorded auditory memory for, as we shall see, most feats of memorising are held to work through visual recollection. It was only towards the end of the nineteenth century that Franz Lizst and Clara Schumann caused a sensa-tion by doing what is now common – playing in public without sight of a score. Mozart, famously, was able to write down from memory the whole of Allegri's *Miserere* having heard it sung in the Sistine Chapel in Rome. The conductor Toscanini attracted similar accolade for his feats of recall. It is said he knew all the notes played on every instrument in the orchestra of approaching 250 symphonies. Indeed it is recounted that, just before a concert, a second bassoonist told Toscanini that the lowest note on his instrument had been broken and could not be played. Toscanini, after a moment's reflection, is said to have remarked that this would not be a problem since 'the note doesn't occur in tonight's concert'.[22]

The modern world, of course, has developed computerised methods of recording events. The capacity to reassemble them at will in whatever sequences we might wish seems to challenge the place of trained memory in the pantheon of mental capacity. Similarly, the accurate recording of events on camera has amplified the evi-dence of first-hand witness and subsequent remembrance. In a fundamental sense, as Carruthers astutely remarks, medieval (and we might add earlier) culture was in essence memorialising, where modern Western culture has become documentary.[23]

Remembering, we might say, has become a matter of remembering where to look something up, or remembering the strokes on a typing pad that lead to a website, rather than an obligation to retain the information itself in the mind.

Visualising Memory

If the place of memory in culture is not constant, the understanding of how it functions has some constancy in Western thought, and this seems to have resonance cross-culturally. To return to our example from the Kuba of Central Africa: in a society whose visual culture is intimately concerned with exploring the possibilities of geometric configuration, of pattern-making, order has both an intellectual and a physical manifestation. It is reported that when whole villages are moved to a new site, as happens periodically, villagers rest on the way in the same relative positions to each other as their huts had in the villages they have just abandoned. The eventual arrangements of huts at the new village site also duplicates that of the old. Although there is otherwise no systematic relation asserted between the two activities brought together in the person of the *bulaam*, dance-master-cum-remembrancer, the very fact that the title-holder embraces both physical and intellectual order is, at one level of interpretation, an expression of a linkage. Vansina suggests that the term *bulaam* may originally have been applied principally to describing their role as dance instructors and to have arisen in the first instance in the aesthetic realm. Impressive feats of historical remembrance came later.[24]

Memory and visual criteria are, of course, otherwise intimately connected in various models of how memory functions. Beyond the 'divine' intervention with which both Simplicius and Thomas Aquinas were (only half-jokingly) credited, there has since ancient times been a recognition that memory can be trained – what has become known as 'artificial memory'. Augustine and Thomas Aquinas both discoursed on the subject. A persistent representation of the mind employs variations on a familiar metaphor we have begun to encounter elsewhere: that of the *tabula rasa*. Cicero talked of memory as an equivalent to written speech; as on a waxed tablet, memory can be imprinted in the mind, working not through writing down letters, but by drawing together groups of images in particular places (*loci*). From this and other observations in Classical sources developed the idea of memory as a series of mental pictures located in a physical space. In a seminal work Frances Yates, who credits Simonides of Ceos as the inspiration for Cicero's memory system, traces the Classical system through to late sixteenth-century England and the creation of the Globe Theatre. The Classical method asserted that memory could be enhanced if a spacious and varied architectural space is imagined to include rooms with various different functions, anterooms, connecting corridors and diverse styles of decoration. A series of striking objects with an association which can be remembered and which act as aides-memoires are then disposed in the various imagined rooms. An orator in the course of a complex speech would then imagine himself visiting different spaces in sequence, encountering the objects arranged there and recalling the different elements of the

oration. Camillo's memory theatre discussed in Chapter 1 is an application of this practice in a physical context.

Yates traces Camillo's influence through Hermetic and Cabalistic thinking to the memory theatre of Robert Fludd,[25] the self-declared seventeenth-century disciple of the Rosicrucians, a mysterious brotherhood known through its manifestos but otherwise undocumented, and with objectives that remain elusive. Fludd's complex theatres have more than a hint of the magic arts about them, deploying occult symbolism, talismanic, planetary and celestial imagery, and a series of architectural spaces or rooms disposed in the heavens. All was conceived in terms of the signs of the zodiac. The term 'theatre' which Fludd uses to describe his memory system in fact refers more to an amphitheatre or stage. Yates goes on to speculate whether the original design for Shakespeare's Globe Theatre did not itself draw on such esoteric sources for its architectural inspiration, mixing zodiacal triangles and Fludd's symbolic geometry to produce a place of popular public entertainment.

In terms of art history, Yates's work has led to a (by now largely accepted) view that in Western art the connection asserted between what is memorable and the deliberately idiosyncratic location of images in space has frequently been exploited. In the Middle Ages the register of much religious art with its sequential or diagrammatic format is interpreted as benefiting from such an understanding of ordering. The arrangement of altarpieces, the marginal, often grotesque, imagery in liturgical manuscript illustration, and mural painting have all been considered in such terms. Yates famously interpreted Giotto's series of Virtues and Vices from the Arena Capella in Padua in such terms.[26]

It is interesting to see how this system of mnemonics fared when transferred beyond the immediate sphere of Western culture. Something of the sort did happen in the sixteenth century in the hands of Catholic missionaries.[27] Most notable was a Jesuit, Matteo Ricci, who in 1577 left his native Italy and travelled first to India and then on to Ming China. His ambition was to interest leading Chinese in the wonders of the memory system in order to attract attention to the associated religious practice of the West. He settled in Nanchang, in Jiangxi Province, and began trying to interest the family of the Governor in his system of imagined memory palaces. His own abilities to use the system soon impressed his Chinese entourage and he wrote home in triumph at the attention being paid to him by local intellectuals. The integration of the sign of the cross (comparable to the Chinese figure for 10) with the memory system derived from Classical antiquity and Chinese ideographs made for a remarkable coalescence of philosophical and theological systems and an extension to the Orient of distinctively European mnemonics.

But there is a problem with all this. The memory theory which we have been discussing insists on the essentially imaginary and personal nature of the mnemonics appropriate to rhetorical purposes. No one is required to make the speech except the orator. No one else needs to log the idiosyncrasies which mnemonic practice recommends so that it may be remembered *in extensio* in the course of an oral communication. Mnemonic tricks are, as it were, in the mind of the orator, not in the

eyes of the listener. However, memory theory applied to artistic practice does suggest the kind of image that will be striking and, we might say, memorable. In the early fourteenth century, Thomas Bradwardine wrote in his treatise on memory and visual images that 'their quality truly should be wondrous and intense because such things are impressed in the memory more deeply and are better retained'. The most potent memory images, he continued, 'are for the most part not average but extremes, as the most beautiful or ugly, joyous or sad, worthy of respect or something ridiculous for mocking, a thing of great dignity or vileness, or wounded with greatly opened wounds with a remarkable lively flowing of blood, or in another way made extremely ugly'.[28]

In both oral and literate cultures the primary association in mnemonic systems is between recollection and physical things. In Iran frescoes have been found at Piajikent in Transoxiana dating from the seventh to ninth centuries AD. It is thought that the frescoes, which illustrate in detail episodes from well-known fables and stories, were painted in the very rooms where the tales themselves were recited.[29] They acted as visual reminders both to the story-teller, to ensure that the details recited were correct and in the right order, and, after the recitation, to the audience, that they might keep the memory of the story fresh. Later, when illustrated manuscripts became current, the technique was applied in juxtaposition to written text as is now completely familiar.

It is often said that the invention of writing, and even more so of printing, threatened to dislodge memory from the status it previously occupied in Western culture. It is not only that we dream in pictures and that dredging images from the unconscious works through visual means. We also remember words or texts not through some auditory form of memory but through seeing them as marks on the page. Anyone who has taken exams knows that learning by rote is a matter of locating in the mind the memory of a fragment of text at a particular place on the page from which it has been learned, perhaps highlighted in some way to make them stand out – as one of Cicero's objects deployed in his imaginary rooms. So too with taste. In what must be one of the more modest acts of memory to attract renown in recent times, Proust's great literary enterprise *A la Recherche du Temps Perdu* was touched off by a minor domestic moment described in an appropriately theatrical manner, the dipping of a madeleine biscuit in an infusion of lime blossom. The exquisite nature of the event was not just the delight of the taste. An architectural and visual context came into mind: Proust's childhood memory of his aunt dunking her biscuit in her Sunday morning tea led to the recollection of the street in which she lived, the old grey house, and the detail of her room. All 'rose up', he writes, 'like a stage set'. And the resulting compendium of memories occupied fully six volumes.

Mnemonic Devices

The *bulaam* amongst the Kuba in Central Africa is charged with remembering important genealogical and other details of the royal lineage and the court on behalf of the wider community. There are, however, a series of portrait statues associated with individual kings (*nyimi*) which memorialise their reign in visual form. The figures (*ndop*) are widely believed in Kuba country to be carvings from life; the present *nyimi* is currently contemplating the commissioning of his own portrait figure. Kuba opinion on this is at odds with art historical interpretation: if the carving of these images is direct, it follows that the one in the collections of the British Museum which represents Shyaam-a-Mbul Ngwoong must be of early seventeenth-century date to cohere with the period when he is known from other evidence to have reigned. It has, however, been dated to the late eighteenth century and identified as coming from the same carver or atelier responsible for the *ndop* of kings who reigned well over a century after the passing of Nyim Shyaam, the founder of the Kuba kingdom. A member of the current royal court has explained that the figure of Shyaam 'is the first *ndop*, a concrete representation of the source and authenticity of royal power. It has vitality, brought to life by the realism of the carving, the symmetry of the portrayal and the colour of the flesh.'[1] Two different understandings of the past seem to be at issue here, one which relies on memory and another which requires a documentary accounting of history.

However, what adds to the indigenous perception of the object and the identification with a particular ruler is less the physical portrait of the royal person, which by external standards appears generic not individualised, than the mnemonic image carved on the front. These are of various kinds: drums, a double gong, an anvil, a person, a fly trap, a parrot, nuts, a human head, a canoe, leopard skin, a cock and an adze.[2] Each image is associated with a story of innovation identified with the king in question and sums up the achievements of his reign. In the case of Nyim Shyaam, the image is of a game

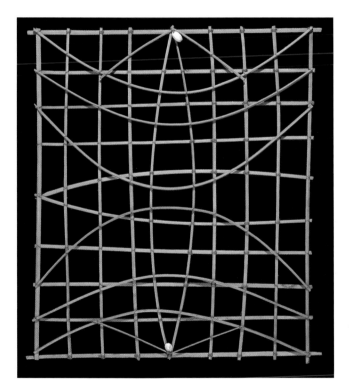

19 Stick and shell navigation device (*mattang*) made by mariners in the Marshall Islands, Micronesia, as an aide-memoire. Late nineteenth century. L. 75.5 cm, W. 59 cm. Department of Ethnography.

board (*Iyeel*) (fig. 20). It is often said that this acknowledges Shyaam's role in the introduction of gaming into Kuba society which, given that he was the founder of the kingdom itself, seems a slim enough claim. Shamashang suggests rather that what is recalled is Nyim Shyaam's victory over his competitors for royal title and the rights, not least that of divine right, conferred on his successors. *Ndop*, it might be added, were traditionally kept in the royal compound and were used in the installation procedures of successive kings to incubate in them the spirit of kingship. Kings were also required to learn the royal genealogy by rote, so the *ndop* may have had a direct function as aide-memoire in that context, with the image at the front of the plinth as a physical rather than imagined *loci* (in the Western model).

It is practices of this kind to which we now turn. That which the orator retains as a purely mental image to guide remembrance is externalised through objects in many other cultural contexts. The questions which arise here concern the ways in which art and artefacts of various kinds may articulate acts of remembering. Thus we move on to look at what happens when an image 'in the mind's eye' takes physical form. Are the general principles of memory that we have encountered in Chapter 2, as an aspect of mental activity in different cultures, reproduced when thought is retrieved through the intermediation of objects?

The 'Knotted Handkerchief'

Mnemonic systems in innumerable cultural contexts work through the exploitation of some form of visual linkage such as the *ndop*. At its simplest the physical referent may simply be a replication of the thing that is to be remembered, as in the cases of myth and story illustration on walls or in manuscripts as discussed above. Such illustration can be all-embracing, a sequential retelling of a complete visual story as a complement to an oral or textual rendition. However, in the present context, the most interesting instances are of what we might call the case of the 'knotted handkerchief' variety, where the mnemonic involves some form of codification, and where its meaning is to an extent more personalised or more culturally specific. Such mnemonic imagery employs a highly condensed system of reference, for an image is required to speak volumes and not simply to sum up a single episode. When the Kuba say of an *ndop* that it *is* the *nyimi*, they imply that it represents everything about him that is remembered – his kingship, his royal authority, his innovation and the stories of his reign. This is not content which is given in the image itself. Rather it is supplied by those charged with remembering. Unlike illustration,

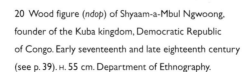

20 Wood figure (*ndop*) of Shyaam-a-Mbul Ngwoong, founder of the Kuba kingdom, Democratic Republic of Congo. Early seventeenth and late eighteenth century (see p. 39). H. 55 cm. Department of Ethnography.

21 Wood memory board (*lukasa*). Instead of the usual beaded patterns, there are five sculpted heads in relief against an incised background of patterns and ideographs. Luba, Democratic Republic of Congo. Early twentieth century. H. 46.5 cm. Department of Ethnography.

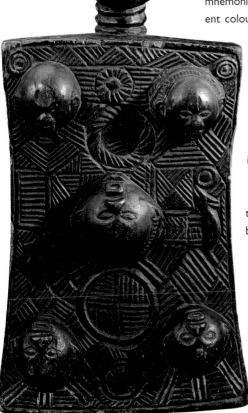

where the imagery can be described and the story content at least guessed at by an uninformed observer, the degree of condensation implied in the knotted handkerchief mnemonic defies external exegesis. Indeed, if this seems close to Cicero's system of remembering oratory, it is perhaps not coincidental that many such systems and devices are themselves associated with the oral recounting of remembered detail.

Ong, as discussed above, refers to rendering thought memorable through encoding it in verbal formulae. There are many examples of physical mnemonics which aid this process. In oral cultures a significant proportion of these act as springs to communication. In other words, they not only give rise to internalised remembrance or thought, but encourage or directly lead to verbalisation; and such mnemonic systems actually need an interlocutor and an audience to be meaningful. The Kuba are far from exceptional in this. The recitation of genealogy, for instance, is a significant part of oral cultures. Like the *bulaam* of the Kuba, the Luba in south-eastern Congo also have an association of oral historians, Mbudye, charged with remembering king lists, and historical events. It is they who are credited with inventing a mnemonic device composed of a board (*lukasa*) with a series of different coloured and different sized beads implanted on it.[3] The beads encode culture heroes and leading historical figures; lines of beads recall journeys or migrations. The boards, then, act to stimulate memory rather than to illustrate it (fig. 21).

This is by no means only an African phenomenon. The Maori of New Zealand similarly recite genealogies (*whakapapa*) as an aspect of establishing authority and aristocracy. The recitation recounts the layering of descent which links individuals to their predecessors in New Zealand, back to the Polynesian navigators whose voyages led to the occupation of the islands, and beyond to the Maori divinities from whom they ultimately derive. The sequential recitation can be aided by a carved mnemonic staff with notches and incised lines (fig. 22). The notches and marks are 'visited' successively in the manner of a Roman orator moving through his imagined memory building in a specific order. These remind the Maori

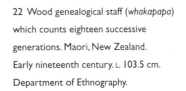

22 Wood genealogical staff (*whakapapa*) which counts eighteen successive generations. Maori, New Zealand. Early nineteenth century. L. 103.5 cm. Department of Ethnography.

owner and the performer of the recitation of the sequence of historical personalities who constitute their genealogy and the events which marked their lives. However, like the *ndop* of the Kuba, Maori genealogical staffs do not just link individuals to their ancestors in a formal structural sense. The holding of the object and narration of genealogy floods the living with the authority and presence of their ancestors.[4] If *ndop* are more than an equivalent to a photographic portrait, genealogical staffs are more than kinship charts – they link the living to their kin in a more profound spiritual way.

Remembering 'Secrets'

Clearly in these cases the knowledge which these physical objects cause to be recollected is to a large extent placed in the public domain – though it is interesting that Vansina reports that the *nyim* at the time of his researches would not divulge his own account of the sequence of succession which authenticated his claim to the kingship.[5] Much else, however, is in the realm of either personal or secret knowledge, and in these cases the enigmatic nature of the aide-memoire has additional significance. Just as the knotted handkerchief is only meaningful to the person who tied it in the first place, so too some mnemonic objects remind those initiated into their secrets of more exclusive, esoteric wisdom. The mnemonic may reveal for some, while at the same time concealing from others. The classic example in ethnographic literature is that of the Bwami association amongst the Lega in eastern Congo.[6] Bwami is sometimes described as a secret society, though historically its 'secrets' were gradually revealed to initiates and remained completely impenetrable only to outsiders and those yet to be initiated into the relevant grade. As a result it provided a mechanism for resisting the external influences of slavers, colonialists and missionaries. In its own operation it acted more as an aristocracy reinforcing kinship links, lineage relationships and clan affiliation. It did not, however, have a rigid, inherited structure of status positions. Rather, advancement was achieved through the development of character and moral perfection and through the successful completion of a complex series of initiation cycles. It is described as at once a system of moral philosophy, a religion without gods and an effective system of authority.

Initiation proceeded through a series of grades, each with a mix of ritual action, dance, song, gesture and the revelation and interpretation of objects of various kinds which needed to be learned and memorised, and which remained unknown to those in lesser grades. The knowledge thus imparted was often in the form of proverbs. In an overview of the kind of process that might be involved in the course of completing the cycle of initiations through to the highest grades, Biebuyck enumerates over 900 proverbial sayings that would have to be learned and understood.[7] A vast range of different items objectifies this proverbial wisdom. These may be in the form of natural objects (for instance, leaves, shells, seed pods, bark, roots, dried fruit, or animal skulls, bone, horns, skins and teeth), manufactured goods (bags, baskets, brooms, sticks, furniture, knives, spears, razors, belts, hats, rattles, cooking utensils, beads and necklaces) or artworks (masks, human and animal figurines, human-headed and spoon-like shapes, and miniature imitations of other objects usually in ivory or wood). To this can be added a

23 Ivory figurines, including a crocodile, used in the rites of the Bwami society as memory aids. Lega, Democratic Republic of Congo. Twentieth century. Figures: H. 16 cm (left), H. 15.5 cm (right); crocodile: L. 14 cm. Department of Ethnography.

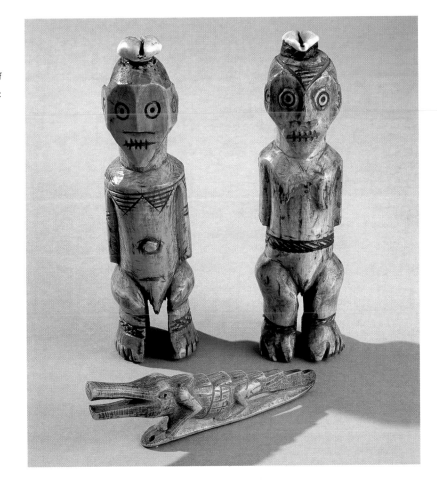

number of objects from elsewhere which by the 1950s had appeared in Lega initiatory contexts: light bulbs, madonna dolls, perfume bottles, plates and dishes.

These are not objects with any cultic significance. They do not act upon the world to change anything – though their confiscation on occasion by colonial authorities suggest that they, at least, saw them as that. Their significance is rather in how they were used and with what aphorism – usually in sung form – they were associated. If we add, however, that each object type could occur in combination with others or could have more than one interpretation, and that how they were used, manipulated, worn, danced with or otherwise presented gives other layers of meaning, we can see that the mnemonic is not based on physical resemblance but on a range of codes and symbolism that lead to proverbial or aphoristic statement. And this too might itself need translation into a statement of moral principle. None the less, the underlying system does for the Bwami initiate what Western theory identifies as the essence of memory enhancement: it objectifies its subject into a condensed image, but one sufficiently distinct from the content it encapsulates to render its burden of encoded knowledge the more memorable to those 'in the know'.

24 String *quipu* whose disposition of knots encodes technical information and mythical or historical knowledge. Inca, Andes. L. (as laid out here) 50 cm, w. 106 cm. Department of Ethnography.

Technical Know-how

Most objects which act to codify technical knowledge may seem to take us beyond our immediate subject. The *quipu* of the ancient Inca (fig. 24) are sometimes described as mnemonic systems and, although they are not completely understood, it is helpful to establish our field of enquiry by reflecting on the extent to which they assist with processes of recollection or, like a written record, simply encode otherwise useful information. Even the most enthusiastic interpreters of *quipu* agree that they are somewhat unprepossessing objects. Indeed they look like nothing so much as large mops, their physical condition not improved by many having been discovered in archaeological contexts. They are composed of strings of varying dimension tied to a common cross strand; clusters of knots are tied at intervals along their length, and they are arrayed in different colours. These knots are of different kinds, the clusters composed of different numbers of knots, and distributed at different intervals on single strands and in different dispositions on adjacent cords. These details are all deliberately placed according to a common system and allow complex data to be passed on.[8] The colour of the threads assists in identifying the topic; typically, for instance, yellow would indicate gold as the subject, red would indicate a record of the operations of the army and so forth.

Quipu were important elements in the administration of the Inca empire. Systems

of runners would convey the requisite *quipu* and their encoded information swiftly and efficiently to distant Andean provinces where the encoded information could be quickly deciphered by other specialists. The message needed to be compact and clear, with a bias towards statistical information. Their simplest function was to act as a form of inventory. Thus topics such as census information, the content of food stores, the size of available workforces or the status of tax revenues might most readily be conveyed by these methods. Indeed, whilst the understanding of *quipu* is far from complete, some interpreters believe they can distinguish more narrative styles of message encoded through this method – details of Inca myth and history, the story of conquest, the structure of laws, and so forth. The efficacy of the *quipu* was even recognised in the early colonial period where examples were admitted in Spanish courts.

The information recorded on *quipu* is thus very sophisticated. By virtue of significant examples being recovered from archaeological sources we might suppose that they were the subject of deliberate deposition. This argues that they may have been seen in the context of memorialising in some way. Further, the suggestion that they may have a more narrative purpose may imply a role in creating memory. But in general it is hard not to see them as a form of accounting rather than as an assistance to remembrance. Similarly, maps, globes, and guides record one person's observation for the benefit of subsequent travellers. No act of memory is necessarily required. We can readily stray beyond our topic by assuming that forms of encoding that are not in the form of script are somehow necessarily memorialising devices.

Some technical devices, however, are relevant to our subject, in particular those which act as reminders of significant dates. Such devices are known from antiquity. Egyptian papyrus has survived from over 3,000 years ago which indicates on an annual basis which days are likely to be fortuitous for particular activities and which are not. Likewise, Assyrian tablets record astronomical details such as the sighting of the new moon or the prediction of eclipses, all tied in with the understanding of human fortune, as well as more regular daily movement of the fates. In Roman times, calendars (*menologia*) were developed from original Greek inspiration to indicate the length of the months, the sequence of festivals and the associated deities and the appropriate labours to be performed, especially those involved in the agricultural cycle.[9]

None of these are instruments which allow the calculation of numbers: they are more or less sophisticated recording devices to ensure recollection of important detail. However, there are numerous mnemonics which are based on mathematical and astronomical observation, and which allow the prediction of recurrent future events, times when it is important to undertake certain actions, as well as the reporting of past ones. A good example are the perpetual calendars used in many parts of Europe from medieval times, notably in Britain, the Netherlands and Germany. These were types of almanac which would allow different kinds of time reckoning. The so-called Great Sloane Astrolabe of late thirteenth-century date, arguably the finest

medieval astrolabe to have survived, and coming from the founding Sloane collections of the British Museum, has on its reverse side a perpetual almanac (fig. 25).

From later medieval times printed calendars became widely distributed with more pictorial, so-called pauper's almanacs for the illiterate. By the seventeenth century these took the form of a diagram incorporating numbers arranged in columns

25 Medieval brass astrolabe with the perpetual almanac on the reverse (image on right), allowing the determination of the dates of the movable Christian feasts and a list of Saints' Days. Astrolabes were the most versatile astronomical instruments in medieval Europe and the Islamic world. English. c. 1300. D. 46.2 cm. Department of Medieval and Modern Europe.

with a series of letters around the outside, often on a medal or similar object. Armed with this, it was possible, for instance, to tell the day of the week on which particular dates would fall. Some examples of these calendrical devices in England were explicitly referred to as coins (rather than medals), the implication being that they could be carried around like currency and be an accessible reference whenever required. They are often referred to as 'memory coins' and are credited to the inventiveness of Samuel Morland (1625–95) who is otherwise renowned for his invention of the calculating machine and his pioneering work on hydraulics. Morland issued a perpetual calendar both in paper form and as a coin as early as 1650. The metallic version had calendrical information on both surfaces.

To this tabulation of days, months and years, some calendar coins added astronomical events, ecclesiastical and other anniversaries, much as a modern diary does

(fig. 26). However, because of the small scale on which the information was inscribed, the details needed to be encoded. Thus, on a coin dating to about 1718, the month of January, for example, includes a series of reminders which, when uninterpreted, appear thoroughly cabbalistic in form. Decoded, they remind the owner of a series of religious and civic anniversaries:[10]

1 1 C	January 1 Circumcision of Christ
6 E	6 Epiphany
19 P F B	19 Prince Frederick born (the son of George II, later Prince of Wales)
25 P	25 Conversion of Saint Paul
30 K C M	30 King Charles I martyred

Other formulations allow the calculation of the movable Christian feasts and, in one sequence, of the sessions of the High Courts of Justice of England (the names also adopted for the academic terms at Oxford and at Dublin):

H T B 1 23 E F 12	Hilary Term begins January 23, ends February 12
E T B 17 A E M E W	Easter Term begins 17 days after Easter (ends 4 days after Ascension day)
T T B 5 D A T C 19 D	Trinity Term begins 5 days after Trinity (Sunday), counts 19 days
M T B O 23 E N 28	Michaelmas term begins October 23, ends November 28

This class of mnemonic system became so ubiquitous that it developed various standards and codes through the seventeenth and eighteenth centuries, and spread from coins, medals or paper forms to other objects often themselves connected with other forms of calculation: sundials, quadrants, watches and even tobacco boxes (fig. 27).

26 This astronomical and calendrical coin gives tables for the determination of Easter and the time of high tide, as well as a perpetual calendar, lists of Saints' Days, dates relating to the royal family from the time of the reign of King George I (reigned 1714–27), and the law terms. English. 1718. D. 42 mm. Department of Medieval and Modern Europe.

27 An ivory diptych sundial by Charles Bloud, with a perpetual calendar on the outside of the bottom leaf. From Dieppe, France. c. 1660. H. 15 mm, W. 63 mm, L. 73 mm. Department of Medieval and Modern Europe.

The Dangers of Forgetting

Navigational devices lie largely outside our field. However, there is one form which has a distinctive purpose as an aide-memoire: the so-called stick charts used by the occupants of the Marshall Islands in eastern Micronesia (figs 19 and 28). These come in a variety of differently named forms depending on whether they are essentially instructional or are developed by individual navigators for their own use. Indigenous classification also distinguishes whether they record only a few immediate islands of the 1,000 or so atolls which make up the island group, or are created on a larger scale to present a more widely dispersed area of islands and the intervening waters. In practice, the information contained on such charts is vital because the islands are themselves so low that few can be seen at more than a distance of, at best, only a few miles.

28 Stick and shell navigational device (*rebbelib*). From the Marshall Islands, Micronesia. Late nineteenth century. L. 99 cm, W. 68 cm. Department of Ethnography.

The charts all work in the same way. They are made up of a series of sticks arranged on what is usually a rectangular frame.[11] The frame is given stability by supporting horizontal and vertical sticks. Diagonals and curved sticks indicate the characteristic swell of the sea given consistent wind directions; they record reflected or refracted waves and the penumbra which occurs on the lee side of intervening islands. The islands themselves are indicated by cowrie shells, lashed in appropriate places on the structure. It is the characteristic behaviour of the waves, rather than the physical sight of islands, which is the essential navigational guide.

For present purposes, the interesting point is that these charts, once constructed, are not in fact taken on journeys by the navigators who have made them. All the existing sources on Marshalese navigation make this point. 'Neither kind [of chart] was carried on board a voyaging canoe, for all the oceanographic erudition was stored inside the Marshalese navigator's head. And these navigators, even today, guard this information carefully and pass it on only to others who have been specially selected for training.'[12] The charts, in other words, are used to create a mental picture, a memory, rather than being consulted first hand on any given journey. Any longer journey, of course, requires sailing long distances out of sight of islands, and often involves travelling through the hours of darkness. The presence of islands is

gauged entirely from the observation of the sea, making it possible to refer what is happening on the surface of the water to the chart retained in the mind, and thereby to travel potentially the length of the islands accurately without sight of land. At night the skilled navigator can lie on the bottom of the boat and by judging the action of the waves upon it as it sails determine its position.

Here, getting lost is a dangerous activity: memory has a serious edge to it. In an African context a similar mix of semi-professional information, memory and ever-present danger is part of the conception of one of the most misunderstood of all ethnographic objects: the nail figures of the Kongo people, known generically as *nkisi*, which are otherwise often referred to disapprovingly as 'fetishes' (fig. 29). Their physical appearance is of a figure, human or sometimes animal, bristling with nails and blades which often pin little pieces of cloth to the body of the object. Magical and medicinal substances are attached usually to the navel, sometimes with a piece of mirror implanted, and complete a type of object which outside commentators have variously described as scarecrows, objects of witchcraft and malign influences. They are certainly immensely complex objects and their possible functions vary, from healing, to juridical issues, providing judgement and punishment, identifying the sources of witchcraft, and even to enhancing the chances of good fortune. They are animated, dynamic objects – empowered, forensic, decisive.[13] What, then, do they have to do with memory?

One aspect of *nkisi* is their function in relation to oath-taking. In order to swear an oath or to fix a treaty, a nail or blade may be driven into the object binding the intention of the party or parties to the undertaking. The addition of a personalised element, whether saliva, hair or a fragment of clothing, identifies the oath-taker. For the oath-taker the hardware driven into the body of the object is a powerful assistance to, almost an instance of, memory. This is all done under the supervision of the operator of the object. Powerful images may over time accumulate an encrustation of nails obscuring their original form. Once fixed, however, the intention needs to be remembered and carried through, otherwise the powers inherent in the object may turn on the client. Likewise, it is incumbent on the operator of the object to remember what each of the supplications fixed by the intermediation of the object is, and which intrusive blade is associated with it. This may well involve remembering hundreds of cases and identifying a relevant one amongst a forest of metal. The matter becomes more incisive when it comes to reversing an undertaking, undoing a stated intention by withdrawing the appropriate blade. In Kongo practice this is conceivable by extracting the correct nail. Remembering and removing the right blade allows the oath to be undone. However, the consequences of taking out the wrong one and releasing uncontrolled power are intensely threatening. For the operator of the object a good memory is an essential attribute of an otherwise dangerous profession. Thus, someone falsely accused may draw out of the object a nail placed there on their behalf as evidence of their innocence. The same act undertaken by the guilty would be fatal.[14]

Here remembering is professional necessity, not an option. It is not just that in

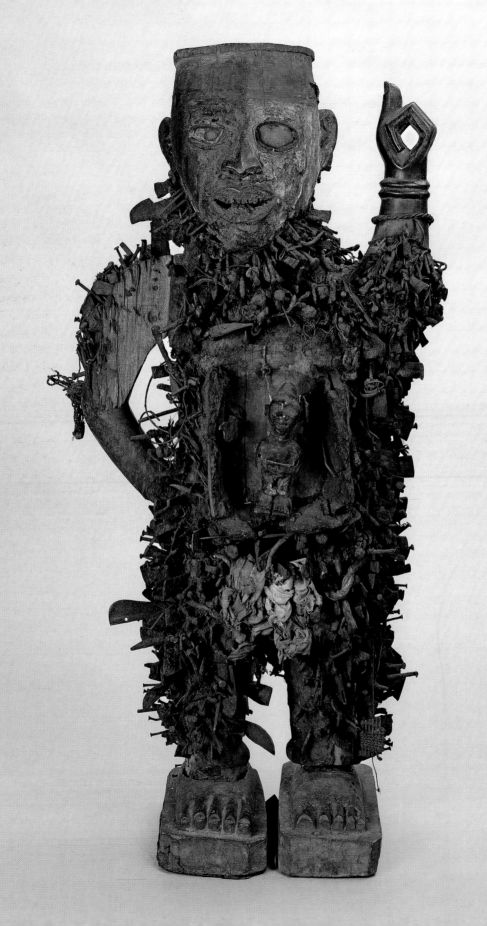

making a mistake the orator or the genealogist will lose their way; the operator of the *nkisi* and his client, like the navigator gone astray in largely empty seas, might lose their lives.

The Rationale of the *Bulaam*

The person of the *bulaam* has provided a thread linking the development of the last two chapters. The simultaneous role of the remembrancer and the dance instructor drawn together in his person are an apt coalescence of the intellectual and the physical ordering, of which memory is progenitor. The role of the *bulaam* takes into the world of visual culture and expression some of the principles which Western oratorical traditions have viewed as fundamental to memory-training. Remembering the correct sequence of references in an oration is as critical to successful speech as genealogical recitation is to establishing the legitimacy of dynastic succession. Remembering the right dance steps is as crucial to not losing your way in performance as navigational memory is to seeing the mariner safely to port. Memory in these cases is not a matter of day-dreaming, of alighting on one thought after another without conscious direction. What is involved here is aiding memory, assisting recall in an ordered fashion the better to communicate thought or to locate persons in the right physical or genealogical space. The aides-memoires as physical images and the *loci* as objects disposed in imagined architectural spaces both play on the same understanding of memory as a visualising mechanism of recall. And they do so in such a way as to give the randomness of recall an organised sequence. In psychological vocabulary, they bridge the worlds of the conscious and the unconscious.

29 Wood figure (*nkisi*), bristling with nails and blades, and with a box in the abdomen containing empowering substances. From Kongo, Democratic Republic of Congo. Late nineteenth century. H. 117 cm. Department of Ethnography.

Living Memory

30 Hide puppet of one of the most familiar leaders of the twentieth century, Mahatma Ghandi, with movable arms and body so that the figure can be animated. Indian. Late twentieth century. H. 147 cm. Department of Ethnography.

Helen of Troy had a number of suggested fathers, though Zeus appears in most accounts as the leading candidate. One tradition has it that Nemesis, the goddess of retribution – of what we might call judgemental memory – was her mother. In Greek mythology it is held that it was the accomplished painter Zeuxis who was commissioned to paint a retrospective picture of Helen for inclusion in the temple of Hera Lacinia. Helen was renowned as the most beautiful of women, possessor of 'the face that launched a thousand ships/And burnt the topless towers of Illium' as Marlowe puts it in *Doctor Faustus*. To achieve the required approximation to perfection, the citizenry of Croton allowed the painter to select five of the handsomest maidens of the town. By selecting their best features – the best nose, the best mouth and eyes, and so forth – and combining them in a single portrait, the required idealisation of beauty was achieved. Zeuxis was painting the features for which Helen was remembered – her beauty. The tribute to her memory was achieved not by painting her as she was, which was impossible anyway, but by combining attractive attributes with which she was associated. The resulting image portrayed none of the single subjects from whom the details were selected, but a wholly new personification.

Whether individuation can successfully be achieved by these means is debatable. Helen's portrait was of an abstract quality rather than a likeness of an individual person, a portrait achieved through the representation of remembered and generalised attributes. Not all posthumous portraiture need be like that, and the shift from idealisation to individuation has been seen as desirable in some cultures. A later Roman solution attributed to Lysistratus was to take a cast of the face of an appropriate living person by pouring wax over them and then retouch the result to improve on it. These portraits were then reproduced not under the name of the person from whom the cast was taken but as images of statesmen and philosophers long since dead yet still celebrated. These were set up in public places and acquired by individuals for display in villas.[1]

In a British Museum context the diary of Olive Garnett, daughter of a member of the curatorial staff with a residence in the Museum's east wing, recalls visits by a surprisingly radical collection of artists, literati and émigré anarchists. Amongst them was Ford Madox Brown, the Pre-Raphaelite painter. The diary entry for a visit in June 1890, when Olive was eighteen years old, reads: 'Madox Brown came in the morning, Robert & I were at home, he did not look well at all but told us some amusing stories and admired the solid walls and space in the house. He said that if he had to paint a portrait of Shelley he should choose my face to paint from, which I took as a very high compliment.'[2]

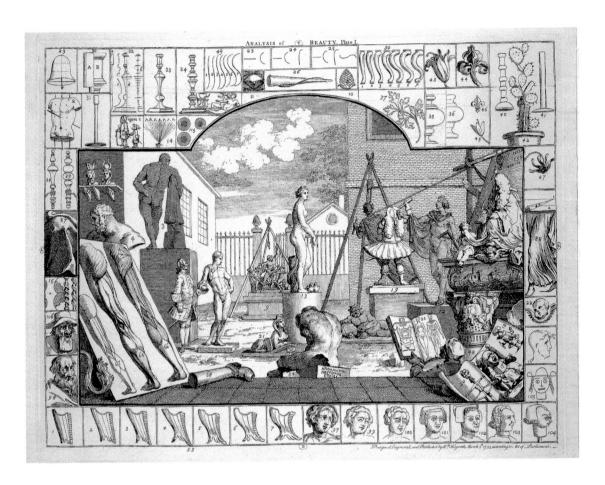

31 Plate of 'The Sculptor's Yard' from William Hogarth, *The Analysis of Beauty*. The yard, together with its catalogue of styles and bodily forms at the edges, suggests an inspirational repertoire available to artists which goes beyond the individualising detail of the person to be portrayed. British. 1753. H. 38.5 cm, W. 53.2 cm. Department of Prints and Drawings.

Heads and Portraits

These three initial examples are of course chosen to subvert some current conventional Western expectations of the portrait, the subject of this chapter. Though associated with the Western tradition and its foundations, each moves towards a contrived representation concentrating principally on one part of the anatomy, the head, through which to portray idealised characteristics. None is particularly concerned with accurate portrayal of what their subject actually looked like. Indeed someone else's features will in some instances do perfectly well. In fact, although presented as portraits done from life, they are in practice all created retrospectively *as if* from life. It is at one level reminiscent of the practice of head-hunting in parts of Papua New Guinea and Irian Jaya, where through taking a head someone else's life force was 'captured' and bestowed upon the sons of the decapitator in the form of a potent 'head name'. The relatives of the deceased might even treat the new owner of this potency as a kinsman though he clearly might well look entirely different from the deceased, for it was the vitality inherent in the head rather than its physical features which was important.[3] The artists above are likewise seeking to be faithful to a person known for a particular combination of characteristics and the moral

force which their remembered deeds encapsulated, rather than for the possession of particular physical features. They are not necessarily especially interested in individuation. However, there are clearly important differences. Their art is retrospective: they are concerned with re-creating memory rather than perpetuating life force through transferring it to another living person.

Portraiture is one of the most ubiquitous vehicles of memory. Indeed memory is so interwoven with the topic that, even if the image was not meant in the first instance to be created as remembrance, it may subsequently be judged according to its ability to encapsulate likeness and imbue it with something of the 'soul' of the subject. Holbein may not have been trying to create remembrance when entrusted by Henry VIII with the role of painting potential royal brides on the continent. His functions were several: one was to act as a kind of creative ambassador, demonstrating Henry's ability to dispatch one of the most celebrated artists of the day to create works for him. The second role was something like that of an employee of a dating agency, to return with an impression of the qualities of possible brides-to-be against which to assess what was otherwise a Tudor dynastic imperative: that of bearing a son in royal wedlock. This goes beyond the mimetic function of portraiture; Holbein succeeded in producing likenesses which were both physical and moral. Although he portrayed character, deeper qualities behind physical appearance, his images have since become familiar as illustrations of sixteenth-century royalty and aristocracy.

But, it may be argued, this is to say no more than that a record of something can in other circumstances become an instrument of memory, that it may be recycled into something it was not created to be in the first place. It is a familiar refrain: we will see later how the ephemera of pilgrimage may be sanctified on the pilgrim's return and acquire a sacred status that they lacked at the pilgrim site. Familiar and inert memorabilia can be empowered by location in new cultural contexts. After all, a person's shoes were not created to be either an instrument of memory, or even memorable. It is only when someone dies, and their personal possessions become suffused with the sense of the missing owner, that the object is redefined as memorabilia. The gallery full of shoes at the Holocaust Museum in Washington would have no meaning were it not for the stories that it recollects, the absences (and the profoundly shocking reasons for those absences) which it evokes, and, for those who know the extermination camps, the 'warehouses' of hair, artificial limbs and so forth piled up there. It is evocative, even if it is only a copy of an 'original' at Auschwitz.

In the concluding chapter of this book we consider memorabilia, things which later, often posthumously, attract a value as memory. We must recognise here that some contemporaneous portraits may subsequently become memorabilia, as photographs notably do. Evelyn Welch, for instance, points out the complicity of seeking recognition in this life by the commissioning of portraits, with the perceived need for future memorialisation. She invokes an early sixteenth-century statement of the Holy Roman Emperor Maximilian I: 'He who during his lifetime provides no remembrance for himself has no remembrance after his death and the same is forgotten with his passing bell, and therefore the money that I spend on my remembrance is

Medal Portraits

Portraits have always held a primary place in the medal tradition. The messages they convey, however, vary widely. In the medal of Jacoba Correggia (c. 1500) by an unknown Mantuan artist (bottom left, D. 54 mm), Correggia's claims to purity and religious faith are highlighted, and her moral and physical qualities presented as timeless. By contrast, on Joachim Deschler's medal (right, D. 65 mm) of the solid and reliable Nuremburg churchwarden, Hieronymous Baumgartner, its date – 1553 – and the age of the subject – fifty-six – conspire to locate it as a record of a particular time. On Guillaume Dupré's medal of the Venetian doge Marcantonio Memmo (1612, below right, D. 91 mm) the magnificence of Memmo's office and of the Venetian office are emphasised. Finally, Avril Vaughan's study of her mother (1992, bottom right, D. 96 mm) is at once a personal portrait and a searching study of old age. Department of Coins and Medals.

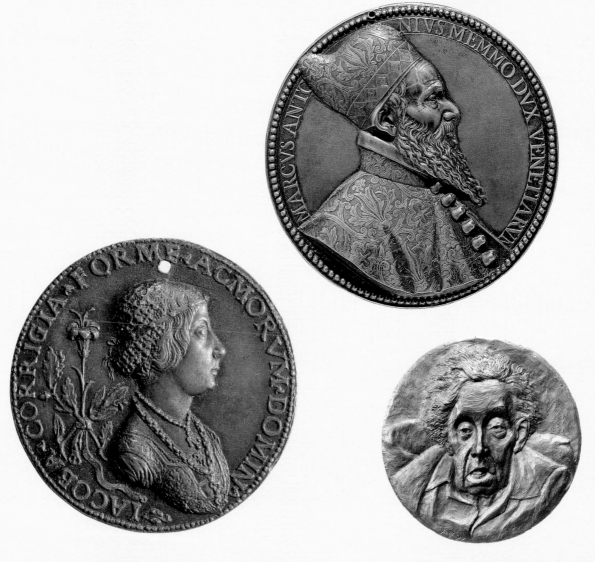

not lost.'[4] The creation of images directly intended to create 'living memory' is our focus in this chapter – Maximilian I would qualify.

Our subject is how living people are remembered. Much of this terrain is sufficiently obvious not to require extensive comment from a conceptual perspective – there is no shortage of discussion about how living people are represented, whether as themselves (and what that might mean) or in some more or less abstract, emblematic way.

There is, however, a potentially artificial distinction to be negotiated. Our next chapter deals with commemoration after death. As indicated above, the difficulty comes when significant people are recollected as if alive, when their remembrance does not admit of the fact that they are in a physical sense no longer extant. Their lives, their appearance and other details of their deeds, have latterly become idealised. They are imagined as alive and people imagine them as part of a continuing living reality.

Clearly this part of the book merges with the next more seamlessly than the division into chapters might suggest. We begin, therefore, with the most obvious expression of such a conception, that which relates to the understanding of the role and continuing impact of religious figures, of exemplary lives and still powerful, efficacious images.

32 Painted wood portrait by Kashinsai Miwa of the artist Sesshū Toyō (AD 1420–1506), Japan's most celebrated ink painter. The sculpture was commissioned nearly 300 years after his death and, like posthumous Classical portraiture, is a tribute to the longevity of his reputation. Japanese. Edo period, AD 1787. H. (including the stand) 23.5 cm. Department of Japanese Antiquities.

Religious Figures

In a Christian context, especially during the medieval period, saints were called upon to intercede between human beings and God, whether as patron saints of a particular church community, or on behalf of a profession. As divine familiars they continued in heaven to serve God as they had on earth, and in that role to fashion beneficial relationships for human devotees. The visualisations of this relationship are various. One notable form was the production of icons which represented the saint through appearance and deeds (rather than through possession of parts of the deceased saint's physical remains). None the less, like more intimately associated relics, some icons could themselves perform acts of healing and protection, and were attributed miraculous power. The now-lost Hodegetria icon was one such. It showed the Virgin and Child and was popularly understood in Byzantium to have been painted from life by the most documentary of the evangelists, Saint Luke. In other words, Saint Luke, at the same time as recording the life of Christ in textual form in the Gospels, was credited with recording in paint the likeness of the Mother of God. The Hodigitria icon was kept in Constantinople with a second miraculous icon, the Blachernea icon of the Virgin. Both were carried in procession through the city on appropriate occasions, which might include times when the city itself was under threat. The Hodegetria icon, however, had a more regular schedule of

33 Copy of a hand-scroll after 'Landscapes of the Four Seasons' by Sesshū, painted in honour of the acknowledged master by Kanō Seisen'in Osanobu when he was only fourteen years old.
He himself later went on to be a significant artist in his own right. Japanese. Edo period, AD 1810.
L. 1,608 cm, H. 43 cm. Department of Japanese Antiquities.

THE MUSEUM OF THE MIND

appearance. It was traditionally taken out every Tuesday and carried by a man with arms outstretched in imitation of Christ in Passion. It was reputed to heal the sick.[5] Indeed, as it was very heavy, the man chosen to carry it would often stagger from side to side under its weight. Some observers of the event at the time suggested that as the bearer of the icon reeled towards a spectator that person might receive particular benefits, having been chosen by the will of the icon as a recipient of blessings.

Here we have moved beyond metonymic imagery. It is no longer a case of the image standing for or representing another, absent, entity – a religious figure. It has at once absorbed, and in a sense supplanted, the memory of the person it was otherwise created to evoke. In this case, however, the fact that it is said to have been painted by none other than one of the evangelists gives it the dual function of being at once a representation of one divine personage and the creation of another. In a sense the function of the icon as an act of and as a spur to memory, has succeeded triumphantly. It has become what it set out to represent. Versions of it, which were likewise claimed to be authentic, ended up in Rome and elsewhere in Italy, in Russia, and in Ethiopia (where as many as seven remain). And, where Saint Luke was not implicated in the production of such icons, another divine source was waiting in the wings – the hand of angels. In the Greek Church in particular, an angelic provenance was often asserted. Like the Body of Christ, such icons were ultimately works of God. And, as the saintly relics of Western Christianity, such icons were regarded as inherently holy, an appropriate goal of pilgrimage.

But we need to be careful in our interpretations of icons. The Orthodox Church itself deliberated long and hard on the nature of the correct relationship of the devout to the icon, and of the icon to the saintly or divine figure represented. During the period of iconoclasm in the eighth and ninth centuries the question of whether the relationships constituted a web of idolatry or a rendering of honour was very much under scrutiny. This could hardly have occurred in the Western branches of Christendom. Here devotion was sometimes devolved upon statuary, but icons – the word deriving from the Greek *eikon,* meaning a religious painting on wood – were in their Western context not accorded the same devotional status. They were not held to have any special power of healing, and only rarely did they attract anything approaching the reverential behaviour of the Orthodox faithful.

In his book on devotional imagery in the Eastern Church, Cormack illustrates a triptych of the Virgin and Child (*Panagia*) from the Monastery of Saint Catherine in the Sinai.[6] It shows, hanging from one of the hinges, a representation of a hand. Acts of devotion might involve offerings including small votive plaques representing the part of the body to which prayers are addressed, food, flowers and candles. Prayers might often be written down and put in a postbox adjacent to the icon – or sometimes might even be scrawled directly on it. Icons were also frequently touched and kissed, and were often illuminated with smoky candles, thus darkening their surfaces. In religious services they were regularly enveloped in the smoke from burning incense. As a result they often had to be retouched and many retain a battered

appearance, an indication not of disregard but, on the contrary, of the extensive devotion they have attracted historically. Past devotional practice is a modern conservator's nightmare.

Modern studies of the Coptic Church in Egypt – a church which diverged from the Byzantine community – suggest that memory still has an important part to play in the relationship between the faithful and the icon. One view is that 'when we look at the icon of a saint, we do not just see a beautiful piece of art, but in one glance we actually read his whole life story'.[7] This has all the features of condensed reference which we have seen to be characteristic of mnemonic systems. It is not so much the physical image in front of the viewer which is important, as the string of mental images it brings about – remembered narrative and, in this context, the exemplary life of the saint. Again, as in ancient Egypt or Rome, it is not assumed that the icon is a direct and accurate portrait of the subject, with the important exception of the claims made for icons said to have been painted by Saint Luke. It is the fact that the icon is personalised by name (in addition to any iconographic clues) and the remembrance thus induced which leads to devotional activity. The Second Council of Nicaea (in AD 787) insisted on this distinction: 'In accordance with the affection and love which we have for the Lord and the saints, we depict their countenance in icons; we venerate not the wooden boards and colours but the persons themselves whose names the icons bear.'[8]

The icon in the British Museum collections known as 'The Triumph of Orthodoxy' was painted in about 1400 and records the restoration of the images after the end of the iconoclast period in AD 842 (fig. 34). The deliberations of the Second Council of Nicaea in the preceding century were confirmed in the following year. The focus of the picture rests in the upper register where the Hodigitria icon itself is shown, the one icon authenticated in theological dogma and popular belief as a likeness from life of Mary and Jesus, the one icon that could not be taken as a generic and secondary image. Its restoration represents at once the triumph of the supporters of icons, and authenticates the case for all the other icons being displayed in church settings. The icon is supported by two angels. To the left is the empress Theodora and her son, Michael III, providing a regal, earthly parallel to the divine figures. The background is in gold, suggesting at once the richness of the earthly parallel and the golden light of divine presence. To the right is a procession of church leaders led by the Patriarch Methodius, and in the lower register a gathering of saints and theologians, the clergy who championed the cause of the restoration of icons. The Hodigitria icon was destroyed when Constantinople fell in the mid-fifteenth century. By then it is thought that the 'Triumph of Orthodoxy' had already been painted and was being specially revered at an annual ceremony celebrating the end of the Byzantine era of iconoclasm and the restoration of the icons.[9]

The image is a double enactment of remembrance. On the one hand it reproduces an impression of what in Orthodox belief was an authentic and unique portrait; on the other it records an actual historical event in idealised form. Thereby, it encapsulates the foundation of the Orthodox tradition of the icon, and it does so

34 Painted Byzantine icon known as 'The Triumph of Orthodoxy'. From Constantinople (modern Istanbul, Turkey). c. AD 1400. H. 39 cm, W. 31 cm. Department of Medieval and Modern Europe.

within another icon which itself represents a triumphal moment in the history of the early Church. The presentation of the Hodigitria icon in this image serves to establish that the making of images of Christ is a legitimate Christian activity going back to the time of Christ himself. The recognition by both imperial and religious authorities of the Hodigitria icon serves to endorse the devotees' experience of thousands of other icons. The implication is that the icon is the stimulus to religious experience and not, apart from the exceptional images – most spectacularly the now missing Hodigitria icon – its substance.

In a British context the earliest image of Christ is that which appears on a Roman pavement uncovered at Hinton St Mary in Dorset, dating to the fourth century AD (fig. 35). The identification is based upon the so-called Chi-Rho symbol behind the head of the figure on the roundel which refers to the first letters of the Greek name for Christ, Christos. The pomegranates to the left and right of the head are held to be symbols of immortality. However, unanswered questions arise. The context of the pavement is that of a private villa and archaeology has uncovered no other evidence of a sacred aspect to the building. It remains puzzling that an image of this innovative religion should be used in an apparently decorative manner and mixed as it is in the wider imagery of the mosaic with an identifiably pagan scene: that of Bellerophon stabbing the mythic Chimera with a spear (fig. 36). We seem here to be witnessing the birth of memory, the first evidence of an all-encompassing religion yet, within the mosaic, presented in design terms as comparable to its pagan antecedents.

Spiritual figures are variously recorded as the focus of devotional activity and thus of active memorial practice. We are familiar with innumerable shrine sculptures and images of the iconic presentation of the Buddha. However, there are other iconographic developments with an equally focused reference. One of the most potent in mainland South-east Asia is the representation of the footprint of the Buddha, often on a substantially enlarged scale (fig. 37). A note by

35 Central roundel with what is thought to be the earliest representation of Christ found in Britain. From a mosaic floor found at Hinton St Mary, Dorset, England. Roman British. Fourth century AD. D. 82.7 cm. Department of Prehistory and Early Europe.

36 Detail from the Hinton St Mary mosaic showing the hero Bellerophon mounted on his winged horse Pegasus and spearing the three-headed monster, Chimera.

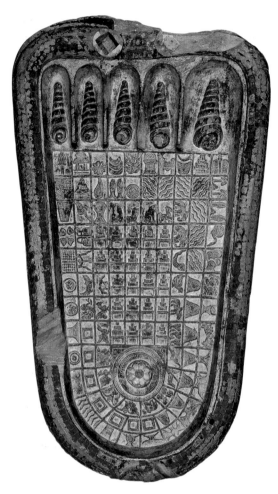

37 Sculpted stone foot of the Buddha (*buddhapad*).
From Shwe Settaw Pagoda, Burma. Possibly
eighth–eleventh centuries AD. L. 171 cm, W. 100 cm.
Department of Oriental Antiquities.

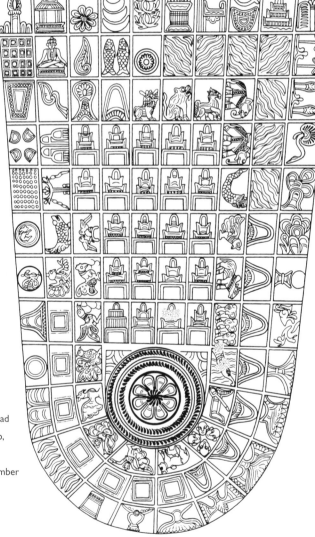

38 Drawing of the *buddhapad*. The Buddha
is said to have left footprints with a level tread
and, at the centre, a wheel with tyre and hub,
as in this example. Surrounding the wheel
are a series of 108 auspicious marks, the number
being consistent with those on other of the
stone footprints. (*Drawing by Annie Searight*)

U Mya from the 1930s remains an authoritative discussion, and illustrates well the process of committing the image to memory from the earliest years: 'Buddhist children in Burma,' he says, 'are taught to say at night, before going to bed, a prayer in honour of the Buddha's footprints which, it is said, the Enlightened One had left on earth before Nirvana. They are also made to understand that these footprints are three in number: one in Ceylon and two in Burma.'[10] As it happens, similar traditions are found in Thailand as well as Burma and Sri Lanka. The primary site in Burma associated with this phenomenon is the Shwe Settaw Pagoda where two gigantic footprints (buddhapad) – very large carved stone images with symbols in relief – are located. These are said to have been left by the Buddha to commemorate his visit to the area. In practice, however, sculptures of footprints are found in monasteries and at religious sites throughout Burma, and indeed elsewhere. This type of commemorative depiction should not be confused with the much earlier use of the Buddha footprint at Buddhist monuments. These are amongst a variety of symbols used in the early centuries of Buddhism to represent the presence of the Buddha – stupa, parasol, tree and buddhapad. Unlike the Shwe Settaw footprint, however, they are not asserted to be authentic footprints left there by the Buddha himself, but are symbols of his presence in narrative sculpture, used at a time when the corporeal image was not depicted (this period of aniconism lasted until at least the first century AD).

The sculpted footprints from Burma, in addition to their size, are by no means ordinary impressions of human anatomy. Each is, in fact, a foot-shaped cosmological device, incorporating an encoded set of references (fig. 38). They include swirling circular shapes representing the 'wheels [that] appear thousand-spoked, with tyre and hub, and in every way complete and well divided'.[11] In addition to the wheels there are over 100 other auspicious marks associated with representations of the sole of the sacred foot; these are listed in texts. They include the four great continents surrounded by thousands of smaller ones, seven treasures – the wheel itself, the elephant, the horse, the gem, the queen, the royal retinue and the crown prince – lion kings, tiger kings, the Himalayas, different types of lotus, and so forth.

In most of the associated oral accounts these two images in Burma are said to have been rediscovered in the seventeenth century AD – a gap of over two millennia since, it is believed, the impressions were first left there by the Buddha during his mythical travels. They thus assert the antiquity of Buddhism itself in Burma and Sri Lanka, and affirm that the Buddha had literally set foot on the soil of those countries. As in many cultures, the land is a silent witness to memory – the place the ancestors are buried, the embodiment of identity. The image of the Pope kneeling to kiss airport tarmac is a powerful endorsement of the autochthonous presence of Christianity in distant lands. In Britain there is little question that Christianity is a foreign import; the question 'And did those feet in ancient times walk upon England's green and pleasant lands?' is certainly answered in the negative (which, arguably, is why the historical instance of indigenous martyrs to the faith, Thomas Becket in particular, is so important to the history of British Christianity, as it is for example in more recent missionary fields, such as Uganda and Madagascar). Like the

metaphor of memory traces which, as we have seen, are held in many Western cultures to be inscribed on the mind, traces left in the landscape – or in some contexts, written traces inscribed on stone or other media – emerge as authentic, pure memory rather than as mere mnemonics.

There are, of course, very few representations associated with Muhammad, except for occasional devotional images of the winged horse on which he flew from Mecca to Jerusalem. Injunctions against representational imagery apart, the Koran itself, the Holy Book of Islam containing the words recited by the Prophet, in a sense represents the founder of the Muslim faith. Looking upon the icons attributed to Saint Luke or the holy footprints of the Buddha, or reciting the words of the Prophet – all authenticate the memory handed down in the faith, and affirm the living reality of the religious experience which flows from such acts.

Memory, Money and the Medal

We have noted that the Roman representation of memory through the vehicle of the God Moneta has established a relation between the concept of memory and the term 'money'. Thus far we have said little about the role of currency in the construction of memory. Yet, it is arguable that – for obvious reasons – the images of individuals on coins, and latterly on banknotes, are by far the most familiar and most widely distributed of the means by which the image of significant people, and ultimately their memory, is perpetuated. Some of the earliest known coins from antiquity which incorporate portraits are perhaps those from Lycia in Asia Minor, dating from the fourth century BC. Firm historical documentation is scanty – much seems unavoidably speculative given the sophistication of the evidence available to later historians. However, part of the rationale for this development appears to be the emphasis on community identity arising in a border region, threatened by Persian incursions on the one hand and being at the outer fringes of the Greek world on the other – and it is significant that the first coins with portraits were those issued as payment to mercenary troops fighting on behalf of the kings of Lycia. Lycian rulers in this context attracted tenacious loyalty representing and focusing local aspirations in the face of anticipated external threats. Their image on coinage, and the use of coinage as payment, gives collective memory a transactional aspect.

Coinage could also be used to embellish a genealogy or prop up a shaky claim to legitimate succession – in each case relying on comparison with the memory of other images from the past. Their wide circulation, and the familiarity of the populace with the images placed upon them, makes coin portraiture an ideal vehicle for the subtle statement of political, personal and moral virtues. We have already seen how Kuba dynastic sculpture in Central Africa deploys a consistent image of the person to record the reign of kings often ruling decades and even centuries apart; we will find something similar in early modern British imagery below.

Continuity of image, or the deliberate recollection of earlier iconic personalities, exploits portraiture as an expression of imperial authority and precedence. In Roman coins this was especially evident when succession was by adoption rather

39 Painting on silk of the Bodhisattva Avalokiteśvara whose spiritual father Amatābha Buddha appears in the headdress. On the left and right stand two deceased people mentioned in the inscriptions whose reincarnation through the 'compassionate saviour', Avalokiteśvara, is invoked. From Dunhuang, China. Tang Dynasty, late ninth century AD. H. 111 cm, W. 74.5 cm. Department of Oriental Antiquities.

than birth. Thus, when Trajan (AD 98–117) succeeded as the adoptive son of Nreva (AD 96–8) he was portrayed in a manner which suggested a close resemblance (and thus paternity) to his predecessor before he was sufficiently installed to develop his own style on portraiture. Earlier Atho had usurped the position of ruler briefly in AD 69. His claims were advanced by drawing a comparison in portraiture and demeanour with his predecessor but one, the Emperor Nero, who has gone down as one of the great villains of history, but who in his day was actually immensely popular and after his death was impersonated by numerous false Neros claiming to be him.[12] Lucius Septemus Severus, of North African origin, emerged victorious from the civil war which followed the collapse of the Antonine dynasty in AD 192. However, his portraits sought to reflect a continuity and suggest a metropolitan and Roman origin. The emperor Constantine (AD 306–37) was deliberately portrayed in the image and likeness of Augustus.[13] Indeed, so prevalent was the manipulation of coin imagery to establishing linkage and asserting genealogical or divine authority, that Walker remarks that coin portraiture is only important where legitimacy is an issue or where rulers are regarded as semi-divine and the subject of cults. In Macedon, where neither applied, coin portraiture was not significant.[14]

40 50 yuan banknote bearing the image of Chairman Mao. Chinese. 1999. L. 16 cm, H. 7.6 cm. Department of Coins and Medals.

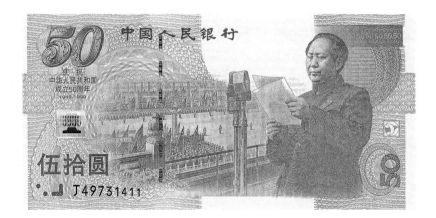

Images of Mao on Chinese currency provide an interesting recent historical parallel. Nothing could be more familiar to Western and Chinese audiences alike than the image of Chairman Mao disseminated in the twentieth century, and said to be the most reproduced portrait in human history. Wang, however, points out that Mao's portrait on banknotes issued in 1999 by the People's Bank of China to celebrate the fiftieth anniversary of the founding of the People's Republic, was only his second appearance on the national currency, and that there were no portraits of him on paper money issued by the People's Republic of China whilst he was still alive.[15] During most of his lifetime Mao resisted the impetus to create a cult of personality around his image. He even had images of himself removed from currency which portrayed Tiananmen (the Gate of Heavenly Peace), though his most famous portrait had been installed there by the early 1960s. It is a supreme irony that it was

only subsequently that his image appeared on currency, *the* fundamental device of the market economy. Whilst in his lifetime he might have judged such an association with a capitalist medium inappropriate, the reason given for the suppression of his portrait on currency was different: he pointed instead to the Resolution of the Second Plenum of the Seventh Central Committee of 1949, discouraging cults of the individual. In life, to extend the argument above, the support of the People in itself provided the authority of Maoist rule and required no separate assertion of Mao's individual legitimacy. When his image did appear in an anniversary issuing of commemorative currency in 1999, his name and date were added (fig. 40). He had become, as Wang remarks, an historical figure.

41–2 Drawing by the Iraqi artist Jewad Salim entitled 'Releasing the Political Prisoner' (below), showing the influence of Picasso's 'Guernica'. It was eventually rendered in bronze and mounted on travertine to create the huge monument called 'Nasb al-Hurriya' ('The Freedom Monument') as shown on a Bank of Iraq banknote (above). Iraqi. 1961. Drawing: H. 43 cm, W. 68.5 cm; Department of Oriental Antiquities. Banknote: L. 17.3 cm, H. 8.5 cm; Department of Coins and Medals.

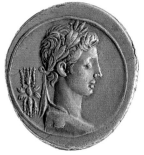

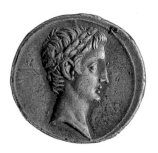

In the Roman world, portraiture on coinage established what would now be called 'brand' images of iconic personages. Such practice is not so evident in the wider Hellenistic world of antiquity. Thus, in a Greek context, coin imagery and statuary did not necessarily cohere whereas in Rome there is a much closer and more demonstrable relationship – and, of course, as a result the credible evidence of coin portraiture in this context is a significant base line against which to identify the innumerable sculpted portraits which survive from Roman antiquity. This too may link to the greater emphasis on realism, on documentary portraiture, in Roman as opposed to Greek tradition. The motivation for placing a portrait on coinage is usually described by classicists as 'cultic'. Portraiture is associated with the elevation of rulers to venerated status. From one point of view, cultic phenomena are a form of the perpetuation of memory. Following Julius Caesar's assassination in 44 BC Octavian succeeded to his great uncle's role as sole ruler of the Roman world. Initially he was known as 'Caesar' rather than Augustus, the name by which he was ultimately known. He thus succeeded firstly to the name of his illustrious predecessor whilst the title of Emperor was yet beyond his grasp. Once Julius Caesar was deified, Augustus called himself 'Son of God', and this inscription also appeared on his coinage. The first coins stamped with his image were issued in 43 BC to pay a loyal army. New coins showed Octavian-Caesar-Augustus in various guises and these were shipped around the empire and remained in circulation after his death, by which time he himself had been elevated to divine standing (figs 43–6).

In the Renaissance, drawings derived from coins, not always successfully identified, were used to illustrate historical works, especially those dealing with antiquity.[16] Such portraits were made, for instance in the mid-fourteenth century, for inclusion in Suetonius' account of the *Lives of the Caesars*. If the plentiful medal and coin cabinets did not provide reference for all the famous men of the past, imaginative forgeries were available to fill the gaps. By 1517 Andrea Fulvio illustrated 200 illustrious lives, from Alexander the Great to the Holy Roman Emperor Conrad who ruled in the early tenth century AD; and in 1553 Guillaume Rouillé published a 'Promptuaire' of medallic images beginning, modestly, at 'le commencement du monde' with Adam and ending with that of his own monarch, the still-extant Henry II of France. Adam, he admitted, was a creative invention of his own based on biblical sources. The earliest transferral of coin and medallic portraiture to historical book illustration accurately reproduced the head but often added

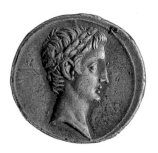

43–5 The divine imagery of Octavian Augustus was reflected on coins and other media. The three silver coins show Octavian as the son of God opposite his divine father Julius Caesar, as the god Jupiter, and as the god Apollo. Roman. 43–32 BC. D. 20 mm (all). Department of Coins and Medals.

46 The three-layered cameo shows him as Augustus after his death, wearing the mantle of the goddess Minerva. Roman. c. AD 14–20. H. 12.8 cm, W. 9.3 cm. Department of Greek and Roman Antiquities.

47 Marble portrait of the Athenian statesman and general Pericles (c. 500–429 BC). He is usually shown with a helmet concealing the unusual shape of the back of his head. Roman copy of a Greek original from c. 450 BC. H. 58.5 cm. Department of Greek and Roman Antiquities.

an invented upper part of the body. These later imaginative creations, as Haskell points out, often did the reverse and suggested fidelity to a non-existent original image by only reproducing the head in imitation of medallic traditions. In the sixteenth century numismatists were ready to acknowledge that portraits on coins and medals of emperors who ruled before Julius Caesar could not have been made during their lifetime. However, the known existence of wax ancestral portraits led to the assertion that earlier imperial portraits were authentic because copied from wax impressions.

In these instances, of course, the purpose is partly to give the reader a sense of what historical figures looked like. But, more than that, the common assertion was that the lives of the Ancients were worth relating because they were in one way or another exemplary – clearly recurrent illustrations of Nero (though he was much admired in his day and his coin image is amongst the best executed of Roman imperial medallic portraits) were not included to illustrate heroic deeds, but rather, by then, historical notoriety. The inclusion of the portrait was explained as a way of directing us to the deeds of the great figures of the past and helping the reader remember their example.

Greek and Roman Sculptural Portraits

The emperor Augustus was rather particular about how he was portrayed, and by whom. He, of course, had the advantage over many other subjects of ancient portraiture of having portraits in circulation during his lifetime, and thereby being able to control their content. He was portrayed as the epitome of the republican Roman, as a successful general (even though he never personally took his troops into battle); and, when he could no longer control the production of portrait images, he was – luckily – moved on with haste to deification. As a god he was guaranteed portrayal with benign and youthful countenance (fig. 46). Not so, however, all the great figures of ancient Greece, most philosophers and thinkers rather than rulers. It is an irony that the representations of the leading Classical thinkers, whose philosophical speculation has been fundamental to the development of the whole of Western philosophy, are in fact known from later Roman copies and interpretations.

The development of imperial portraits in the Roman world had its antecedents in Greek practice. Most of the portraits of Greek subjects that survive are Roman copies in marble of Greek originals, often initially cast in bronze. In Classical Greece, however, portraiture was largely posthumous. From the fifth century BC the image of the creative intellectual – mature, bearded, reflective – was promoted as a positive stereotype.

If any of those thus commemorated have posthumous cause for complaint, it would have to be Socrates (fig. 48). After all, he is not credited either with good looks in life, nor with an agreeable

character. But his intellectual ability was beyond dispute, though not perhaps his pragmatism or his ability to forge an appropriate accommodation of rival interests. Socrates, let us remember, was condemned to death in 399 BC because of his provocative and controversial views; and his physical looks were compared to the frankly unfavourable appearance of an inebriate companion of the god of wine, Dionysus. We are left with a paradox. Why should a great, if challenging, intellect be subject to the continuing humiliation of a physical representation of ugliness when the conventions of portraiture allowed for posthumous reinvention? Indeed, in the context of Athens, where sculpture tended to idealise the body, the squat

48 Marble statuette of the Greek philosopher Socrates (469–399 BC). Probably made in Alexandria during the second century BC. H. 27.5 cm. Department of Greek and Roman Antiquities.

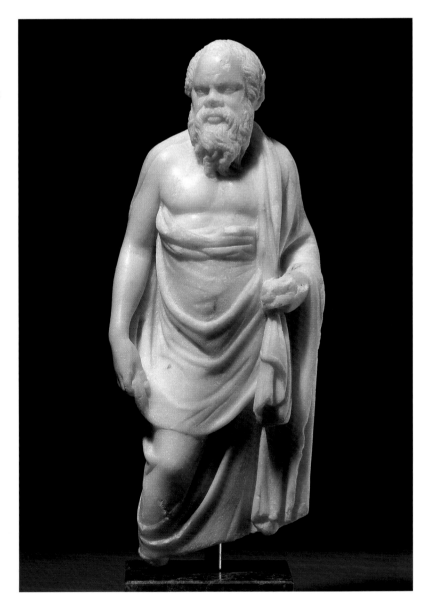

proportions, bulging belly and ape-like face are all the more remarkable. Continuing portrayals of ugliness such as this are an unusual commodity in the world of commemoration.

A common interpretation of this exception to the rule is that the unprepossessing exterior of Socrates' portrait throws into yet greater relief the perfection of his intellect. Zanker goes further.[17] As Socrates challenged the fundamentals of Athenian society, he suggests, so his statue challenges Greek conceptions of portraiture. Exterior ugliness belies the interior soul; conversely, exterior perfection is no guarantee of interior worth. Athenian obsession with portraiture of the external form of the body gives a flawed and superficial impression of true worth. 'Seen in this light, the portrait of Socrates makes a rather forceful and provocative statement and becomes a kind of extension of Socratic discourse into another medium.'[18] What is portrayed, in other words, is a metaphysical totality and not simply a physical impression.

And in the case of Greek portraiture, of course, the perpetuation of memory through portraiture was not a short-lived phenomenon. There has been some debate as to whether some of the earliest and most influential figures in Greek thought actually existed. We have the *Iliad* and the *Odyssey* – that much is undeniable; but were they actually the work of a blind poet who wrote them as long ago as the eighth century BC? By the time Homer's portrait had been created and he was firmly identified with the pantheon of divine intellectuals, it hardly mattered (fig. 49). He had been created in memory whether or not he actually lived, composed, wrote, but never saw. His image was copied down the centuries by Greek artists and then, of course, entered the repertoire of Roman copyists to assure his place in the visual culture of libraries to the present day. Homer will forever be an elderly bearded poet with unseeing eyes, Socrates forever locked into an image of ill-favoured dumpiness.

49 Marble portrait of the poet Homer. Roman copy of a Greek original from *c.* 100 BC. H. 22.5 cm. Department of Greek and Roman Antiquities.

Mughal Portraiture

The chosen medium of commemoration in Mughal portraiture in India was neither the coin nor sculpture but the painted image, whether in the form of wall painting or book illustration. The Mughal court employed its own painters to produce (and reproduce) illustrated manuscripts and albums. The scenes were various including bestiaries, natural history illustrations, mythic scenes, fables, versions of European and often Christian scenes derived from prints brought in from the sixteenth century by Jesuit missions – and, of course, court scenes and portraits. The greatest effervescence of Mughal painting is associated with the reign of the emperor Akbar and his successors Jahāngīr and Shāh Jahān in the sixteenth and seventeenth centuries. Akbar's approach both to the administration of his subjects and his ambitions in commissioning paintings was notably eclectic. In 1575 he created a central religious institution, the Dār al-'Ibāda, which sought to reconcile the disparate faiths of Christian, Jew, Zoroastrian and Hindu with his own Islamic belief.[19] Similarly the volume of illustration Akbar set about commissioning required nothing less than a conscripted army of painters to execute it: Muslim and Hindu, Indian, Central Asian

and Iranian. They worked on the classics of Persian and Turki literature, on Sanskrit fables and the Muslim classic texts. There was considerable work for translators, scribes and artists. The purpose was both to reflect the multi-faith composition of his empire and to enlarge the sympathies of his officials and generals by embracing the textual traditions of Muslim and non-Muslim alike.[20]

50 Prince Khurram being weighed against gold and silver. Gouache on paper. Mughal, India. c. 1615. H. 26.6 cm, W. 20.5 cm. Department of Oriental Antiquities.

In terms of portrait painting, Akbar developed a practice which had first arisen under the Timarids and subsequently in Persia. It was slow to take on elsewhere as a recognised and respectable genre. In Akbar's court, however, both dynastic portraits and dynastic historical painting flourished. The use of stencils and the updating of the imagery to take account of aging allowed the images to be both more widely distributed and more up-to-date without the need of constant resitting. And, once established, Akbar's successors continued the practice. Images of the ruler himself were produced on the walls of the public rooms of his palaces. All this relates in general terms to an interest in recording and commemorating through art. Amongst many potential examples, one important painting in the British Museum collection may serve to illustrate the continuation of Mughal court art into the seventeenth century. It comes from a volume of illustrations entitled *Tūzuk-i Jahāngīr* (*Memoirs of Jahangir*) and shows Prince Khurram being weighed in gold and silver (fig. 50), a portrayal of a ceremony which marked the beginning of the solar year.[21] The detail is exceptionally well observed. Jahāngīr himself and his son are the most prominent figures in the composition, surrounded by Mughal ministers and generals. On the richly decorated carpet in the foreground are laid out ornate folded textiles, whilst in the background can be seen treasured objects collected by Jahāngīr – ornate vessels and Chinese imports of porcelain and figurines. This celebration of magnificence in a volume of memoirs, accompanied by autobiographical writings, shows an exceptional attention to the theme of memory. It is a feature of Mughal imperial aggrandisement not otherwise associated with Islamic cultures of the period.

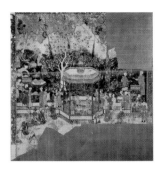

One painting, which appears to date from about 1555, the year before Akbar's succession, and to have been executed by an Iranian artist working for the court of his predecesor, Emperor Humāyūn,[22] is perhaps the most explicit instance of art in the service of memory. It is a large painting called 'Princes of the House of Timur' and is an exercise in dynastic time-shifting purportedly bringing together in one scene Mughal rulers and their ancestors going back to the era of Timur in the late fourteenth century (fig. 51). The interesting point about the picture, however, is that by giving the date of its original execution, the fact is obscured that it has been extensively overpainted in the early seventeenth century, incorporating figures who were

51 'Princes of the House of Timur'. Watercolour and detail in gold on cotton. Mughal, India. c. 1550–55 and extensively repainted in the early seventeenth century. H. 108 cm, W. 108.5 cm. Department of Oriental Antiquities.

not even born in the reign of Humāyūn.[23] As we see it today, it is at once an early and a late example of Mughal art. It not only goes back in time from the era of Humāyūn (though this has been partly obliterated in the repainting), it also moves forwards to the time of his successors. In addition to redoing parts of the backdrop, the later artists have also repainted all but a few of the figures in what is, after all, a thoroughly crowded scene. For the most part the original pose and costume have been left untouched. However, most of the faces have been totally altered, being modelled in a naturalistic manner which did not emerge in Mughal painting until the reign of Jahāngīr. Thus, in addition to Humāyūn, the painting as it has come down to us now includes portraits of Akbar, Jahāngīr, Shāh Jahān and his brothers, the princes Khusraw and Parwīz. The original positioning of the various figures reflected a different set of relationships and priorities, and indeed most probably did not have a strong dynastic element to it. However, in the makeover, the identity and relative disposition of the figures in the repainted scene has been carefully constructed to reflect the dynastic relationships as they were perceived in the second decade of the seventeenth century. This goes well beyond the repair or renewal of an older image; it is a thorough reworking and recasting of the Mughal dynasty story. The passion to repaint figures in the more naturalistic style of later Mughal art is by no means limited to this example, but it is the most dramatic instance since it involves the deliberate updating of a pictorial legacy by a successor. If each generation rewrites its own history, so too each generation needs to refocus and visualise afresh its own memory, in this case literally.

Like his son Jahāngīr, Akbar, in addition to having his own portrait painted on many occasions, also had produced a large album of images of all the grandees of the realm 'so that those who have passed away have received a new life and those who are still alive have immortality promised them'.[24] Here, memory and the promise of everlasting life have been wrapped up together in the creation of portraits. In many cultures, as this book frequently discovers, this is achieved by the assertion that if the living continue to attend to the memory of the deceased this in itself guarantees longevity beyond the grave. This leaves eternity in a thoroughly earth-bound orbit. However, the Mughal idea seems to unite the representation of the individual with the identification of those deserving of admission to enduring eternity. The portrait is at once a construction of memory and a passport to another dimension of existence. In Mughal hands the Islamic mistrust of figural representation is given a positive, culturally diversified twist.

Substitute Identities

The story of the 'Princes of the House of Timur' painting is by no means an exceptional one. It reflects an attitude to art which is neither precious nor antiquarian. In the Western tradition opportunistic artists and publishers have readily adapted images to produce new and alternative readings of historical realities. We have seen numerous examples from antiquity where idealised depictions are largely invented. There is a need to distinguish between 'official' portraits, where in different cultures individual likeness may be a desirable but not always a necessary requirement, from those where

52–3 William Faithorne, 'Oliver Cromwell between Two Pillars' (left), a very rare print probably issued in 1658, shortly before Cromwell's death. The plate from which the print was produced went through various states, being resuscitated in 1690 when William III's head was inserted and several other minor changes were introduced (right). British. 1658 and 1690. H. 56.2 cm, W. 42.2 cm. Department of Prints and Drawings.

unlicensed commercial or other motives have usurped the memory of the person depicted and potentially duped both the buyer and viewer of the works. In the British context one of the most successful of such innovators must be Peter Stent. In 1640 Stent published an etching by none other than Rembrandt which was said to represent Thomas More, but in fact is thought to be a commissioned portrait of Stent's father. Perhaps his most renowned piece of opportunism was to commission an engraving of an equestrian figure which, with but little difficulty, could have alternative heads slotted in to create portraits appropriate to the changing times. Thus Richard Cromwell slipped seamlessly into a portrait of Charles II with the Restoration.

Was this subterfuge, slick seventeenth-century practice, as Haskell, for instance, implies in relation to Stent?[25] When it happens often enough it becomes a little like the fairground booths where people can put their heads through a hole in a painted backdrop and be photographed with a caricatured body. Perhaps the most substantial set of these changing historical personages is that created over a number of years by the talented engraver Pierre Lombart.[26] Lombart was in London through the period of the Interregnum and working at about the same time as Stent; indeed Stent published a set of Lombart's engravings of the Liberal Arts and Sciences after L. Richter in the 1650s. Seven transformations have been identified from a design of an equestrian figure cribbed from a portrait of Charles I by van Dyke. In the first the horseman is Oliver Cromwell. It then becomes a headless rider before translating into two portrayals of Louis XIV. The fifth version is back to Oliver Cromwell

before becoming Charles I. Finally, in the seventh, it reverts once again to Cromwell. At least the inserted heads are not imaginary (see also figs 52 and 53).

We have commented above on Samuel's discussion of the difference between memory as a form of social knowledge and history as a professional discipline. For the historian the inaccurate portrait, denying the right individual image to the subject, is a travesty. John Evelyn, exploring the character of Oliver Cromwell from the contemplation of his image, could only feel deeply compromised by the shenanigans of a Stent. Yet, the portrayal of the person not as an individual, but as one whose identity is submerged within their role as a particular class of person, has a long cultural background. The result from the perspective of memory is less a travesty than it is from the perspective of documentary history. The murals which the Protestant communities of Northern Ireland repaint on the sides of the end houses of terraced Belfast streets every 12 July recall an event which took place in 1690, the Battle of the Boyne. No one would assume that the image is an accurate representation of 'King Billy' (the Protestant victor, William of Orange). On the other hand, no one would assume from its context that it represented anyone else. From the point of view of memory, the equestrian figure in seventeenth-century garb and heroic pose remains a most potent and evocative rallying point of contemporary identity.

The General and the Individual

The topic of portraiture is clearly enormous and the forms of visual expression through which identity is conveyed highly varied, especially when viewed cross-culturally. The focus on the portrait as an aspect in the creation of memory has necessarily led from icons as religious representations to a discussion of what we might call the politics of representation, where the construction of the context of a portrayal, the detail of the individuation, and the reference to other precedents to suggest relatedness, are all important. If these portraits are descriptive they are descriptive of social, political and cultural aspiration rather than brutally honest, incisive descriptions of objective physiognomy or character – indeed, even where they portray the individual as unprepossessing or idiosyncratic, the point may be that the aspiration expressed through such demeanour is to challenge norms (including those of portraiture) rather than to conform, as in the case of Socrates. One clear line of tension which a focus on memory exposes in the genre of portraiture is that between the portrayal of people as they are or were, and how they would wish memory to treat them or how memory actually has treated them. Most of what we have looked at is explicitly a representation of the latter pairing. What is portrayed becomes, or actually *is*, memory. This leads to another concluding tension: that between the portrayal of the general and the individual.

Memory needs differentiation. Portraits which are unattributed to particular subjects do not hold the attention of the viewer as do those which are named. Indeed, as the attention to remembering names in so many contexts of memory might suggest, false attribution is in some ways better than no attribution at all. Without a named subject there remains little to contemplate except for the technical skill and

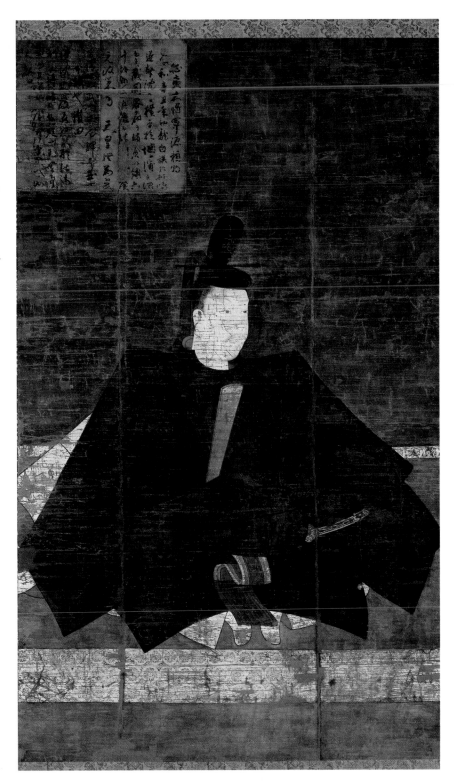

54 Hanging scroll with a portrait of Minamoto no Yoritomo, the founder of the Kamakura Shogunate, in court dress. Japanese. Fourteenth century (some authorities suggest later dates). H. 145 cm, W. 88.5 cm. Department of Japanese Antiquities.

aesthetic insight of the artist. With a name to work on, even attached to the wrong subject, there is at least something to stimulate memory. Later we will see how naming and inscription are regarded in several ancient contexts as a more definitive vehicle of commemoration than the sculpted imagery with which it is associated.

Amongst the Kuba generalised treatment of the figure of the royal subject gives few clues to identity. Sculptural variation is introduced in the image on the front of the plinth on which the king sits, and thence in the stories of the reign of kings to which this refers. Thus is individuation achieved. We have used the *ndop* of the Kuba as an illustration of mnemonics, but could equally have chosen to discuss the present point through their example. Minor subtleties and variations are sufficient to breach the distinction of the general and the individual, sufficient to generate portraiture and sufficient to memorialise. Borgatti, in discussing representational portraiture in Africa, shows a photograph of the Swiss anthropologist Hans Himmelheber together with a series of portrait heads carved of him by Senufo, Baule and Dan artists in Côte d'Ivoire.[27] In each case a different and recognisable result is achieved by slightly adapting local stylistic conventions, introducing a higher than usual forehead and a more receding hairline, or giving greater emphasis to the line of the eyebrow. Thereby meaningful variation is created in what is otherwise a tight set of stylistic conventions. Equally the 'true to life' Roman portraits, for all that they achieve a greater element of likeness, are still idealisations displaying characteristics associated with the subject. What is displayed in the sculpted busts is what in Classical culture would be regarded as appropriate physiognomy, but not necessarily the physiognomy of the subject. In other words, the impetus to individuation is not necessarily dependent on the production of unique or idiosyncratic images. Memory needs an element of discrimination between the portrayal of its subjects, but not a yawning chasm.

55 Brass plaque showing an Oba (king) sacrificing a leopard, symbolising his authority over the realm of wild nature. The representation of his feet as mud fish identifies him with Olokun, god of the great waters and of earthly wealth. Although sometimes identified with Oba Ohen (early fifteenth century), the portrayal brings together wider symbolic elements associated with kingship in general. From Benin, Nigeria. Probably sixteenth century. H. 39.5 cm, W. 35 cm. Department of Ethnography.

56 Drawing of a double self-portrait by Jock McFadyen, one with a cap, the other without, the artist having gone bald overnight. British. 1983. H. 65.6 cm, W. 50.2 cm. Department of Prints and Drawings.

In Memoriam

LA CALAVERA
DEL EDITOR POPULAR
ANTONIO VANEGAS ARROYO

57 'Calavera', or broadsheet, issued by the printer Antonio Vanegas Arroyo in 1907 from an engraving by José Guadalupe Posada. Such broadsheets are printed in advance of the Day of the Dead with epitaphs satirising the living by conceiving of them as animated corpses. In this case the mockery is self-directed. Mexican. H. 35.5 cm, W. 39.2 cm. Department of Prints and Drawings.

The large island of Madagascar lies between the Equator to its north and the Tropic of Capricorn which skirts its southern coastline. It stands in the western Indian Ocean beyond the horizon of the mainland of continental Africa. My own recollections of undertaking ethnographic fieldwork there in the 1980s are dominated by images of the architecture of tombs standing massive and solid in the countryside, of the sequence of ritual events which take place nearby, and of the ever-present reference point provided by the ancestors for even the most apparently minor of domestic arrangements.[1]

Imerina, the province in the centre of the island, is a largely treeless expanse of high uplands. Here and in surrounding areas, villages cluster round rice fields often deeply etched in terracing into the hillsides, and with channels directing the rainfall down a complex of routes to irrigate successive fields. The rice terraces represent the toil of generations of ancestors (*razana*), and the duty to maintain them falls to those who live in the adjacent villages. Large stone tombs, sometimes topped with a small wooden hut-like structure, are located in their midst. It is the ambition of everyone to be united at death with the ancestors through incorporation into the appropriate tomb. People may move from place to place in life, some perhaps overseas, but ultimately everyone knows the tomb in which they can anticipate final relocation. Not all those to be placed in the tomb, however, will necessarily have been known to their future co-residents, and those coming to bury will not necessarily be known to those in the home village, especially since wage migration began at the start of the twentieth century and disrupted communities. None the less, there is a sense in which the tomb group are an identifiable unit. They share the same address in death and the same ancestors, even though they may not be related by ties of blood and their common ancestors do not necessarily form a genealogical community.

The most potent ritual acknowledgement of the ancestors is the *famadihana* (literally, 'turning the dead'), a ceremony in which new bodies are placed in the catacomb-like tomb and/or others are brought out and rewrapped in new silk funerary shrouds (*lamba mena*) (fig. 58).[2] It takes place in the dry season (roughly June to

September), perhaps years after someone's death, and it is a relatively public event. Sometimes printed invitation cards are issued. Where no new remains are to be incorporated but only older ones reshrouded, the timing of the event is itself initiated by an act of remembrance. Perhaps misfortune has occurred and it is thought that, without remedial action, the flow of restorative and protective blessings from the dead to the living will remain too meagre. A relative will dream of the deceased, often expressed in terms of being haunted by the thought that the ancestor is cold, the funerary cloth having rotted away. It is as if remembrance has not been sufficiently sustained.

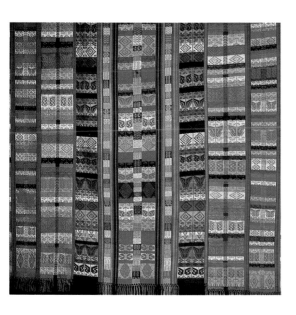

58 Detail of a woven silk textile (*lamba akotifahana*). Such textiles were worn as a prestige shawl by high-ranking Merina. Many were subsequently used as burial cloths. From Merina, Madagascar. Nineteenth century. Department of Ethnography.

The person conducting the ritual usually goes to the tomb several days before the ceremony itself to seek blessings for the event. This often has a very strongly personalised aspect of remembrance as the dead are addressed directly and perhaps their foibles in life are recounted. 'We are coming on Wednesday to conduct the *famadihana*. Rakoto, you must not go to till the gardens as you were wont to do. Rabesahala, you should not go looking for rice in the market. Rajaoson, no rum that day.' When it comes to the actual ceremony the remains are taken out and inspected, and the bones may be washed or 'cleansed'. There may be empty bottles placed there, coins, jewellery or other personal items. There is even an example of someone buried with a radio left on with the batteries running down. Such items may be replaced and the remains rewrapped. The deceased is then taken in lively, even riotous, procession, preceded often by a large framed photograph of them when alive. They are sung to, danced with and they may be shown developments in the village since their last 'outing'.

Like medieval pilgrims, those leaving may take with them a small container of earth. This is sometimes described in sentimental terms as a kind of nostalgic keepsake expressive of the wish to return. The whole event, however, is charged with the necessity of reinforcing the flow of ancestral blessings on which human vitality depends. And the very process of taking the dead out, rewrapping them, juggling them about in procession, contributes to their breakdown. They become in a physical sense part of the soil itself. Taking soil away is a means of placing the departure under ancestral protection. By the time ancestors have become unidentifiable to this degree, so too the memory of them as individuals will have faded. Individual recollection is not just a matter of there still being living people who remember the deceased and can attend to their remembrance in *famadihana* – it is also a matter of there being substantive physical remains left to be rewrapped. By this point the individual has entered a very large and undifferentiated category – they are forgotten but still present in the daily influence the ancestors as a whole exercise over the affairs of the living.

The fact that the journeying of the shrouded corpses in riotous procession round villages takes place in public means that they are often witnessed by visitors to the island. The language in which the events are described by such outsiders is often

derogatory and distancing: *famadihana* are presented as evidence of a persistent 'ancestor cult'. Many Malagasy (the generic term for the people of Madagascar) are, however, proud of their Christian faith. The events are organised by business people, doctors, civil servants, pilots – not just the less-educated rural population. For such people the understanding of the ancestors and of the Christian faith are not alterna-

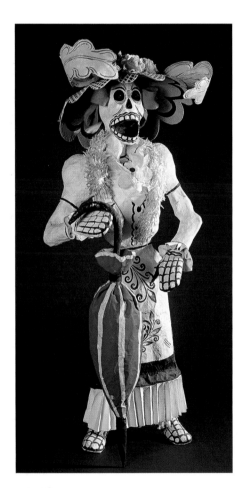

tive or conflicting systems of belief – much as the authors of the Hinton St Mary mosaic in fourth-century Britain saw no conflict in mixing an image of Christ with pagan references. One is an external theological and moral system; the other is a practical and parochial matter of direct remembrance. A Western model of remembrance is of quiet, pious reflection. Joyful, public hysteria is not the expected pattern of behaviour in relation to the beloved dead, let alone trawling through and rearranging the decaying remains of deceased relatives.

These emotions are part of a whole range of personal and cultural responses to death, and of complex relationships the living have to the dead. The way in which this is represented in imagery is the subject of this chapter. It is largely concerned with recognising the dead as having entered a different existential or spiritual condition from that of the living. Whereas in the last chapter we were concerned with the representation of the living (or of the dead idealised and as if in life), here we focus more completely on the forms of memorialising which occur after death. To some extent it is about recognising and seeking to overcome the discontinuous nature of our relationship to the dead, about how memory functions to take us beyond the emotional and social disjunctions – indeed the implicit threat to social cohesion – that arises. We begin with cyclical events which give a regular and annual occasion to celebrate our relationship to the dead; and we will move later in the chapter to consider graves, monuments and other forms of posthumous commemoration. One aspect is the sensitivity which surrounds the preservation of the 'name' of the deceased in many cultures.

59 Papier mâché figure of *La Catarina*, a character modelled on engravings by José Guadalupe Posada, and now widely identified with Day of the Dead celebration. By the Linares family, Mexico City. 1980s. H. 129 cm. Department of Ethnography.

The Day of the Dead

In Mexico, as in Madagascar, Day of the Dead celebrations are characterised by what to some would seem a challenging structure of emotion and behaviour. This is celebrated around All Souls' Day, an established element in the Catholic calendar which takes place at the beginning of November. Octavio Paz described the Mexican approach thus: 'What is important is to go out, open up a way, get drunk on noise, people, colours. Mexico is in fiesta. And this fiesta, shot through with lightning and delirium, is the brilliant opposite of our silence and apathy, our reticence and gloom.'[3] Mourning for the recently deceased is tempered by a joyful effervescence which attracts the return of the souls of the departed.

Honouring the ancestors has a public dimension: graves are dressed, markets bulge with flowers and fruits, exotic ceramics, coloured paper punched with designs, special breads and chocolate, sugar skulls. These are places humming with excitement and festivity. Museums, and other public buildings, have set-piece displays. From one of these, 'The Atomic Apocalypse' by the Linares family, now in the British Museum collections,

60 'The Atomic Apocalpyse', a set-piece papier mâché construction made for public display in the context of Day of the Dead celebrations. By the Linares family, Mexico City. 1980s. Department of Ethnography.

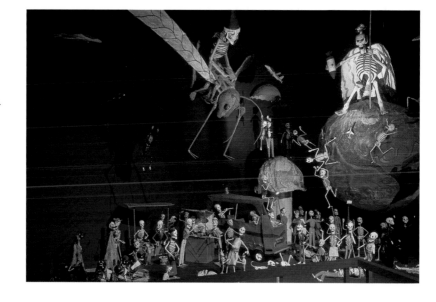

61 A Mexican *ofrenda* specially constructed by Eugenio Reyes Eustaquio in the gallery of the Museum of Mankind, London, for the 1991 exhibition 'Skeleton at the Feast'. Department of Ethnography.

was acquired (fig. 60). On the day itself dancers, often dressed or masked in costumes with skeletal references, and men taking the role of women, perform in public squares; in rural areas they move from house to house within the community.

However, the main commemorative events take place in a family setting. *Ofrendas* (offerings laid out for the souls of the returning dead) are set up at altars in the family house (fig. 61). The altars themselves will incorporate individual photographs of the family dead where these exist. These can be dramatic architectural constructions of satin cloth and gold braid, the whole lit with candles. An interesting variation reported by Carmichael and Sayer is the Altar of the Living Dead (*muertos vivientes*) at Iguala in the state of Guerrero.[4] Here a replica tomb is created within the house, complete with painted landscape and stars as a backdrop and plants placed around it. The deceased's image will be placed above the 'tomb'. For the day of the soul's return, mourners will be hired to stand by the tomb in imitation of episodes in the life of Jesus. These include simpler versions in which young female relatives sit in the constructed shrine dressed as angels, to more elaborate ones such as the Last Supper. On the Day of the Dead itself not all the departed souls return together. There is a perceived sequence. Thus the souls of any children are held to be first to return, followed separately by those of adult men and then by women. Their route to the altar, with its offerings waiting on display, is sometimes emphasised by constructing a route of flowers from the front door to the installation. It is even

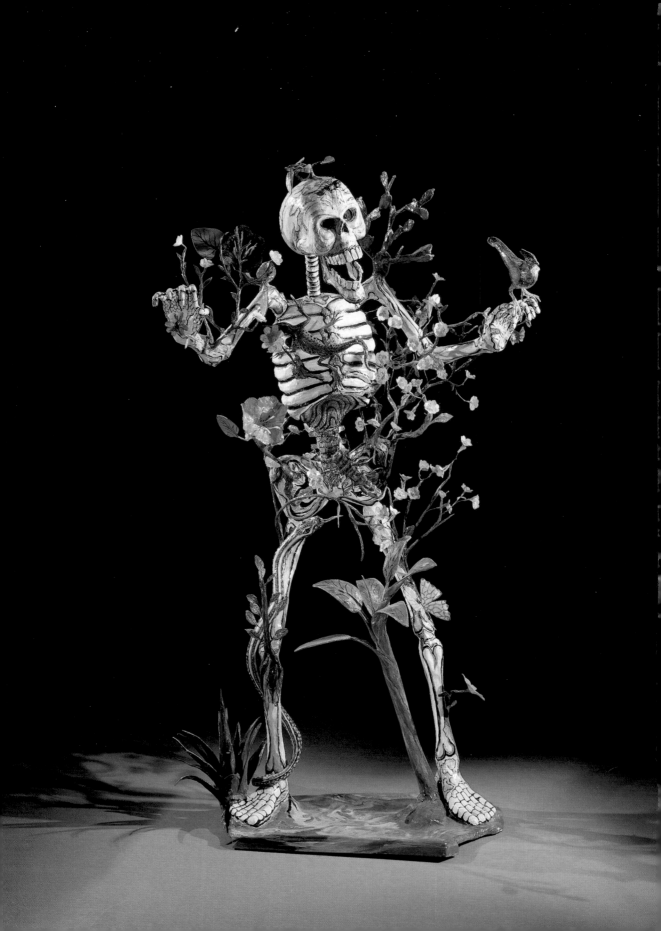

reported that some houses are at the end of a floral route which goes to the cemetery where the dead are buried and from which their souls will arrive.

A significant element of the *ofrenda* is the offering of special food. Feeding the dead is a familiar act of engagement between the living and their ancestors in many societies. In ancient Egypt, for instance, there is some evidence that mummies might on occasion be kept in private houses for a time and treated very much as guests to be honoured with banquets.[5] In ancient Rome, at the anniversary of a death, tombs were specially opened so a meal could be shared with descendants. Food and drink were offered through vents cut into the grave or holes in the chests used to contain the ashes of the deceased.[6] Similarly, in Mexico the souls of the departed, visitors and family all have an opportunity to share in special foods. Practice varies, but the interviews conducted by Carmichael and Sayer reveal some interesting local interpretations.[7] Thus, a view from Puebla State includes the following: 'I cook things with special flavour, because it is the flavour, or the aroma, that the dead extract. The dead don't physically eat the food; we believe they come and kiss it. Later we eat it ourselves.'[8] Another interviewee from the city is of the same opinion: 'It is the spirit, or the essence, that the dead extract. I've never noticed a change in food, but we always offer water and, do you know, the level really goes down! This can't be evaporation because there is no heat – just the flames of the candles. If we put out a full glass of water, it is often half full next day.'[9]

Anthropologists have analysed such practice in terms of theories of gift-giving and exchange. The food is offered in expectation of the reciprocal benefits that can derive from a well-appointed and satisfied community of ancestors. An attention to these practices in terms of commemoration and memory leads to an equally self-centred reading. It emphasises a concern for a continuity of remembrance. Many of the Day of the Dead interviewees talk in terms of their fears that in due course they may themselves be forgotten by their own descendants unless they do things now in the right way for their own deceased relatives. The ultimate reciprocity is that between generations. The now-alive may eventually enjoy the hospitality and the remembrance of their own surviving kin, when they in their turn pass on. If the *ofrenda* is inadequate, the deceased will be forlorn, only haphazardly remembered. If nothing is offered they will, in effect, be forgotten and have completely died. As the Swahili say, those whose name and deeds are still lodged in the memory of their family or community are the 'living-dead'; it is only when the last of those who knew them in life have themselves passed on that they are truly dead. Remembering is a means of extending life beyond the limitations of biological existence.

The Body and the Skeleton

In Mexico, then, there is an annual opportunity to remember and honour the dead. The imagery includes two opposing references: one is to the deceased who is honoured and whose image will often form part of the altar; the other is to the physical state of the deceased as skeletal – skulls dominate the proliferating ephemera of Day of the Dead festivals. In Madagascar the procession with the rewrapped corpse

62 Painted papier mâché skeleton rendered as a trellis up which grow plants and flowers, and on which birds, snakes and animals nest and climb. By Felipe Linares, Mexico City. 1980s. H. 170 cm. Department of Ethnography.

has at its head the identifying photograph, but the body within has previously been uncovered and inspected in its skeletal state. Wittgenstein remarked that death is not an event which has to do with life because it is not 'lived' through. In life each individual experiences themselves as distinct, possessed of physical appearance, mannerisms and autobiographical events which define a specific personality, a sense of uniqueness. From the point of view of the living, experience of the dead in an afterlife is inaccessible other than through visions, dreams and the evidence of good or ill fortune which the living might attribute to the actions of the dead. In death the remains become undifferentiated, generic. An epitaph on a second-century AD Roman funerary stela has a skeleton carved on it and bears a Greek inscription: 'Looking on the fleshless corpse, who can say, passer-by, whether it was Hylas or Theristes?' Unless treated by some form of intervention, skull and skeleton become indistinct from other skulls and skeletons, even to the expert physical anthropologist. In emphasising them in ritual practice, it is as if the memory of the deceased as they were in life, and the hope of the Resurrection, is secure to the point that skull and skeleton evoke not disintegration and annihilation but a triumph over death.

63 Dancing skeletons from a painted scroll. Japanese. Late nineteenth century. H. 135 cm, W. 66 cm. Department of Japanese Antiquities.

The *memento mori* tradition in Western medieval culture also juxtaposes the two, the individualised portrait with the generic skeleton — the peaceful image appropriate to the perfection attained in Resurrection — with the pathetic aping skeleton. Medieval culture had many different means of commemorating the dead. Notable are the use of epitaphs and the institution of the chantry — a practice of commissioning memorial masses 'chanted' for the soul of the dead (and not, initially, part of a church building). The Reformation swept away much of this cult of memory, at least in northern Europe. But one element remained — what Binski has called this culture of the macabre, a late medieval phenomena.[10] The macabre image might in some contexts be portrayed on its own as a single skeletal representation, but it arose from the juxtaposition of the body in perfection with the body in decomposition, and the contrast was significant. As in Malagasy rewrapping ceremonies or Mexican Day of the Dead shrines, the play on antithesis, the marking of the ravages of time is fundamental. The most structured presentation of the double image occurred during the fifteenth century on the so-called *transi* tombs. Binski describes these as double deckers where in one image the deceased is laid out in full social splendour, bedecked in the trappings of office, and in the timeless repose of a life fulfilled; the contrasting image beneath, placed in closer proximity to the corpse itself, portrays what we may assume to be the same body now in decomposition, shrouded or naked.[11]

The development and geographical distribution of *transi* tombs has been discussed in various ways. The sources of the tradition are clearly many and complex and no single explanatory model will suffice. One of the most pervasive explanations recalls the effects of the Black Death and the familiarity with death and decomposition that plague brought. However, following Phillippe Ariès, Binski makes the interesting point that the development of the *transi* tomb is associated with the widespread use of coffins in northern Europe as opposed to Mediterranean funerary practice. The northern cultural preference has been to conceal the corpse completely. In Italy and elsewhere it is usual for at least the head to be exposed during the funerary proce-dure. Thereafter, in Naples at least, the body is periodically ritually washed in a manner reminiscent of the *famadihana* of Madagascar. We might say, in the context of our attention to the theme of memory, that the deployment of the memorialising imagery on *transi* tombs of northern Europe substitutes for the absent (because concealed) body. Indeed from the 1200s the concealment of the corpse led to the production of wooden or waxed effigies of the deceased which substituted for the body of the deceased during funerary rituals.[12] Some examples survive in Westmin-ster Abbey, placed there it seems to mark the anniversaries of the royal dead. Binski concludes by simplifying what is clearly a highly complex phenomenon: 'What was concealed by social practice in the north was revealed through art; what was revealed by social practice in the south was concealed, or even repressed by art.'[13]

The comparison with Merina practice in Madagascar is suggestive; but it is also divergent. In Madagascar, there is a sequence to bodily states which in its symbolic contexts is highly charged. People are born into the world literally wet. The processes of aging and wrinkling are conceived of as a slow and gradual drying out. With death, the separation of bones and flesh make this explicit. The fluids of decomposition are polluting, and in some parts of Madagascar were in the past collected and separately disposed of, leaving the dry and purified remains from which ancestral blessings and human vitality are believed to derive. The practice of *famadihana* attends to this process of drying too. But once the body has been inspected and rewrapped it is, as we have noted, taken on a riotous procession around the tomb. People in a state of high elation often jump on skeletal remains paying no heed to the fact that they are shaking the bones against each other and contributing to breaking them up. There is a central paradox here. If such practice is a heightening and refreshment of memories of the deceased, it is also contributory to their being ultimately forgotten. For, as the bones disintegrate and become dust, memory loses its necessary individuation – a physical focus in the skeletal remains. The tombs lie in the midst of the rice fields. The vitality of the dried remains contributes to the vitality and fertility of the very soil from which human sustenance derives. In other words, to become as it were the soil and stuff of pure vitality, memory must be released and the dead become part of the wider conceptual community of the ancestors.

Transi tombs and related aspects of the *memento mori* tradition move in a different direction. Here the skeletons seem to be the dead talking, and indeed the tombs are often accompanied by a text which articulates this explicitly. To become dry, purified

64 Terracotta model for the tomb of Frau Langhans by the sculptor Jean-Auguste Nahl. She is shown breaking free from the tomb with her child. Swiss. 1751. H. 247 cm, W. 46 cm. Department of Medieval and Modern Europe.

of polluting decomposition, and contributory to the vital charge of life, is in Madagascar a desirable fulfilment of a long life. In northern Europe, late medieval and early modern tombs emphasise the macabre not the celebratory in this process. The double image is a compression of time, a before and after. This, they say, comes to us all – as I am now, so will you become. It is at once a statement of humility from the dead (and such tombs were, of course, only affordable by those of elevated status), and also an admonition to the living, a hefty sight of mortality. The tomb asks us to remember the dead through the perfected body; but it is also a spur to self-reflection – the decaying double exhorts us also to remember ourselves and the inevitability of our own ultimate biological fate.

However, this same range of contrasting images has also been rearranged into a more dynamic format by some later artists of the memorial. In 1751 the wife of the Pastor of Hindelbank in Switzerland, George Langhans, died at the age of twenty-eight in childbirth. She was by common consent one of the most beautiful women of her day. The sculptor Jean-Auguste Nahl was commissioned to create a suitable tomb to express for eternity the pastor's own deep sadness and to perpetuate the memory of his beloved wife (fig. 64). The result was a conception which imaginatively rearranged the imagery of the body and the skeleton to give an optimistic twist to a traditional theme. Thus the outside of the tomb has the familiar image of the worm-eaten skull; but the centre is shown being split apart as the living bodies of Frau Langhans and her deceased child escape from the clutches of death and the restrictions of the tomb. This 'happy allusion to the certainty of our resurrection', which inspired both the bereaved husband and his chosen sculptor, gained extensive fame and was rendered both as a print and in a ceramic model. The image of the dead defying biological deterioration and breaking free of their graves is a motif which has continued to attract Western artists both as a religious theme and as a metaphor for the power of memory itself to revitalise the past.

Memento Mori

Such images of the grotesque were not limited to their placement on tombs. As a medical man Sir Hans Sloane was interested in attitudes to death. His collection included a number of objects which demonstrate other contexts in which *memento*

Imperial Roman Funerary Practice

Top and middle Two bronze coins. Roman.
Mid-second century AD. D. 33 mm (both).
Bottom Gold coin. Roman. Fourth century AD. D. 20 mm.
Department of Coins and Medals.

In Roman belief the greatest emperors were fated to become gods after
death. The two coins on the right show a multi-storey imperial funeral pyre
and an eagle. A wax image of the deceased ruler would be burned on
the pyre and an eagle released from the top. Its flight heavenwards would
be regarded as representing the ascent of the emperor's soul to the gods.
The coin below shows the spirit of the first Christian emperor, Constantine
the Great (AD 306–37), being carried into heaven in a chariot as the hand
of God reaches down to greet him.

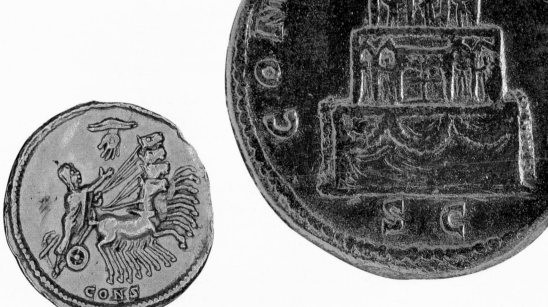

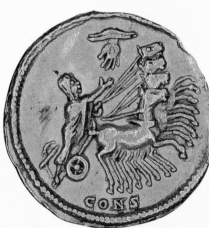

65 Detail of a painted scroll showing the assassination of Indira Ghandi and her spirit rising from the dead. Indian. 1980s. Department of Ethnography.

mori imagery might be deployed. These include a fine fifteenth-century French ivory with two Janus faces, again emphasising the juxtaposition of imagery as in tomb sculpture (fig. 66). One is still recognisable as a human head in the first stages of decomposition. It is shown being devoured by worms and snails with, inscribed on the forehead, the words 'A LA SAINT NAVOT'. The reverse of the image is a skull with a toad buried in its mouth. Here the inscription reads 'POINT DE DEVANT A LA MORT'. There is also a series of rings showing heads and skeletons and the enamelled decoration goldsmiths used in making them. Two seventeenth-century examples were found at Canterbury and are identified as 'old burying rings', though they bear the legend 'MEMENTO MORI'.[14] Such rings and other artefacts of mourning seemed to set the sense of loss in the context of a wider pattern of inevitability and experience, including the experience not just of the dead but also of the currently living. The message of the tombs is here converted into a portable, compressed message. Dissociated from the grave, these *memento mori* images are no longer concerned with memory in any restricted sense. They seem to have been transformed into reminders not to forget who we are nor what we shall become.

By the seventeenth century such *memento mori* imagery, occupying a liminal area between the living body and the corpse, had become popular in Britain, and was employed on invitations to attend funerals, jewellery distributed to those in mourning, and even the wrappers of biscuits prepared to be eaten at the reception after the burial.[15] Attendance at a funeral involves not just the paying of respects to the deceased, but a confrontation with one's own mortality. *Memento mori* imagery was applied in numerous contexts, not just on the various tokens of mourning. It appeared, often with the more transgressive moralising imagery of the Dance of Death,[16] on furnishings, mural decorations, trade tokens and samplers, woodcuts, popular prints and paintings – an effervescence of the kind we have seen in contemporary Day of the Dead ephemera in contemporary Mexico, and, going back to the late nineteenth and early twentieth century, the riot of imagery produced by the master of the Mexican art of the macabre, José Guadalupe Posada (see fig. 57).[17]

At first glance, salvation does not seem to enter into these phenomena. But, in the Christian context within which these images were created salvation is surely implicated. The skeleton, naked, deprived of both clothing and flesh, is also witness to another absence: the absence of the departed soul of the deceased. Thus the soul is

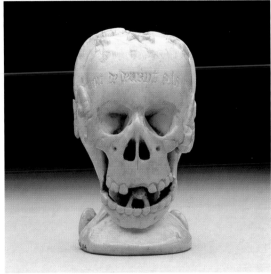

66 Two views of an ivory *memento mori* image. French. Sixteenth century. H. 6.3 cm. Department of Medieval and Modern Europe.

salvaged from the wreckage of the decaying body. It goes on as the social roles of the deceased pass to others and continuity is re-established. Individual death does not overwhelm the ongoing fabric of society.

Communal Graves

Perhaps the set-piece of posthumous commemoration lies within the grave itself and with the way in which it is marked on the surface. The subject of memory is approached in archaeology in its attention to the disposition of bodies within the burial, grave goods and the construction of tombs, cenotaphs and monuments.[18] Indeed it is already indicative that in any archaeological museum, not least in the displays of the British Museum, it is paradoxically often the case that we learn most about the lives of past peoples from the analysis and the artefacts which have been recovered from burials. Reflection on life at major moments of transition is a large part of commemoration. But it is not an easy topic. Archaeologists constantly wrestle with the problem of intentionality. In attributing significance to the deposition of finds it is important to distinguish the deliberate from the random. Undisturbed grave assemblages largely escape such questioning for they can usually be assumed to be deliberate acts of deposition, complete in themselves. Yet, the disturbing of remains in antiquity can itself be an indication of remembrance, returning to recharge the memory of the deceased, or in some cases usurping memory and directing it to other purposes or to other people than those for whom a grave or tomb was originally created.

To give one example, a decisive change of approach has recently been claimed for mortuary practice and its related evaluation of memory in the Beaker phase in Bronze Age Britain. Where there are communal burials at a site some mortuary practice ends up with a jumble of bodies and bones. In these cases a Malagasy-like

Treasure Trove

Gold and silver torcs and other jewellery found at the site of Snettisham in Norfolk, England. Most of the hoards from which these objects have been recovered date from c. 70 BC. Various dimensions. Department of Prehistory and Early Europe. National Art Collections Fund.

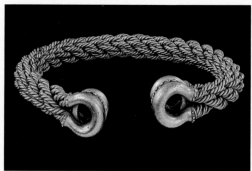

A crucial question arising from the discovery of archaeological deposits is whether they were random or intentional acts of disposal: whether the purpose was to forget and destroy the objects dispensed with, to hide them for future recovery, or to create a sanctuary

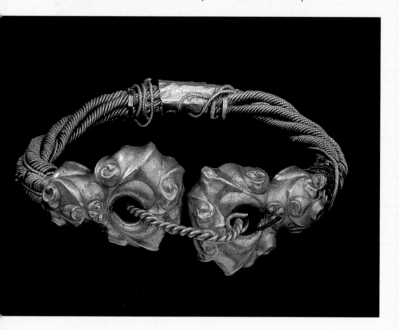

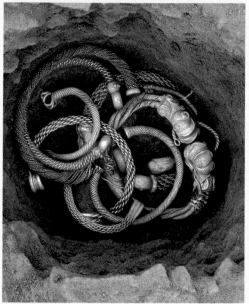

of some kind in which they might accumulate. This determination, which implies interpretations of the status of memory and memorialising in archaeological deposition, has had legal implications. In Britain, disposal for future recovery was a leading criterion in the declaration of so-called Treasure Trove. In the case of the Snettisham hoards, at least eleven separate disposals have been identified, constituting the largest deposition of gold and silver in a single area from Iron Age Europe. It was considered an intentional deposition and declared 'Treasure'. Difficulties in determining intentionality subsequently removed this criterion under The Treasure Act (1997).

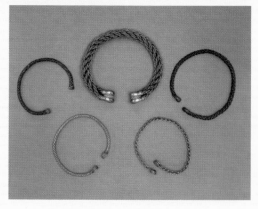

situation may well be assumed. It is clearly considered more significant to bury the deceased together at a single cemetery than haphazardly and separately. They were intended to constitute a group and, together, the collective remains indicate an attention to the significance of the ancestors. However, in Britain this approach which characterised the Neolithic was to shift significantly. Reanalysis of a barrow in

67 Group of objects from a 'Beaker' burial from Barnack, Cambridgeshire, England. Copper Age, 2350–2100 BC. Vessel: H. 18.5 cm. Department of Prehistory and Early Europe.

Cambridgeshire originally excavated in the 1970s suggests a carefully constructed sequence of memorialising burials.[19] Most attention has been given to the primary burial at the site, one of great wealth which is now preserved in the British Museum (fig. 67). The individual buried in such style was clearly someone of great influence and connection. Later burials at the same site lack such rich grave goods and appear to have been very varied, suggesting no consistent pattern of interment. Yet the fact of this differentiation in styles of interment can be interpreted in another way. Last has argued that 'the placement and attitude of each body reveal the group's memories of all previous events at the site, suggesting this hallowed ground was remembered through the years in stories, songs or physical markers of some kind'.[20] At least seven generations of individuals can be identified as buried at this one earthen barrow. Each successive interment seems to respect the previous ones such that differences in wealth, status or genealogical relationship to the existing occupants of the burial are acknowledged.

The resulting site, if this analysis is correct, reflects a continuous narrative in which individuality or biography is acknowledged, but the successive memory of the group using the burial site is also expressed. The barrow comprises perhaps twenty burials over a period of some 200 years, a relatively infrequent sequence of events

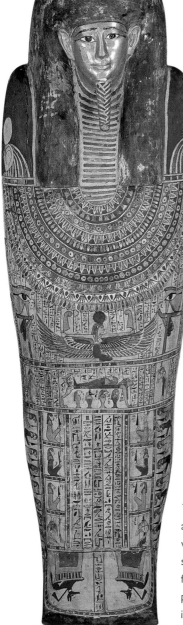

which suggests both an organised remembering of previous interments and a process of selecting appropriate persons to be buried there rather than at adjacent mounds. The apparent randomness of the burials emerges as a consequence of each successive burial being regarded as having its own individual identity within a common totality. And as such it actually conforms rather better to the Malagasy notions which have been our reference point in this chapter than does the 'Neolithic' model. In Madagascar, the attention to each ancestor's proclivities as they are recalled from their life histories gives way through the reburial process to the eventual apprehension of the deceased as part of a community of ancestors. Individuality gives way over time to homogeneity, differentiation to communality, or, in Last's analysis of Beaker burial, biography to collective memory. This is a very suggestive interpretation. However, it is difficult to interpret such archaeological materials as these Bronze Age burials definitively for there is no clinching textual evidence to support assumption and broaden understanding of the full symbolic and historical context of these interments.

Mummies and Names

Happily, for ancient Egypt we do have textual material both in the form of surviving papyri and hieroglyphic inscriptions within the tombs themselves with which to understand the complexities of funerary practices. Discussion of ancient Egyptian funerary practice emphasises the role of burial procedures in moving the deceased on to the eternal afterlife. A succinct discussion of this aspect of Pharonic funerary complexes and their changing character is provided by John Taylor.[21] In ancient Egypt the spirit of the deceased person (*akh*) might either remain in the earth-bound kingdom of Osiris or be transported to the realm of the sun-god Ra, the originator and, through the daily return of the sun at dawn, the perpetuator of life. To sustain the spirit's vitality as *akh*, its physical identity needed to be preserved and it also needed sustenance. For the wealthy the former was secured through the process of mummification, sometimes with the added insurance of a substitute body in the form of a separate carved image, the provision of a painted face mask placed over the head of the corpse, or, by the Eleventh Dynasty (*c.* 2000 BC), an anthropoid coffin (fig. 68). Long-term provisioning was achieved by a supply of offerings of food reinforced by a series of images and objects which might serve as surrogates for particular commodities. After the middle of the Twelfth Dynasty (*c.* 1985–1795 BC), female figurines and *shabtis*, small sculptures of agricultural labourers to work for the benefit of the deceased in the hereafter, were included in tombs. For these to be animated to the service of the deceased's spirit, amuletic and other magical devices were provided. Texts containing magical formulae could also empower the objects and the *shabti* to sustain the *akh* in perpetuity. Other burials included more personalised possessions, whether utilitarian items like household furniture, or personal possessions such as musical instruments or tools associated with the deceased's trade in life.

This primary purpose of ensuring the successful easing of the dead into the after-life, however, does not preclude acts of memorialisation. Indeed an appropriately elaborate funeral and a well-equipped tomb to ensure passage onwards into eternity was one outcome of a successful and 'memorable' life. Apart from the preservation of the body through mummification, the preservation of the memory of someone was closely tied up with the recollection of their name. As in Papua New Guinea to the present day, the name was seen as the embodiment of the person and all that they stood for. The remembrance of the name, most effectively through becoming the subject of a cult, was also a form of preservation. If a continuing identity is conditional on a shared memory of common association, naming is essential to both. Burials included an accessible cult place where the name and titles of the dead were visible. These were often elaborated into first-person autobiographical inscriptions including direct addresses to passers-by.

The durability of names is, thus, an important issue in Egyptian culture. A person's name had a particular potency. Various views are discernible in antiquity as to which is the most efficacious manner of remembrance. A case has been made for the written form – indeed the scribe's own possibility of immortality was itself identified as an appropriate by-product of the ability to inscribe names and thus enhance memory. A text on a papyrus dating to the Nineteenth Dynasty contains a revealing eulogy dedicated to authors and writers:[22]

> As for scribes and sages
> from the time which came after the gods
> – those who would foresee what was to come, which happened –
> their names endure for eternity,
> although they are gone, although they completed their
> lifetimes and all their people are forgotten.

The written word read by others, even read to those with no relation to the person named, was a desired form of memorialisation. The text continues:

> A man has perished: his corpse is dust,
> and his people have passed from the land;
> it is a book which makes him remembered
> in the mouth of a speaker.

We learn, indeed, that of possible forms of remembrance a name inscribed on a literary papyrus for subsequent reading was regarded by the eulogist as a better form of memorialisation than a house or shrine, better than a stela in a temple. It is interesting that memory here, as we have seen in Chapter 2, is associated with speaking and hearing, not just with seeing and inwardly acknowledging. Given the very low levels of literacy in the Egyptian society of the time, memorialising is most meaningful in an oral or narrative context, and is not simply a written tribute.

68 *Opposite* Wood painted and gilded lid of the coffin of Djedher, representing the deceased in a transfigured state with the blue wig, golden skin and curled beard of a divine being. Egyptian. *c.* 300 BC. H. 156 cm. Department of Egypt and Sudan.

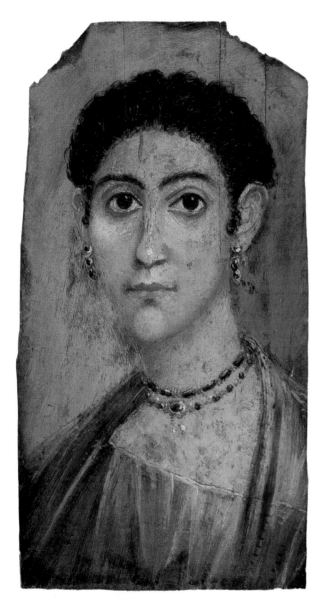

69 Mummy portrait of a woman on limewood. The subject is shown with hairstyle and costume consistent with the styles of the second century AD. From Hawara, Egypt. Roman period, AD 100–120. H. 38.2 cm, W. 20.5 cm. Department of Ancient Egypt and Sudan.

The substitute figures of the deceased placed in tombs were also named. These were in no physical sense close portraits of the deceased but appear to have been turned out rather like anthropomorphic tombstones which only attain personalised reference when a name is inscribed upon them. Again the inscribing of the name on an otherwise anonymous sculpture invests the image with the memory of an identified person. Their idealised form is of course appropriate to their association with the passage of the dead into the afterlife where their individual identity was surrendered to a generalised divine visage.

Cults associated with individuals often only lasted for a few generations in ancient Egypt. But others could be associated with a focus of cultic commemoration by having their own remains placed in someone else's tomb. This was not necessarily seen as erasure, in the sense of a deliberate attempt being made to forget, or as a form of appropriation. Rather, it could be viewed as a way of benefiting the remembrance of the former occupant by recharging the cult with a new association. Something similar occurred when kings sought to embellish the resonance of their names and ensure their future remembrance. This could be achieved by drawing parallels between themselves and significant well-regarded predecessors, even with those to whom no genealogical link was necessarily asserted. This might be done by composing royal titles which made the connection, or by restoring buildings or temples associated with celebrated rulers of the past, and being acknowledged subsequently as the patron of the refurbishment, a phenomenon well understood by present-day fund-raisers. By such means the elite might ensure their memory after they had themselves passed on to the afterlife.

Mummy Portraits

Although, then, there is considerable evidence of commemoration in Egyptian practice, there is little to suggest a widespread non-royal tradition of portraiture, either posthumous or in life. This was to change when Egypt fell under the administration of the Roman Empire. From the middle of the first century AD a tradition

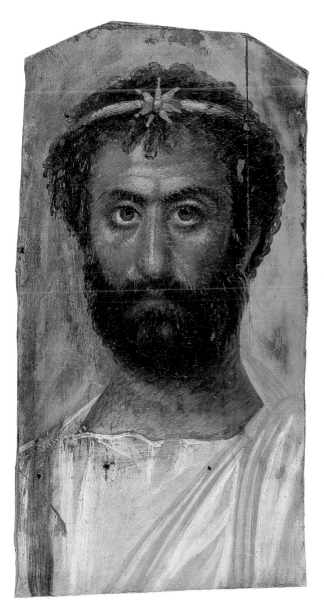

70 Mummy portrait on limewood, thought to be of a priest, though the luxuriant hair suggests a novice. From Hawara, Egypt. Roman period, AD 140–160. H. 42.5 cm, W. 22.2 cm. Department of Ancient Egypt and Sudan.

of painting panels to be incorporated into the construction of mummy casing developed among the Roman elite in Egypt, and particularly in the region of Fayum, an oasis town near the modern site of Cairo. This, it has been argued, moves significantly in the direction of portraiture in the sense of directly representing the individualised physiognomy of the deceased.[23] Indeed it is suggested that the fact that they are cut and shaped to the form of the mummy indicates that they may once have been hung as more regular shapes on the walls of a house and only subsequently used in funerary contexts. If this were so then they must clearly have been painted from life. In the British Museum collections is a rectangular framed portrait of a woman dated to AD 50–100 and found together with a mummy in excavations undertaken by Flinders Petrie at Hawara. This picture is smaller than many. Most of the 'mummy portraits' are close to life-size, as was essential if they were to function in giving realism to the preserved mummified corpse by adding an image of the face and upper body over the preserved remains. However, its existence points to the presence of a tradition of painting framed portraits to be displayed in both home and tomb and perhaps carried, in a manner reminiscent of contemporary practice in Madagascar, at the head of the funeral procession.

These mummy portraits appear to arise from a fusion of northern Mediterranean skill in portraying a strong sense of individual identity and Egyptian funerary practice. In so doing the balance noted above between funerary arrangements focused on progression to the afterlife and commemoration, has shifted decisively towards the latter. In Roman hands, memory has taken precedence over fashioning an eternal future. Within the painted portraits this function of commemoration is achieved both by physical observation of facial features and by attention to the detail of dress, ornament and hairstyle. These, as Walker describes, represent an early example of the 'jeans and coca-cola' phenomenon.[24] Even places at a distance from Rome were up-to-date with Roman metropolitan style – so much so that it is possible to date mummy portraits to within a decade or so on the basis of the elite fashions displayed in the painting.

Here the techniques of Egyptian burial have been adopted, but given a distinctive

Biographical Coffins

Four wood coffins with satin lining inside, commissioned from Ga carvers in Teshie, Ghana. 1999. Various sizes appropriate to contain a human body within. Department of Ethnography.

In many parts of Africa, as elsewhere in the world, people are often represented in death by the status they held in life, rather than by any detailed recounting of the events of their lives. Once deceased, indeed, they are sometimes not referred to by the name they held in life but some other name, or they may only be referred to in aphorism or metaphor. Their name and their life-force passes on to their descendants in whom they are, in one sense, still present.

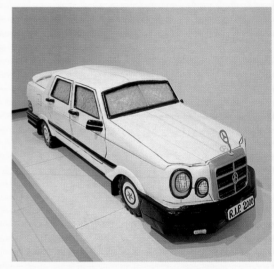

Their burial, if they are of royal or chiefly birth, may sometimes take place in secret, and not be a matter of national mourning or pageant. The grave goods buried with them may reflect the richness of their lives, but once interred these too only exist as memory.

Among the Ga people in Ghana, modern coffin-makers have taken their inspiration from the palanquins and prestigious funerals of the past, and contemporary carpenters now construct 'fantasy' coffins whose form is redolent of the biography of the deceased.[25] Thus, wooden motor cars may be constructed for successful business people, fish for those deriving their livelihood from harvesting the rivers and the sea, and, according to one source, 'huge, gaudy parrots clutching pens in their beaks' for academics.[26] A fashion for creating coffins in the form of the Bible is regarded as one of the most acceptable styles; these are most readily admitted to the church itself where others may only be permitted at the graveyard.

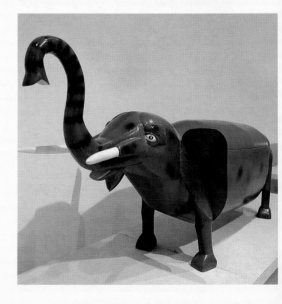

Roman context. Mummification is no longer about arresting decay, overcoming death to achieve eternity in the life beyond. Though idealised, the Roman painted portrait, which replaced the Egyptian mask over the mummified remains, had none of the god-like features appropriate to Egyptian belief. Nor is it clear that the provision of a painted image as part of the funerary complex was always intended to promote a cult of the individual dead. Indeed there is no evidence that the images were anything other than secondary representations of the person, achieving in their skill of execution an innovatory verisimilitude, but not, for all that, making the dead 'alive' – other than as memory. Survival beyond the grave was not asserted, and the dead played no part in wider religious belief.

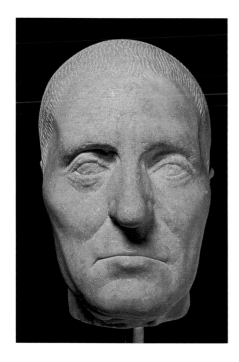

71 Marble head of a Roman, the folds of the skin under the chin suggesting that it may have been based on a death mask. c. 60–40 BC. H. 45.75 cm. Department of Greek and Roman Antiquities.

Imago

The emphasis in Roman Egypt is not that different from conventional Roman practice, even if it is eclectic. As with the cyclical rituals with which we started this chapter, the focus on genealogical continuity is important. We have alluded elsewhere to the practice in ancient Rome of taking wax casts from the faces of deceased relatives (*imago*). Funerals for the notable Roman dead involved the display and animation of these masks (fig. 71). They are known from the descriptions of the Greek historian Polybius in the second century BC. He wrote: 'The image consists of a mask, which is fashioned with extraordinary fidelity both in its modelling and its complexion to represent the features of the dead man.... And when any distinguished member of the family dies, the masks are taken to the funeral and are there worn by men who are considered to bear the closest resemblance to the original, both in height and in their general appearance and bearing' (*History*, 6, 53). Thus these ancestral pageants employed masked actors to portray individual deceased. Their clothing cohered with the status the dead had in life: a purple striped toga for a consul or praetor, one embroidered with gold for those celebrated for military feats. They rode in chariots preceded by the appropriate insignia of office. The dead in this triumphal funerary procession were symbolically relocated in the bosom of their family. From other sources we learn that 'portraits of moulded wax were kept in special cupboards for use at family burials, so that when someone died he was accompanied by the whole host of ancestors' (Pliny, *Natural History*, 35, 2.4–6). Like a museum's reserve collection, they were kept on special access, appropriately stored and, we understand, with the name of the deceased on the box.

Subsequently, at the funeral oration, the masked actors sat in the audience whilst the deeds of the most recently deceased were eulogised. The oration might seek to make explicit connections between the deeds associated with the ancestors made present in masked form, and perhaps to take liberties in reinterpreting and improving on the heroic genealogy of the family. The eulogy and the presence of *imago*,

instruments of memoralising, imparted glory to the recently deceased. The texts of the orations were preserved by the family, though most have subsequently been lost or disintegrated. Tombs too had inscriptions which acted as more permanent forms of obituary, setting out the details of the person's life and career, sometimes with a personal statement invoking the sentiments of a commissioning widow.[27] These were on public view.

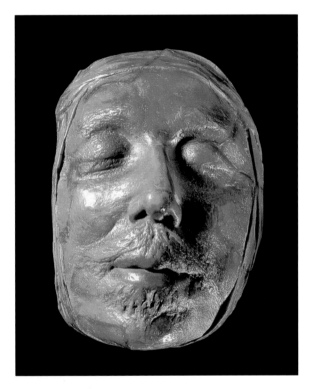

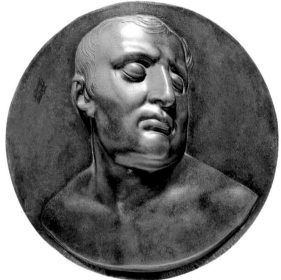

73 Medal showing a mechanically reduced version of the death mask of Napoleon. French. First half of the nineteenth century. D. 15.5 cm. Department of Coins and Medals.

72 Wax death mask of Oliver Cromwell (1599–1658). The cloth wound round the body for embalmment shows at the edges but Cromwell's famous facial wart is absent (perhaps through the action of embalming fluid). Copies of the original were subsequently made. British. Between AD 1658 and 1753 (when it entered the British Museum). H. 21.3 cm, W. 16.2 cm. Department of Medieval and Modern Europe.

The Monument

The most ornate of Graeco-Roman memorials are the sarcophagi originally produced by the Greeks and later adopted across the Roman Empire.[28] Many were of local manufacture, but marble from what are now Greece and Turkey was traded across the Mediterranean for the purpose, often being finished and detailed on arrival. A large number of lids were made from Italian marble quarried at Luna. The decorative elements included a standard repertoire of imagery: cupids, garlands, the skulls of sacrificed animals, and by the third century AD, mythological scenes, all contributing to the identification of the dead with figures of heroic stature. Funerary oration, the presence of *imago* and the architecture of Roman death combined to secure an appropriately memorable legacy for those of notable birth and achievement.

Individualisation of sarcophagi was achieved in various ways. One was in the detailing of the lids which often included elements to the specification of those commissioning them. Most of these are associated with Attic sarcophagi. The personal touch

might simply have been achieved by means of an inscription, but some of those created included sculpted portraits where the whole had been finished at the quarry workshop with the head left in rough for completion when the future occupant of the stone chest had been identified and a likeness could be added. In practice, however, many were in fact left incomplete, possibly because preparations were not made sufficiently in advance of the demise of the incumbent. One style involved the portrayal of the dead reclining on a funerary bed. A remarkable example, on a particularly elaborate funerary urn thought to be from Rome, shows a woman holding a separate portrait bust of a man, presumably a husband who had predeceased her (fig. 74). The bust is carved in a different style from the female figure and, after the conventions of bust portraiture, shows the upper torso unclad, in contrast to the female figure with flowing draped clothing. The composition brings together two apparently distinct traditions of Roman portraiture in a single posthumous act of memorialisation.

A development of the second century AD was the merging of portraiture with mythology. Thus, a Phrygian sarcophagus said to be from Athens, for instance, illustrates the labours of Hercules which, it has been suggested,[29] may refer to the deceased's qualities of industry and persistence in the face of adversity (fig. 75). But, additionally, the leading families began to take to themselves god-like qualities, representing members in divine guise and creating tombs which resembled temples. In view of the need to do this in some haste when people died unexpectedly, most appear to have employed stock images but had the head recarved and individualised. As a result, age and gender sometimes had to be altered, with a woman's hairstyle having to be adapted to the short-haired image of a young boy or transformed into a

74 Funerary monument of a reclining woman supporting a portrait bust of her deceased husband, whose ashes were likely to have been placed in an urn behind her. Roman. First century AD. L. 155 cm, H. 75 cm. Department of Greek and Roman Antiquities.

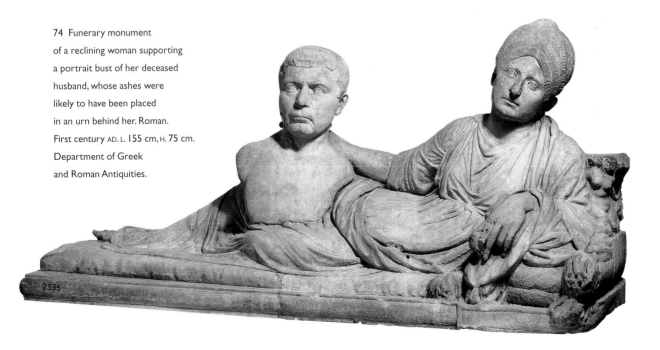

shorn militaristic style for a warrior – with, of course, the breasts adapted to suggest a muscular male torso.[30] Where children in particular died, a sentimental inscription might be added, and genre figures of the grieving parents might be included.

The concluding remarks in Susan Walker's *Memorials to the Roman Dead* are redolent of our theme:[32]

> The individual is as much evoked in words as in a portrait in stone. Emotionally demonstrative at funerals, the Romans had no place for the dead at the centre of their religious belief. The dead lived in the carefully cultivated memories of others: drawing on a symbolic language used for centuries by various peoples of the Mediterranean, the stones of memory offered a long-term prospect of immortality.

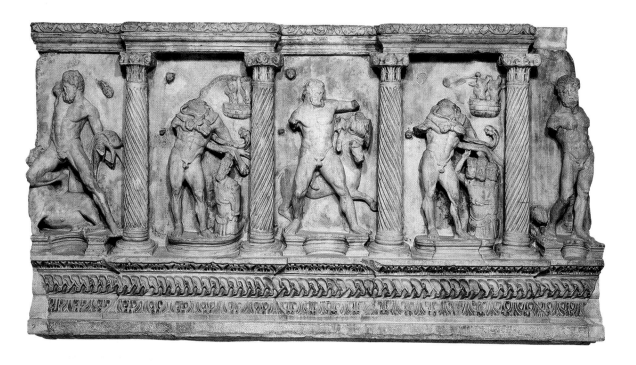

75 Marble sarcophagus showing Hercules performing five of the twelve 'labours'. From Athens. Roman. AD 160–90. H. 110 cm, W. 210 cm. Department of Greek and Roman Antiquities.

Monuments are built to last; they conform to the ideas of durability which, we have seen, is central to the form of memory anthropologists have described as 'incorporated'. Scattered through our discussion here are many examples of the ways in which endurance may be assured – from mummification to the creation of imposing memorial structures. The resolution of the contradiction between the death of the individual and the continuation of their remembrance is achieved in many diverse cultural forms. Most have to do with the continued treatment of the deceased as if they remain alive. Western authors have commented on the oddity of book-signing sessions in Japan in which authors can find themselves signing their precious work both for the dead, who would hardly have the opportunity of reading their deathless

prose, as well as for the living, who might. Similar behaviours are familiar in a wide range of divergent cultural situations. In ancient Rome, the empress Faustina was commemorated by a golden effigy when she died in AD 141. Subsequently, at the decree of the Senate, the image was carried on a chair to watch plays at the theatre whenever her husband, the emperor Antonius Pius, was in the audience. Her chair was placed in the box in which she had formerly sat, and around her were seated the women of the most prominent families of Rome.[32] Somewhat earlier, Julius Caesar, whose statue was found in public places where he himself was never seen, sometimes had state documents attached to them. Later, imperial portraits were reportedly petitioned to right injustices. Likewise, behaviour at war memorials includes bowing and saluting as well as the placing of wreaths – an acknowledgement of memory through the treatment of inert objects as if they are possessed of vitality.

From these behaviours, and the concepts and emotions which underlie them, derives the association of remembering with healing. Where Freud regarded the achievement of individual psychological healing as advanced by drawing back into consciousness otherwise forgotten events, the healing of social ills has taken a similar course. In South Africa the Truth and Reconciliation Commission adopted a similar strategy to lay to rest the ghosts of apartheid. War memorials have a very specific role to play in these moral conflicts. Some of the most insightful analyses of their significance focus on the Vietnam War Memorial in Washington, a designed site created by Maya Lin in a publically funded competition.[33] Some of the commentaries have invoked a useful distinction between memorials, designed to embrace the healing possibilities of remembrance and reconciliation, and monuments which have a more celebratory, even triumphalist role. Memorials precede and ultimately become monuments. The memorial exposes all – it is equivalent to the grief and the depth of remembrance occasioned by funerals. The monument equates, in terms of moral charge, to the end of grieving: it moves moral ambiguity on towards resolution; it implies forgetting, leaving behind the humiliation of ultimately irrelevant and futile demise in a situation of war, or the personal anxieties of intimate remembrance in the case of individual death. Memory in these contexts is the acknowledgement of achievement, a method by which the living make an accommodation to absence, and the dead are allowed to live on. In graveyards this might be occasioned by the erection of the headstone some time later at a site which, until then, has been an anonymous, unacknowledged burial site. The time lapse defines a period of grieving.

Where and when a monument is installed is not an inconsequential matter. Thus Maya Lin's Vietnam memorial could not be installed anywhere other than on the Mall in Washington, the national place of commemoration, surrounded by the museum buildings of the Smithsonian Institution, and overseen by the seat of government high on Capitol Hill. The Cenotaph in Whitehall in Central London, at which the fallen of the World Wars of the twentieth centuries are annually commemorated, is similarly surrounded by the buildings of the Ministries of State and near Downing Street, the residence of the Prime Minister. The royal family, leading political figures

of the day, Commonwealth High Commissioners, and surviving comrades come there to lay wreaths. Before that, however, the war dead were celebrated at the Tomb of the Unknown Soldier in nearby Westminster Abbey. It was on petition by war widows that a public and secular site was created in 1920 and the architect Edwin Lutyens commissioned to create an appropriate monument. Although not expressed in these terms, it was as if the period of grieving was over and the expressive symbolism of a tomb in a cathedral had been surpassed. The war widows themselves were ready for an enduring monument in the midst of a public thoroughfare accessible to passers-by.

The statue of Horatio Nelson, victor at the Battle of Trafalgar in 1805, was initially located at Charing Cross before he achieved his lofty placement in 1842, perched at the top of a column in the appropriately named Trafalgar Square nearby, accessible only to the pigeons. At Charing Cross, though it was nearly four decades since his death, '100,000 persons' are said to have come to examine the statue of him in two days and found it to have 'the great merit of likeness and character'. The *Illustrated London News* claimed that his monument was much more than 'a national tribute to his fame: it was a funeral record . . . raised in a sacred spot and consecrated by religion'. The sacred spot, however, must have been conceived to be any spot on which Nelson's image stood, or his proximity to the heavens in Trafalgar Square, for the report went on to remark that the Square itself may not have been the finest choice of location being but 'the commonplace . . . front of the National Gallery'.[34]

The Ephemeral

By comparison with the enduring nature of such imposing stone or concrete monuments, the fragile disposable artefacts of some forms of remembrance may seem less adapted to achieving a consistent continuity of memory. In this context one of the most discussed objects in ethnographic literature is *Malanggan*.[35] These are produced in New Ireland, an island in the Bismark archipelago, off the coast of Papua New Guinea. *Malanggan* are intricately constructed in the form of a figure set within a lattice of carved and incised fretwork (fig. 77). The incisions draw on motifs from the surrounding environment, deploying birds, pigs, shells, fish and so forth with precision and accuracy, and all brightly painted. The nature of the carving creates a spatial complexity of inner and outer areas and interpenetrating forms, such that parts of the form act to contain others which, in effect, inhabit the inner core. The whole is brought to a state of perfection, however, only to be placed upon a grave surrounded by a fence of coconut leaves for a single night, and then 'killed', either destroyed or sold on to Western art collectors as of no further use.

Underlying the production and destruction of *Malanggan* is the idea that the sculptures provide a temporary repository for the life force which might otherwise be dispersed with the death of a person. The sculpted framework is referred to as a body or as 'skin', and the sculpture is conceived as charged with the concentrated energy accumulated by the dead throughout a lifetime. In the creation and death of the sculpture

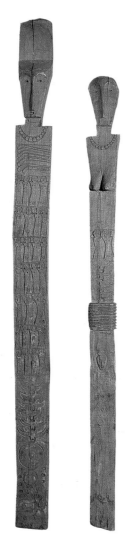

76 Wood male and female memorial posts with biographical references incised in the body (*thing tial*). Lai-Chin, Burma. Twentieth century. H. 185 cm (left), H. 158 cm (right). Department of Ethnography.

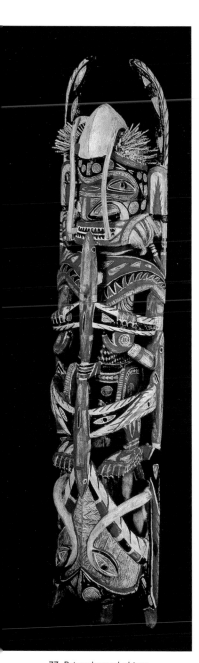

77 Painted wood object
(*Malanggan*) whose design
is owned and inherited.
From New Ireland. H. 148 cm,
W. 27 cm, D. 23 cm.
Department of Ethnography.

this vital force is harnessed to be rechannelled to the living in the form of power, not least power in the form of authority over the production of further *Malanggan*.

These, then, are solid potentially durable wood objects; but they are regarded in New Ireland as supremely ephemeral. Once the life force has been assembled, concentrated and redirected, its work is done. The interpretation of this phenomenon advanced by Küchler is that the memory of the sculpture takes precedence over the object itself. Indeed the possibility of the continued existence of the object is actively disavowed. It is as if the object has a brief reason for existence but otherwise is only made so it can sustain and exist as memory. The memory survives whilst the image rots away. *Malanggan* are reproduced at intervals that may be up to twenty years in duration. In the meantime rights over their future creation are a subject of exchange and tied up in issues of land and political legitimacy. When the 'owner' of the design of the sculpture in their turn dies, it is reproduced for the final stage of their funerary rites. The deceased may have seen the sculpture in their youth and subsequently have acquired rights over it, its design and the right to reproduce it. The artist commissioned to execute the sculpture is instructed in its design and form by another elder who shares reproduction rights with the deceased. Its work done, it may again become available for renewed ownership and pass on to a successive generation. It is in this sense literally a memory: no record of it is kept; it exists only briefly in reality and thereafter exists only as a mental image which is owned by specified individuals.

However, there is another sense in which these images are fundamentally about memory, even if their episodic realisation and lack of continuity as an embodiment prevents them from being converted into anything with the more specific long-term associations of memorials. Strathearn discusses the extent to which *Malanggan* are like copyright or patents. They are, she concludes, more like patents, if imperfectly so. Along the way, she notes: 'Finally, the design is not "copied" as such – rather it is lodged in the memory as an image to be recalled at a later date. Indeed, in respect of certain elements of the *Malanggan*, we may note that claimant's rights exist only *until* the moment of their realization in material form, the point at which they are transferred to others; people "own" them most securely as memories still to be realized.'[36] *Malanggan*, we might say, exist as potent and active memory when they simultaneously inhabit both the past and the future. For, when realised in the present, their only function is to recharge the living and return again to an unspecific dimension of time. Physical absence is, in this case, a condition of their maximum effectiveness.

Malanggan conform to an understanding of the present as constantly overwhelmed by memory of the past and expectations of the future, a point eloquently made by a cultivated representative of quite another culture, Samuel Johnson: 'Indeed, almost all that we can be said to enjoy is past or future; the present is in perpetual motion, leaves us as soon as it arrives, ceases to be present before its presence is well perceived, and is only known to have existed by the effects which it leaves behind.'[37] The need for commemoration of significant moments of passing is one such effect.

Remembering and Forgetting Events

Before the invention of advanced technological means of recording, remembering events and people has been a question of capturing retrospectively moments which have already past. In the 1552 version of Gargantua and Pantagruel, Rabelais imagines an extraordinary scene. While on a voyage Pantagruel seems to hear human voices in the stillness at sea: '"Can you hear something comrades?" he asked, "I seem to hear people talking in the air. But I can't see anything. Listen . . ." So as to miss nothing, some of us cupped the palms of our hands to the back of our ears . . . the more keenly we listened, the more clearly we made out voices, till in the end we could hear whole words.' What they heard, Rabelais explains, was the sound of a great sea battle of the past which had been frozen by winter and was now being released into the air once the spring thaw set in.[1]

Because fictional, this may seem hopelessly imaginative and unrelated to actuality. However, it is an appropriate metaphor. There is a sense in which repetitive ritual events, albeit possibly with different actors on successive occasions, re-create and recall to memory previous actualisation of the same kind. In art, these recollections are enhanced as they become the subject of grand panoramic reviews of the events. The great ceremonial scenes recorded by Italian Renaissance artists such as Carpaccio or Bellini are amongst the most celebrated in Western art. They have something of the

78 Australian banknote which on this side shows images commemorating migration into Australia. The other has a representation of the original Aboriginal occupants of the land. The imagery seeks to embrace memory in conflating the past with the present. L. 15.5 cm, H. 7.8 cm. Department of Coins and Medals.

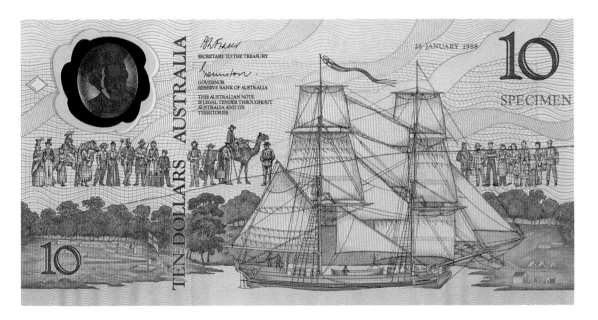

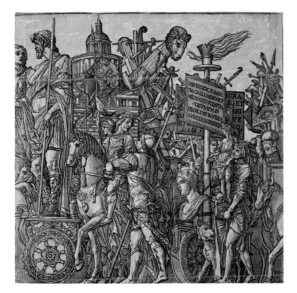

79 Andrea Andeani,
chiaroscuro woodcut of
'The Triumph of Caesar',
after Andrea Mantegna. Italian.
1598–9. H. 37 cm, W. 37.2 cm.
Department of Prints and Drawings.

eye-witness account about them. Their scale and attention to detail, their recording of events in an architectural setting whose detail would be known to many of their viewers, gave them an air of authentic record which many other famous reviews of historical events lacked. From the depiction of the Norman Conquest in the Bayeaux tapestry, to the murder of Becket, the execution of Mary Queen of Scots, or the colonial encounters recorded in the *Illustrated London News* of the day, many visual records of events have come down to us as the work of artists who were never actually present. What we have seen of the representation of people is no less true of the representation of events — both are often constructions of memory imitating history, rather than accurate records themselves. They appear to be documentary, some may indeed be illustrations informed by first-hand accounts, but most are later reconstructions. They are, like the images summoned up by those hearing the sounds released from a melting iceberg, refractions rather than reflections of what has occurred.

In this chapter we look at some well-known images of events to explore what construction memory gives to the episodes of history. Much of this is in the realm of the imagination, yet it is not usually a knowing attempt to falsify. We end this chapter with consideration of how the enhancement of history by the glorification of events slips into forgetting. We conclude by asking in what circumstances the evidence on which memory feeds may be deliberately erased.

Blood and Memory

Perhaps the most graphic examples of such events are those known from the Maya world. Here the representation of sacrifice and blood-letting combine with glyphs to place events at a particular time and identify them with particular people. Blood itself is clearly crucial, and the emphasis on it in graphic contexts reflects this wider significance. Kingship was normally expected to pass from father to son, and so when a

male heir was born a ruler would draw his own blood as an offering to the ancestors in recognition of the longed-for event. 'Blood' relationships were thus celebrated with the literal and intentional spilling of the fundamental substance linking the vitality of human beings to ancestral lineage. At the installation rites of kings the spilling of blood went further and involved full human sacrifice, the victims often being those captured for the purpose in warfare.[2]

Some of the most explicit representations of blood-letting are found on the Yaxchilan lintels in the British Museum, which come from an area on the Guatemala/Mexico borderland and dating from around AD 725. These are carved in high relief in limestone and show aspects of the formal ritual procedures of royal installation rites. The lintels were commissioned by the particularly militant Jaguar Dynasty, and record the events surrounding the accession to the throne of Yaxchilan. That identified in the literature as lintel number 24 shows the king Shield Jaguar ornately attired and with the shrunken head of a past victim lashed to the top of his head. He holds a flaming torch. Facing him in a kneeling posture is his principal wife, Lady Xoc, equally elaborately attired and with an imposing architectural headdress. The glyphs identify the event as an act of blood-letting which occurred on 28 October AD 709.[3] The dramatic part is taken by Lady Xoc who is shown drawing a rope with protruding thorns through her tongue so blood falls onto strips of cloth below.

The succeeding lintel (number 25) takes the sequence of activity to the next frame (fig. 80). Lady Xoc, shown still kneeling but now alone, gazes upwards to be confronted by a warrior armed with spear and shield emerging from the open jaws of a large two-headed serpent which rises up from the blood-stained scroll. In her hands Lady Xoc holds instruments of sacrifice and a skull. The serpent is a visionary manifestation of the founder of the Yaxchilan Dynasty which in the image emerges literally from the spilt blood. The implication is that the blood-letting has caused the hallucinatory vision – as will actually happen if the brain is subject to a loss of oxygen caused by significant blood loss.

In the final scene of the sequence (number 26, now in the Museo Nacional de Anthropologia e Historia in Mexico City) Shield Jaguar is shown with one of his wives apparently preparing for battle as his warrior armour and weapons are being presented. His wife has blood oozing from a wounded mouth and has in her hands

80 Limestone lintel showing Lady Xoc conjuring up a visionary serpent during the blood-letting ceremony which was part of the Installation rites of the Maya rulers of Yaxchilan in modern Mexico. Late Classic Period, c. AD 725. H. 129.5 cm, W. 85.7 cm. Department of Ethnography.

the Jaguar helmet and shield. This scene is dated by the associated glyph to February AD 724 and is presumably a separate occasion,[4] though some have seen it as the final act of the blood-letting of Lady Xoc,[5] preferring to comprehend the series as parts of a single sequence. Similar events to these are known to have happened in the various Maya states for a thousand years. This is not a unique ritual sequence, only exceptional in the graphic detail of its medium of record.

From the present perspective, there are two related points which emerge. The first is that the lintels relate a significant event in the development of the Jaguar Dynasty at Yaxchilan, and they do so retrospectively. They have been created to give pictorial remembrance to an accession ritual which happened well over a decade earlier (with the final element a year previously). Furthermore they create the scenes whole in a way that no single participant would have seen it. The expectation would be that the vision of the serpent and the ancestral warrior will have appeared to Lady Xoc as it is she who performs the act of piety by letting her own blood. Yet we are not shown the scene from her point of view but from that of an observer of all that occurs, making the reality of ancestral visionary experience as a result of the ritual acts visible to all. The lintels were placed above the doorway at which rituals continued to be performed, and a parallel series was commissioned in about AD 770 by Shield Jaguar's son, Bird Jaguar, to record his own accession rites when he succeeded his father in AD 752. The ritual actions, by repetition – and in this instance still more forcefully by repetitive graphic illustration – represents memory in the sense of return to a formulaic set of actions which speak of durability rather than change. As with much (it is tempting to say 'all') ritual activity, it is less concerned with history as linear progression, and more concerned with memory as a means of asserting cyclical notions of time of ever-increasing compass.

Secondly, in Western culture, blood has a significance which it is tempting to locate in Maya thought and practice also. Blood is at once physical, an expression of genetic connectedness, of shared substance. On the other hand, it expresses a social connectedness: it is fundamental to genealogical reckoning. To be of one blood is to be intimately related. Blood relations have priority over in-laws, and beyond that over non-kin. The Yaxchilan lintel scenes are, like much in Maya art and inscription, obsessively concerned with dynastic relationships. Other imagery at Yaxchilan, at Palenque and elsewhere, focuses on the part played by nobles in both witnessing the events of royal succession and endorsing the claims to dynastic legitimacy which are woven into accession rituals and their pictorial illustration. A bench panel from Copan in the British Museum, dating from the same period as the Bird Jaguar lintels, records the accession of Yax-Pac. Here the king appears with nineteen past kings portrayed as if actually present in person as witness to his succession. In a sense the blood-letting achieves just that in a visionary context.

Archaeological evidence alone is unlikely to lead us to a deep understanding of Maya philosophical thought. There is enough graphic evidence, however, to suggest that blood linkage could be seen as a sharing of fundamental substance. A possible further interpretation might be that blood contained within the body imparts the

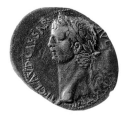

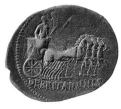

81 Silver coin of the emperor Claudius (AD 41–54), celebrating the emperor's conquest of Britain in AD 43, an event of empire-wide significance. The coin itself was made at Caesarea in modern Turkey. D. 25 mm. Department of Coins and Medals.

vitality of the whole ancestral line. When spilt, it releases the separable presence of those who share in its substance in the form of visionary appearances. If so, we are moving to suggest that memory is not just created by repetitive ritual events and genealogical recitation. Rather, there may be a sense in which for the Maya memory was actually an inherent quality of blood, released when spilt in blood-letting ceremonies – as Rabelais imagined sound to be unleashed from thawing icebergs.

Commemoration of Battles and Hunting

If the Maya lintels largely speak of ritual events and visionary experience, many others record the spilling of human blood in the heat of battle, or frequently the blood of animals in the course of the hunt. Two features are common to most such portrayals. The first is that, until the more recent documentary approach to recording the experience of the ordinary combatant, the imagery associated with the remembrance of events focused on the person of the ruler or commander in whose name the engagement took place. Visual presentations of scenes of conflict suggested their central role in heroic deeds on the battlefields. We have noted instances where individual emperors were portrayed as military rulers when they never actually engaged in battle. The wider point is that memory is put to the service of conveying the message that the king has the power to command life and death.

Secondly, the premium on the production of imagery is in the hands of the victor.

Memory follows the pattern of oral accounts in dramatising triumphal deeds and emphasising heroic achievement. Commemorative imagery recording humiliating defeat is hardly conceivable, unless — occasionally — the purpose is to recall bad times in order to emphasise new beginnings. In some cases a single image is required to sum up the event and their burden of communication is shared with that of monuments where the purpose is to record communal achievement rather than individual demise. Others, however, are sequential and allow a narrative to be developed to parallel the stories which sustain the event in memory.

Those known from the Ancient Near East set the standard in antiquity. They have about them a familiar, somewhat boastful air of self-glorification. The hunting scenes on the Assyrian reliefs in the British Museum are often cited as major works of ancient art (fig. 82). The famous scenes of lion-hunting from Ashurnasirpal's and Ashurbanipal's palaces at Nimrud, dating to about 865 and 645 BC, are remarkable feats of artistic observation. In the annals of the former king we read: 'The gods Ninurta and Nergal, who love my priesthood, gave me the wild animals of the plains, commanding me to hunt. 30 elephants I trapped and killed; 257 great wild oxen I brought down with my weapons, attacking from my chariot; 370 great lions I killed with hunting-spears.'[6] This is almost a genre in the depiction of royalty throughout the wider region. Later silver dishes from the Sasanian period in ancient Persia show similar feats. A silver dish in the British Museum shows a Sasanian king, probably

82 The Assyrian king Ashurbanipal (668–631 BC) drives his spear into the mouth of an attacking lion. His spare horse follows. Detail from a limestone wall relief in three registers (total height 1.66 m) from the North Palace at Nineveh (in modern Iraq). c. 650 BC. Department of the Ancient Near East.

83 Silver plate showing a Sasanian king, thought to be Bahram V (AD 420–38), hunting lions. As elsewhere in the region, the successful lion hunt was emblematic of royalty and a familiar subject of art. (Modern Iran.) Fifth–seventh centuries AD. D. 18 cm. Department of the Ancient Near East.

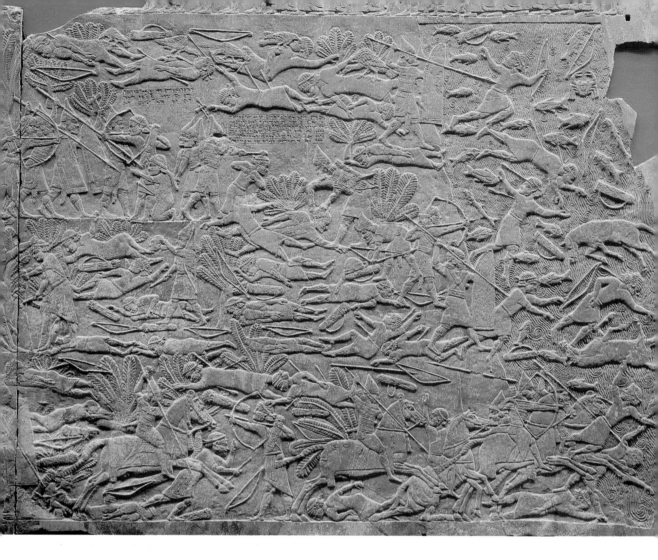

84 Detail of a relief carving showing the Battle of Til-Tuba with the Assyrians driving the Elamites into a river. From Nineveh (in modern Iraq). c. 660–650 BC. Department of the Ancient Near East.

Bahram V, holding a lion cub in one hand whilst defending himself with his sword from attack by a lion and lioness (fig. 83).[7] In all these cases the deeds are shown being acted out exclusively by royalty. The other scenes in the Assyrian reliefs do little to diminish the sense of satisfied achievement. Thus all battles are won and both territory and conquered peoples move immediately under the benign rule of Assyrian kings. Indeed, who would not wish to be Assyrian? In the scenes illustrated in the reliefs, it is only the opposition, like the lions, who meet a bloody end; loyal soldiery is guaranteed longevity.

The most complex relief of this sort comes from Sennacherib's palace at Nineveh and is dated to around 660–650 BC. It shows the decisive Battle of Til-Tuba, the engagement which saw the Assyrians under Ashurbanipal rout the Elamites. The reliefs have a narrative structure, moving from left to right in successive horizontal bands. They show the well-equipped Assyrians in chariots and on horseback supported by helmeted infantry as they confront an ill-protected Elamite army armed only with bows and arrows in close-quarter combat. The Elamites begin to give way and eventually take to full-scale retreat until they are finally driven into a river (fig. 84). A successive scene shows a triumphant and contented procession of people

emerging from an Elamite city to welcome Ashurbanipal's appointment as ruler. He is escorted by Assyrian troops and presented to his new subjects. Meanwhile, in the river below, the remnants of the battle can be seen, with dead Elamite soldiers floating in the waters alongside the fish.

The attention to detail may derive from a practice of artists drawing on scrolls in the field and transferring their impressions to later sculpted forms. But this does not prevent the historical narrative from being essentially allegorical. Kings, the principal priests of the god Ashur, were concerned to commit their reign and their deeds to the remembrance of posterity. There are some free-standing individual portraits known, such as that of Ashurnasirpal from the shrine of Ishtar at Nimrud (fig. 85), and there may no doubt have been others which are now lost. However, tableaux of the ruler in the thick of things and always winning through give a consistent official account of their achievements. This is memory with no downside.

The underlying purpose of the Assyrian reliefs differs from that of the war memorials which through the late nineteenth and twentieth centuries have become familiar all over the world. The Assyrian reliefs are centred on the glorification of the ruler to the exclusion of the commemoration of the loyal soldiery lost in the conflicts: in the reliefs it is enemies who die. They are about memory on the way to mythologising. This contrasts with memory which is still rooted in the documentary, committing to collective memory events which affected the whole community.

Among some native North Americans single images which built up into a pictograph known as a 'winter count' were created on an annual basis to refer to events or whole episodes. These were painted onto animal skins building up a series of images, each with specific historical reference. In theory one image is selected to stand for each year that passes. These might include reference to unusual celestial events, the spread of smallpox or other disease, battles and the deeds of warriors, and the death of an important person. For instance, a Yanktonai (or Nakota Sioux) winter count in the British

85 Stone statue of the Assyrian ruler Ashurnasirpal II (883–859 BC). From the shrine of Ishtar, Nimrud (in modern Iraq). H. 113 cm, W. 32 cm. Department of the Ancient Near East.

86 Yanktonai winter count
with a series of historical
pictographs. Sitting Bull is pictured
on the left inner register and,
viewed in the same direction as
the standing figures, appears seated.
Sioux, Native North America.
1785–1901. L. 112 cm, w. 90 cm.
Department of Ethnography.

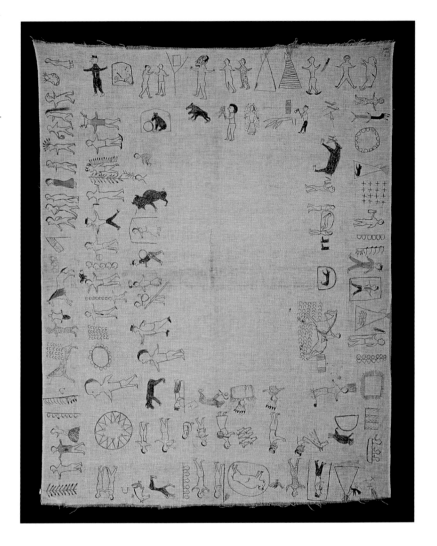

Museum has 119 pictographs and covers the years 1785 to 1901 (fig. 86). It includes an image of a seated buffalo which is understood to refer to the winter of 1890–1, the year Sitting Bull was murdered.[8] This is not the victorious Sitting Bull of Wounded Knee; it is a record of ignominious death at the hands of a native policeman.

Remembering and Forgetting

If various kinds of visual tableaux act to promote positive remembrance of the past, it is appropriate to end this chapter by looking briefly at the opposite activity, that of erasing memory. How is forgetting important to remembering? There is a sense in which too rich or retentive a memory is as incapacitating as one which is too fugitive. In his short story 'Funes the Memorious', Borges writes of the luckless Funes falling off a horse and getting a knock on the head such that, rather than forgetting everything, he finds he can remember everything that has ever happened to

him. He thereby loses the capacity to generalise and suffers overload. He needed to forget, both to achieve coherent recollection and to be able to draw lessons from experience.

Yet if it does not occur of its own accord, forgetting is not straightforward to engineer. As thinking about going to sleep impedes falling asleep, so trying to un-think something has the effect of drawing attention to it – and, still worse, it may thereby end up rendering the recollection unforgettable. Something similar happens with objects. One of the most evocative documented instances of seeking to erase memory in antiquity is recorded by an otherwise sober commentator, the Roman senator Pliny the Younger. He describes the fervour with which the memorialising portraiture of the hated emperor Domitian was destroyed: 'It was our delight to dash these proud faces to the ground, to smite with a sword and savage them with an axe as if blood and agony follow from every blow. Our transport of joy, so long deferred, were unrestrained; all sought a form of vengeance in beholding those muti-lated bodies, limbs hacked to pieces, and finally the baleful, fearsome visage cast into the fire to be melted down.'[9] The description is not written in terms of destroying a statue but of killing a person. The spirit is that killing statuary erases memory. The evidence, however, is that forgetting is rarely so definitive.

One of the most dramatic acts of attempted erasure of recent years was the destruction in early 2001 of the two colossal Buddhas in Bamiyan province in Afghanistan by the forces of the Taliban. It is thought that the Buddha figures had been cut into a hillside of solid sandstone rock between the third and fifth centuries AD. Their destruction followed an edict issued by the Taliban leader Mullah Mohammed Omar against non-Islamic 'graven' images.

It was at once an appalling and an ironic act: it was appalling because the Buddhas had commanded a long valley through the Hindu Kush and the Koh-i-Baba moun-tains standing above an oasis town. For centuries they had dominated a section of the old Silk Road that had linked the civilisations of China to the expansive Roman Empire. It was also ironic because the Buddha too was opposed to such imagery and forbad images of himself to be made other than as reflected in the ripples of a pool. When images of the Buddha were eventually created it was ostensibly to remind followers of their own approach to a Buddha-like state of being, about the potential within each devotee to attain a state of Perfection. However, even if the Buddha rejected idolatry, the figures of him represented an affront to fundamentalist Muslims. Equally important, they were part of the traditional heritage of an opposi-tion stronghold within Afganistan, even though the inhabitants of the province of Bamiyan may not themselves be Buddhists in contemporary times.

Yet the irony is double, for the destruction of the Bamiyan Buddhas created absence, and in absence memory finds its most impassioned and most fertile ground. Oddly, the lack of the Buddhas has made them the more memorable and, inevitably, with a new regime, moves are afoot amongst Muslim Afghanis to reinstate the figures once again. Such acts are of course familiar from the toing and froing of contemporary politics where changes in government can involve the toppling not

87 Silver shekel of the second Jewish revolt against the Romans (AD 132–5). It is made from a restruck Roman coin showing the Temple at Jerusalem destroyed by the Romans in the catastrophic first Jewish revolt (AD 66–70). This memorial of the lost focus of Jewish devotion was deliberately intended to obliterate the Roman emperor's image. D. 26 mm. Department of Coins and Medals.

just of rulers, but of their associated statuary. As Forty points out, when fifty monuments to Lenin were removed from the streets of Moscow, fifty empty pedestals were left; and above each the void was much more noticeable than the sculptures which once sat there largely unremarked.[10]

A much more effective strategy of ensuring something or someone is forgotten is to leave the image intact, but remove any associated script. Rendering anonymous may be a more subtle means by which to ensure ultimate forgetting than dramatic acts of destruction. We have seen above the significance attached to names, their inscription and the reading of them on monuments in ancient Egypt. Yet, inscription and the identification of generic images with individuals by a written attribution to their memory likewise exposed them to forgetting. The erasure of a name from an object or inscription simultaneously annihilates their memory and thereby the evidence of their personhood. There are many examples. The most systematic erasure occurred during the reign of King Akhenaten (1353–1335 BC) when large-scale religious reform was under way. Subsequently, in reaction to these same reforms, King Akhenaten's name was itself removed both from monuments and from other state records. When such erasure occurred a person's name could also be removed from royal genealogies and the period of their reign accommodated by the dates of the reigns of others being adjusted to fill the gap. In ancient Egypt the game of memory was an extremely fickle one. Even if supplanting memory was not the point, and removing identifying inscriptions was not at issue, entire obelisks were sometimes walled in, an act of total eradication of memory on the out-of-sight out-of-mind principle.

This fear of the destruction of a well-constructed memory sometimes eventuated in pleas and warnings to future generations not to tamper with inscriptions and monuments. In ancient Persia there is more than a hint of pleading in the epithet Cyrus had placed on his tomb at Pasargadae: 'Mortal! I am Cyrus son of Cambyses, who founded the Persian Empire, and was King of Asia. Grudge me not my monument.' Cyrus, perhaps, had more reason than most to hope that future generations would not treat him badly, as he had himself been instrumental in restoring images of Babylonian gods to their appropriate shrines when he added Babylonia to his empire.[11] In Assyria, Sennacherib expressed the ambition that his own memory would be secure in the hands of his successors and that they in their turn would honour his memory through appropriate ritual acts: 'In days to come, when these walls become old and begin to decay, let the ruins be restored by whichever of my descendants has been chosen by Ashur as shepherd of the land and people. Let him find the inscriptions which record my name, anoint them with oil, offer a sacrifice, and restore each of them to its place.'[12] Restoration of the reliefs would secure the restoration of his memory.

There remains one final strategy of forgetting, which is perhaps the most resonant of all – sacrilege: the remembrance not of persons, nor of events judged to be significant, but of deliberate attempts to desecrate memory itself. Again this is an ambiguous act. Had those assaulting Lenin's image lopped the head off the imposing

figure, yet left the body intact – rather than toppling the whole statue from its plinth – the result would have been different. From the perspective of memory, what would have remained would have been a potent 'body' of evidence of the act of erasure, and not a failed attempt at arranging historical oblivion. Freud understood well the potency of that remnant of memory which lay beneath the functioning of the conscious mind, memories neither fully formed nor yet definitively forgotten. These were memories in limbo: memory as a lingering sore, stranded between routine recollection and total forgetfulness. Their recall through dream, or through recounting on the psychiatrist's couch, was the means of reconciliation. Thus rescued from the unconscious, the turbulent memory could be laid to rest: it could either be confronted or forever dispelled, and finally forgotten. Either way, it was dealt with. But sacrilege, as an act of attempted erasure, remains a running sore, trapped between remembering and forgetting.

The story of the head of the Roman emperor Augustus now in the British Museum is perhaps one of the most dramatic instances of both bold commemoration and this dismissive attempt to erase memory (fig. 88). Its precise history is not completely known. It seems to date from about 27–25 BC and is thought to have been made and originally set up in Alexandria during the period of the Roman occupation of North Africa. The head itself is in cast bronze with inlaid alabaster, glass and coloured stone eyes. It is larger than life-size and clearly was once part of an imposing sculpture asserting the authority of Roman rule over a significant part of North Africa stretching inland from the Mediterranean coast. It was found, however, in excavations at the site of the Temple of Victory at Meroe in the northern Sudan, where it was discovered beneath the threshold of the building. It appears to have been carried off by warriors raiding deep into Roman Egypt and not so much celebrated as a trophy of war, as buried in an act of disavowal and insult. Captured prisoners, bound and submissive, were painted on the steps. Walking over the head to enter the building, for as long as its unseen presence was remembered, was perhaps an act of desecration – but it was one destined in the end to lead to inevitable forgetting.

Yet what remained of Augustus's memory in Alexandria? At this distance of time we cannot absolutely know the answer. The figure from which the head came may well have been dislodged from its place of prominence and splendour. It is not clear if what remained of the figure was toppled into the harbour, left to lie on its side – or even remained for all to see as a headless presence on a plinth. Each scenario represents an option between the extremes of effective remembrance and eternal forgetting. As remembrance, perhaps, it is the act of sacrilege which is the most potent image that comes down to us from antiquity. However, the irony of it all is that archaeology, short of recovering the act of sacrilege in Alexandria, alighted on the dissevered head in Nubia. In its current resting place in its exhibition case in the British Museum, it is only its original context as one of the grandest and most evocative representations of Augustus that can now be asserted. In antiquity, remembrance and forgetting may have been more intricately intertwined.

88 Bronze head of Augustus, taken from a larger-than-life statue and found at Meroe, Sudan. c. 27–25 BC. H. 47.75 cm. National Art Collections Fund. Department of Greek and Roman Antiquities.

Holy Relics and Memorabilia

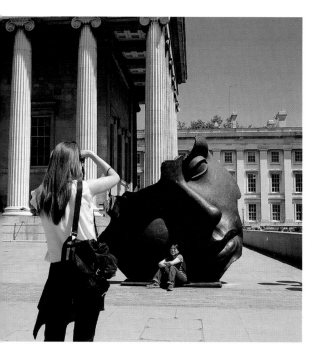

89 Visitors to the British Museum in summer 2002, having a commemorative photograph taken in front of a bronze head by Igor Mitoraj.

In 2000, a large, dark bronze head by the German-born artist Igor Mitoraj was installed in the forecourt of the British Museum. It is the only non-architectural object that can be seen outside the building. It had originally been created in 1991 and was first shown in the British Museum forecourt between December 1994 and February 1995 during an exhibition of contemporary work entitled 'Time Machine' inspired by objects from antiquity. It was subsequently donated by the artist. The work is known under the title 'Tsuki-no-Hikari' (Moonlight), its Japanese title being a reference to another version of this work which is in the sculpture park at Hokkaido in northern Japan. The allusion is itself a happy coincidence. On its re-installation in the British Museum, it became a popular place for a commemorative photograph to be taken. For visitors from the Far East it was in the ideal position. It framed the group or individual to be photographed with the portico of the Museum beyond. Those who have travelled in Japan will be especially familiar with this form of memorialising. Shrines and temples typically have benches, and even a frame available in front on which to put the current date. Here group photographs are taken to authenticate the visit undertaken. Official photographers abound to arrange more formal photographs. The snap is a *kinen shasin*, a memorial photograph. Its origins go back to the stamping of clothing or visit books to record the completion of pilgrimage. The British Museum has unwittingly provided a secular version of a means of authenticating a religious visit. The Mitoraj sculpture provided a site at which we could see memory in the making, something for the photograph album in which its image will be poured over later and the visit to a foreign place of pilgrimage recollected. Beyond this memorialising site lies the museum itself, its collections – and its souvenir shop.

In this chapter we deal with memorabilia, with objects brought back from other places, or brought forward from other times. In a modern context, mementos are the most familiar example of the former, and photographs the focus of the latter. In both cases, the concern of memory is with objects which often raise feelings and emotions, but which lack the intensity and devotion of many of the objects brought back in historical times from religious shrines and places of pilgrimage. Today, like the memorial photograph of the Far Eastern tourist, Western pilgrims return with

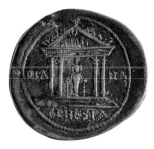

plastic-coated badges, which have no deeper religious significance, as records of visits to holy places. Yet, like pilgrims of old, they may also bring back holy water or other curative material to give continuance to the healing presence of the pilgrimage site. This intertwining of the empowered, meaningful object and the nostalgic memento points to an element of convergence of the pilgrim and the tourist in contemporary circumstances. Yet pilgrimage is the abiding underlay. If asked to dispose of the curative water or the pilgrim badge, the devout would surely choose to retain the former. We begin, therefore, by looking at pilgrimage.

Pilgrim sites

Pilgrimage, like the secular tourism of modern times, implies travel – but it has rarely been a comfortable process. Indeed for devotees, pilgrimage usually involves making lengthy journeys marked by self-sacrifice and suffering, travel whose very hardships are themselves indicative of the depth of the pilgrim's qualities of devotion. In both the Islamic and Christian traditions, the primary sacred sites are for most followers

90–1 Roman silver coins showing the temple and statue of the goddess Diana (Artemis) of Ephesus, an important ancient pilgrim site. When St Paul attempted to preach Christianity there it caused a riot amongst craftsmen whose images of the goddess 'all Asia and the whole world worship'. (Modern Turkey). Second century AD. D. 26 mm (both). Department of Coins and Medals.

92 Shibata Zeshin, 'Pilgrims on the slopes of Mount Fuji'. Japanese. 1880. H. 19.3 cm, W. 16.8 cm. Department of Japanese Antiquities.

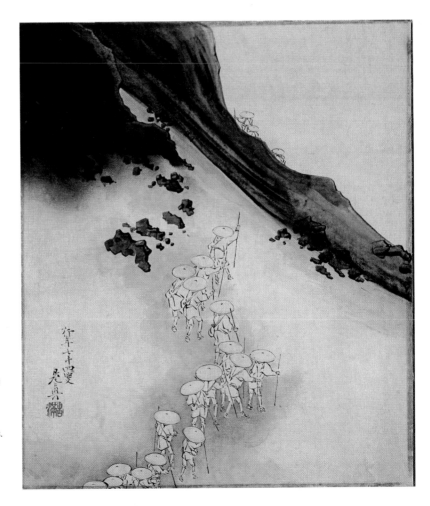

in distant places. For Jews the fact of a lengthy history of exile implies returning to the sacred places of Israel. But even local acts of pilgrimage often require enduring considerable self-induced hardship such as traversing the Pilgrim's Way in southern England, ascending Croagh Patrick in Ireland, or climbing the sacred Mount Fuji in Japan (fig. 92). If the journey is less demanding, devotees often make it more so by, for instance, undertaking it barefoot.

For Muslims the Koran itself specifically recommends the *hajj*, the annual pilgrimage to the holy city of Mecca, as one of the five pillars of the faith. For Buddhists four places of pilgrimage were prescribed by the Buddha as sites associated with the most significant events in his own journey to Perfection. In Hindu faith a ranking of sites of pilgrimage is less evident. The great Hindu epic, the *Mahabarata*, recommends a process of wandering from site to site rather than a single defined act of pilgrimage. Some places, however, notably Benares on the banks of the holy river Ganges, associated with the God Shiva have long histories of mass pilgrimage. For Sikhs the Golden Temple of Amritsar and the pool in which it is set remains a primary place of pilgrimage. For Christians the site of Golgotha, where Christ was crucified, and the tomb, the site of the Resurrection, are the most potent places of pilgrimage amongst many in the Holy Land and indeed elsewhere in the world.[1]

All such sites evoke the collective memory of devotees through sacred acts associated with them. Memory is a profound part of the process. For potential pilgrims the accounts of previous members of the faith who have completed the major act of penitence relayed in narratives of the journey itself, of things endured and of the unforgettable, perhaps healing, experience of the sacred places visited, are intensely motivating. The things brought back by returning pilgrims recall the sacred journey successfully fulfilled and help lodge the experience as a permanent remembrance. Indeed, to the extent that some may have amuletic qualities, they may keep the memory alive in a physical and not just an imaginative sense. It is these objects on which we need to focus here.

Christian Pilgrimage

For Christian pilgrims the Church of the Holy Sepulchre (or Church of the Anastasis, the Resurrection, to use its Greek name) in Jerusalem has been a major place of pilgrimage since the fourth century when the eastern and western parts of the Mediterranean were united under the Christian rule of Emperor Constantine. Saint Helena, the mother of Emperor Constantine, visited Palestine in 326–7, and was responsible for the refurbishment of many pilgrim sites in the Holy Lands themselves (in addition to her donation of a copy of the gospels in Greek on gold vellum to the cathedral which once occupied the Parthenon building in Athens). The construction of the Church was begun the year before her visit, under the joint patronage of her and her son, to enclose the site of Golgotha and the Anastasis, the reputed tomb of the Resurrection. It subsequently had a chequered history being burnt by the Persians in the seventh century and razed to the ground by the Muslim Caliph al-Hakim at the start of the eleventh century. The Anastasis rotunda was

rebuilt at the end of that century and subsequently extensively renovated and reconstructed by the Crusaders. In addition to the sites themselves, many relics or objects with specific New Testament reference adjudged to be authentic were housed there. Thus the Holy Sepulchre is recorded in the sixth century as containing the True Cross, the lance with which Christ was struck, the plate on which the head of John the Baptist was presented and the horn with which David was anointed king. Elsewhere in Jerusalem the Crown of Thorns and other religious relics were to be found (see pp. 122–3).[2]

Pilgrims from the eleventh century onwards brought home with them a variety of souvenirs. Many had, or later acquired, inherent healing powers. Amongst the most popular were small vials of oil which had touched the True Cross, ampullae containing water from the River Jordan, boxes of earth from sacred tombs, and so forth. In *The Decameron* Boccaccio satirised the tradition of the pilgrim's souvenir by having a penitential monk return from the Holy Land bearing a small bottle containing the sound of the bells of the temple of Solomon. Sites themselves were also depicted in pilgrim memorabilia. Thus the Church of the Holy Sepulchre featured in the roster of pilgrim memorabilia. Byzantine souvenirs included images of the Church, whilst by the late seventeenth century ornate three-dimensional scaled models of the building were being produced and were preserved in European aristocratic collections of the period. An excellent example, which neatly meets the criteria of souvenirs outlined above, is included in the British Museum's Sloane collection. It is in olive wood with mother-of-pearl inlay (fig. 93). There are a number of other examples known, all attributed to the late seventeenth or early eighteenth centuries, and generally identified as coming not from Jerusalem but from Bethlehem.[3] One is said to have been taken to Russia as early as 1651. A particular feature of these replicas is that the outer architecture is removable revealing the interior configuration of a site which, within its massive enclosure, encompassed the most major sites of the story of the

93–4 Wood, ivory and mother-of-pearl models of the Church of the Holy Sepulchre, Jerusalem. Made in the Levant for pilgrims. Late seventeenth/early eighteenth centuries. L. 7.9 cm, W. 5.9 cm (left); L. 48 cm, W. 27.5 cm (right). Department of Medieval and Modern Europe.

The Holy Thorn Reliquary

Reliquary made to house a relic from the Crown of Thorns which was placed on the head of Christ at his Passion, before the Crucifixion. The spine of the thorn itself is visible in the rock crystal window in the centre of the reliquary. From Paris, France. c. 1405–10. H. 30.5 cm. Waddeston Bequest. Department of Medieval and Modern Antiquities.

This object is an evocation of the story of Christ and the Last Judgement which is the context for the thorn displayed at the centre of the reliquary. Within the central scene are the Virgin Mary (to the left), St John the Baptist (to the right) and Christ himself at the centre.

Around the outside are shown the twelve apostles (above right) with God the Father at the top. At the bottom angels trumpet the dead rising from their tombs (above). The reverse of the reliquary has doors with images of St Michael and St Christopher (right) which leads to a small, now empty compartment that may also have housed a holy relic. The reliquary was originally in the collection of Jean, Duc de Berry (d. 1416).

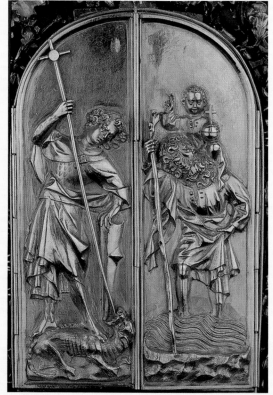

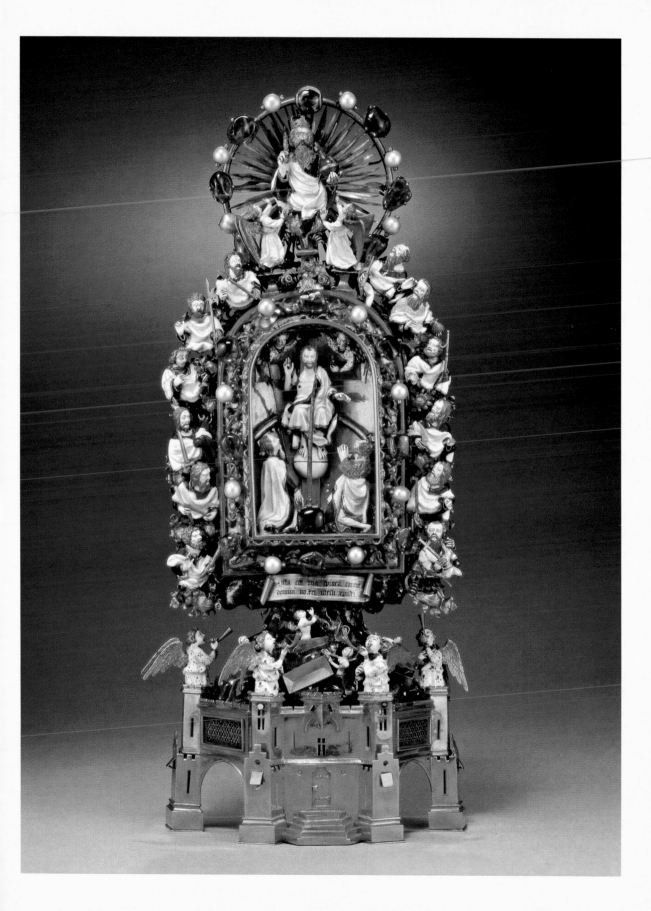

Crucifixion and the Resurrection. Subsequent additions included sacred tombs and other points of pilgrimage. If in a reduced form, the replica of the Holy Sepulchre sought to represent the intense focusing of sanctity through accurately reproducing the holy sites within the real building itself. It is intriguing that, although created initially as souvenirs, the models themselves have become historical records and have been used to interpret the configuration of the building in the seventeenth and eighteenth centuries.

As the story of Christianity developed from its origins in Palestine, through its promotion in the lands of the Mediterranean, and, via the expansion of a Roman Empire converted to Christianity, to western Europe and eventually beyond, many other sites of Christian pilgrimage arose. In medieval times Rome itself emerged as a major pilgrim attraction. Here were to be found the tombs of Saint Paul and Saint Peter, and parts of the sacred elements dispersed throughout Palestine – for example, places where wooden fragments of the True Cross itself were kept. In the western reaches of Christendom, Santiago de Compostela developed as a remote holy place on the back of a claim that the body of Saint James was buried there, though, as Coleman and Elsner argue, its popularity may have had more to do with its proximity to the Moorish expansion into southern Spain at a time when Christianity and Islam were locked in aggressive conflict.[4] Saint James was transformed from the gentle fisherman with broad-brimmed hat and staff familiar in depictions elsewhere into a mounted knight with sword and cross.

Although fragmentary relics were dispersed from sites of pilgrimage as gifts, others were removed in a more furtive manner by light-fingered visiting monks. As far back as the Dark Ages such activity was regarded almost as approved practice rather than a dereliction of the priestly calling. It was known as *furta sacra* (pious or sacred theft). After all, it was argued, the saints whose relics they were would hardly permit the removal of their remains if they did not approve.[5] The most renowned example of such stealth was the theft of the complete body of Saint Mark from Alexandria and its transportation to Venice in 828. The images of the lion of Saint Mark associated with Venice hold a book bearing the text 'Pax tibi, Marce, evangelista meus. Hic requiescet corpus tuum' ('Peace be with you, Mark, my evangelist. Here shall your body rest'). These are said to be the words of an angel welcoming Saint Mark, divine approval of the tomb-robbing which led to his posthumous travels. The original Basilica San Marco was built to enshrine the saintly remains, and his arrival in the city state led to him usurping the position of the Byzantine patron of Venice, Saint Theodore. As the new Venetian patron saint, his relics were taken round the city in solemn procession every year. By such acts of appropriation innovative collective memory was established in distant places. The veneration of saints was crystallised through installing relics and creating new saintly cults.

Particular places where exceptional acts of healing or martyrdom occurred developed their own more local or national focus. In Britain no other site acquired the popularity of Canterbury. Its story is well known. Originally laid out by the Romans, it is one of only two places in Britain where the site of a known Roman church is

still a church today. The original church of St Martin's was reopened by Saint Augustine when he arrived in Britain in 597, and Saint Augustine is of course himself buried in Canterbury, at the College which is now named after him. However, its primacy as a site of pilgrimage derives from the martyrdom of Saint Thomas Becket in 1170 within the church on his way to celebrate Mass at the altar (fig. 95). The cult that grew up around him started almost immediately with stories spreading of miracles deriving from contact with cloth said to have been dipped in his blood by the faithful who witnessed the event. In 1171 a London-based priest claimed to have been cured of paralysis by drinking water said to have contained a drop of Becket's blood. Water might be sanctified by being in contact with a relic or reliquary associated with Becket and was widely sought after as a miraculous cure. Becket was quickly canonised (by 1173), and by 1220 a shrine had been established in what was then the newly built Cathedral, the original church having been burnt down. It remained a major site of popular pilgrimage, despite the destruction of the shrine itself in 1538 by Henry VIII during the period of the Reformation. Part of the motivation for its destruction was also to erase the memory of a signal act of royal humiliation as Henry II came to Canterbury four years after the martyrdom and walked barefoot through Canterbury being whipped by monks in penitence for a martyrdom in which he was implicated.

The routes traditionally taken by pilgrims to Canterbury are known as the Pilgrim's Way (though in fact there are thirteen such routes identified in Britain if other destinations are included), one leading from Winchester, the other from Westminster. Travellers along these paths may not all have had the diverting company of Chaucer's fictional companions, but they did at its end have access to one of the great sites of medieval devotion. The pilgrims were mostly British and French, Becket being of Norman descent and having studied in Paris in his youth.

95 Alabaster panel with a scene from the martyrdom of St Thomas Becket. Although carved as long as 300 years after Becket's murder, such pieces were still produced and exported all over western Europe for incorporation into church altarpieces. British. *c.* 1450–1500. H. 37.2 cm, W. 25.1 cm. Department of Medieval and Modern Europe.

What pilgrims acquired on their journeys, in addition to spiritual uplift, were memoriae of varying degrees of sanctity. Perhaps the most familiar were the so-called Canterbury tokens, mass-produced at this, as at similar sites elsewhere in Europe, and within the reach of the pockets of most pilgrims (fig. 97). These were usually made of lead with the sign of the saint or in Becket's case also of the shrine itself, stamped on them. On the return of the pilgrims to their home parish the badges were often dedicated in their own local church – what began as a souvenir of the journey became a small popular relic in its own right. Some even acquired healing powers. John Cherry tells the story of the Frebrygge family in the City of London.[6] They had a Canterbury badge with Saint Thomas's image on it. In 1486 their child who was then nine months old and teething had the badge put in his

96 Silver-gilt girdle with heraldic shields, inscribed with place names on the Pilgrim's Way from Winchester to Canterbury. In the centre is St Christopher carrying the infant Christ, whilst the tail-piece shows St Thomas Becket. By Omar Ramsden. 1916–26. L. 104.2 cm. Department of Medieval and Modern Europe.

mouth by an older boy to calm him. 'And anon,' as Cherry quotes, 'since children love swallowing things, he had no sooner got it in his mouth than he would have it in his belly.' However, the coin got stuck in the child's throat and he began to choke to death. 'In unimaginable alarm and anxiety' the family appealed for divine intervention and that of 'the most noble King Henry [VI] that death might not overtake the child', whereupon, miraculously, the child coughed up the badge and all was well. The father immediately set out for King Henry's tomb at Windsor to give thanks – and not least to deposit the offending badge at the shrine as a votive offering. 'There he might have bought a pilgrim sign of Henry VI, but', Cherry concludes, 'we hope he kept it away from small children.' Given the brush with royalty

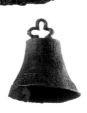

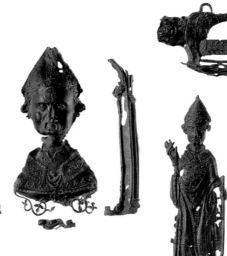

97 Selection of medieval lead-alloy pilgrim tokens associated with the shrine of St Thomas Becket at Canterbury Cathedral, where he was assassinated. English. Fifteenth century. H. of sword 12.4 cm. Department of Medieval and Modern Europe.

which led to Becket's assassination, this redressing of the hierarchy of pilgrim tokens has additional poignancy.

As in the Holy Lands, saintly sites in Europe offered a range of ampullae, waters, oils and soil from tombs. Amongst the most potent acquisitions were actual or presumed relics. Becket has no single identified resting place. His relics were quickly dispersed, divided up and given to allies and pilgrims to be enshrined in reliquaries at churches of which he became the patron saint. A significant business developed in making caskets to hold such relics. Large numbers of reliquary caskets were made at both Canterbury and, in enamelled form, at Limoges in France (fig. 98). These depicted the details of the martyrdom of Saint Thomas and the ascent of his soul into heaven, in the same way as stained-glass windows in churches dedicated to his name illustrated the same events. His veneration and memory was thereby perpetuated well beyond Canterbury. The number of Becket caskets that were created is testament to the extent to which his relics were distributed, but, as time went on, mixtures of relics associated with different saints were often placed in the same caskets. These reliquaries took a variety of forms, some taking their shape from the nature of the relics within. They might be shaped like arms, hands, fingers, feet, toes. Among the most dramatic were heads which were accorded an additional significance in that they made the departed saint present in both representational and personalised form. Like the Basle reliquary in the British Museum dated to the early thirteenth century (see frontispiece), many emanated from Switzerland and may or may not have contained the skull or a fragment of the skull of the saint with whom they were associated.[7]

The portability of these caskets allowed the relics to be taken to other churches and their sacred powers to be exploited more thoroughly than the practice of sanctifying pilgrim badges brought back by returning devotees. Relics guaranteed the

presence of a saint whereas the badges were largely tokens. They were therefore regarded as having the most exceptional healing powers and were not only the focus of liturgy in formal Christian service, but were also exploited for a variety of secular purposes from the swearing of oaths to the resolution of disputes, and even for purposes of monastic fund-raising.

The healing power of the memento is not limited to

98 Copper-alloy and enamelled reliquary depicting the Adoration of the Magi. From Limoges, France. c. 1200. H. 13.6 cm, L. 137 cm, W. 6.5 cm. Department of Medieval and Modern Europe.

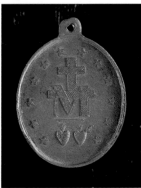

99 The Miraculous Medal,
based on a design seen in a dream
by Catherine Labouré in 1830.
French. H. 39 mm, W. 29 mm.
Department of Coins and Medals.

medieval or Renaissance times. Well into the nineteenth century so-called 'miraculous medals' had immense popularity.[8] They originated in France where their original maker, Adrien-Maximilien Vachette, produced over 2 million of the medals between 1832 and 1836, though even that huge output failed to keep pace with demand. Other factories also producing them were to be found in Italy, Belgium and England. By 1836 the medal had spread to America, by 1837 to Poland, by 1838 to Russia and China and by 1839 it was circulating in Abyssinia (Ethiopia).

The medal pictured here commemorates not a place of pilgrimage but the visionary experience of a novice French Sister of Charity, Catherine Labouré, in 1830 (fig. 99). In one of a series of apparitions she beheld a vision of a medallic design focused on the Virgin with the promise that it would have healing and protective powers for the faithful:

> After a while an oval frame surrounded the Blessed Virgin, on which were written in letters of gold, the words: 'O Mary, conceived without sin, pray for us who have recourse to thee!' ... I heard a voice, which said to me: 'Have a medal struck according to this model. Those who wear it will receive great graces especially if they wear it around the neck. There will be graces in abundance for all who wear it with confidence.'[9]

The Miraculous Medal thus designed in a vision showed, on the obverse, the Virgin standing on a globe with a serpent beneath her feet and a plain halo around her head. A text contains the promissory graces: in the English version, 'O Mary, conceived without sin, pray for us who have recourse to you'. On the reverse, again as specified in the vision, is a strange sign, a cross surmounting a letter M with a bar across it and beneath, the heart of Jesus surrounded with thorns beside the heart of Mary pierced with a sword.

The visionary experience of Catherine Labouré was kept secret until after her death, but the mysterious appearance of the medal was associated with rumours of its divine origins in an apparition and soon it was credited with miraculous effects, healing of the sick and conversion to Catholicism. It received royal approval when Louis-Philippe of France and his two children took to wearing it, and was taken by the Sisters of Charity on missionary visits overseas.

Here the common modern understanding of the souvenir is challenged. Modern souvenirs have an in-built redundancy. They are not supposed to do anything, have any particular function, or make anything happen; they are not supposed to have cultic significance. Or rather, what might initially be no more than a token or memory of a visit, albeit one inspired by deep religious desire, might later become an object attributed medicinal, magical or sacred powers. Its initial function, however, was, like a passport stamp, to register the fact that the visit was made. Recent pilgrim mementos conform more completely to this model. These are no more than badges, usually with a standard image depending on the pilgrim site – Lourdes, Loreto, Knock, for example (figs 100–103). They often show Our Lady in profile and to that extent follow the commemorative conventions of the medallic tradition,

adapted to modern techniques of mass production. When a group has made a pilgrimage together they may have the name of the group added to the badge to personalise the commemoration. There is, however, no sanctity attached to the badge, as could accrue to older pilgrim tokens.

 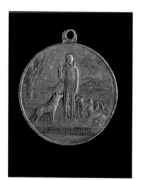

100–103 Four pilgrim badges sold as mementos to visitors to the Christian sites associated with Our Lady of Lourdes, of Walsingham, of Knock and St Francis of Assisi. Twentieth century. Various dimensions. Department of Coins and Medals.

Pilgrimage in Other Faiths

In the Muslim faith, as mentioned earlier, there is a clear priority attached to the *hajj*, the annual pilgrimage to Mecca. Unlike other faiths, it is incumbent on those followers who have the means and the physical ability to go on the journey of pilgrimage – it is a requirement and not an option. Yet tangible souvenirs and mementos of what for many is an epic pilgrimage are much less evident amongst Islamic pilgrims than members of many other faiths. Indeed the acknowledgement of a divine edict fulfilled is less in the form of a physical remnant of the sacred site of the visit as perhaps of drawings made retrospectively of the journey on the pilgrim's return – illustrations of camel caravans on the walls of domestic houses, for example. Those who have undertaken the demanding journey to Mecca may adapt their name to include El Haji in their title as an acknowledgement of their successful completion of

104 10 rupee banknote issued by the Bank of Pakistan but overprinted for use in Saudi Arabia by Pakistani Muslims on the *hajj*. Twentieth century. L. 14.5 cm, H. 8.2 cm. Department of Coins and Medals.

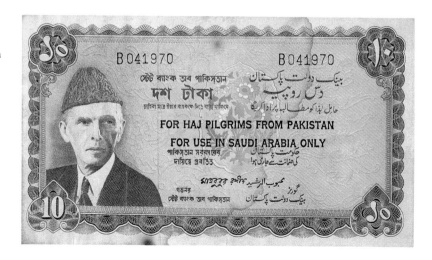

the divinely ordained mission. There are, however, rather rarer examples amongst Muslim sects of practice familiar on the pilgrim trails elsewhere. Thus, many Shi'ite shrines offer the faithful prayer stones in the form of shaped clay discs which act less as memorabilia and more as a spur to prayer.

Hinduism is a multi-layered faith. The kind of consumption of religious souvenirs which is a part of Christian traditions of pilgrimage is not readily accommodated to some of the central ideas of Hindu belief. Thus, it is widely understood that a condition of outward austerity and renunciation is an expression of inner spiritual strength. The idea of pilgrimage is one of travelling without unnecessary encumbrance, the better to cultivate the gifts of meditation. The souvenir as 'possession' is at odds with the notion of self-denial. Furthermore, although pilgrim sites do certainly have specific association with divine presence, their fixity in a particular location is more ambiguous than we have seen above. Gods associated with separate shrines are firmly located in space, yet their spiritual presence is everywhere. Benares, the residence of the great male deity, Shiva, is one of the holiest sites in India and neatly encapsulates the subtleties. It is at once the city of light, the place where the sanctity of all others is condensed and assembled; a journey around Benares is a journey around the whole of India, for the whole is encompassed in the part. Visiting the places of pilgrimage in Benares is believed by many to be the equivalent of one of the most arduous of all pilgrimages still undertaken today. This is the pilgrimage along a route followed by barefoot devotees which includes shrines at the four cardinal points of the Indian subcontinent (the *dhamas*). These are located at Badrinath in the Himalayas, Puri in the east, Rameshvaram in the far south and Dvaraka on the west coast. A tour of Benares is in a sense a tour of the Hindu cosmos, a point made by the temple dedicated to Mother India, Bharat Mata, where the central icon is not an image of deity in anthropomorphised form but rather a large sculpted map of the subcontinent. Yet Benares, as well as being the quintessential place of pilgrimage in its own right, is also present in concept in many other places. It is refracted symbolically at numerous other sacred sites.[10] This distributed sense of holy space qualifies the significance of any individual site.

In a sense, Hindu pilgrimage is more tenuously associated with memory than we have seen to this point as it is more about things made present than the remembrance of things past. The common experience of Hindu pilgrimage is one of absorption into the person, in part literally by absorption into the body, of substances imbued with the presence of the deity. As elsewhere, pilgrims bring home holy water which may be used to sanctify domestic shrines, but otherwise the consumption of food and liquid, the use of ash and flowers combine to instil in the devotee the beneficial effects of the enhanced access to deity which places of pilgrimage make possible.

Yet, much depends on the site.[11] Clearly a conception of deity without a known physical form defies our expectation of personalised memory working through largely visual means of recollection. There are, however, specific places where images of individual deities have been accepted and are uniquely resident. An example is Puri where an image of Krishna, otherwise not found in a pan-Indian context, is

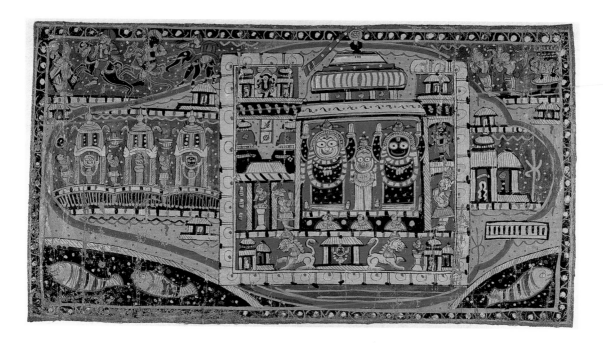

105 Hindu pilgrim painting
of the temple of Jagannatha at Puri,
Orissa. Indian. Twentieth century.
H. 36.5 cm, W. 69 cm. Department
of Oriental Antiquities.

located. Where such anthropomorphic images are found, particular significance is associated with eye-contact, *darshan*.[12] The gaze of the pilgrim meeting that of the deity is auspicious and desirable. This is the case despite Hindu belief that identifies sacred energy not with the image itself but, ultimately, with the deity which, through an act of correctly performed ritual, comes to be present in the image. It is a power at one remove from the source. None the less it is sufficiently effective as a means of concentrating and focusing the devotee's relationship to the deity that it becomes an identifiable source of divine potency. And thus, as in Christian iconography, reproduced representations of deities, especially those with a single place of residence and resulting uniqueness as an image, may be taken away by pilgrims. These were in the past largely in painted form but latterly have been mass-produced as prints (fig. 105). Once back home, the devotee may place the print in his own domestic shrine where, at a further remove, the *darshan*, holy eye-contact, may still be beneficial.

No doubt there are many candidates who could be judged the first recorded pilgrim. However, a good case can be made for the Indian emperor Ashoka (c. 273–232 BC), for he undertook one of the most complete pilgrimages in antiquity. This is recorded in the *Ashokavadana*, a long poem in Sanskrit. It is recounted that the emperor visited not only the four sites identified as significant in the life of the Buddha, but also a further twenty-eight holy sites. His pilgrimage thus encapsulated a memory of the Buddha's biography. The act of commemoration was further enhanced by the construction of memorials at each of the sites and the honouring of the relics of followers of the Buddha (fig. 106). The *bodhi* tree at Bodh Gaya in northern India was especially singled out. Indeed Bodh Gaya was certainly a site of significant pilgrimage from a very early date because it was here that the Enlightenment took place, surely the most

important event in the life of the Buddha. In the British Museum there are pilgrim sou-
venirs in the form of small sculptures which depict, in miniature, the temple at Bodh
Gaya; these date to the eleventh and twelfth centuries AD. One of them was recovered
from the excavations at the site itself which were undertaken by Sir Alexander Cun-
ningham in the latter part of the nineteenth century, while the other was discovered far
away, in a Buddhist context in Tibet. It had been carried there by a devout pilgrim who

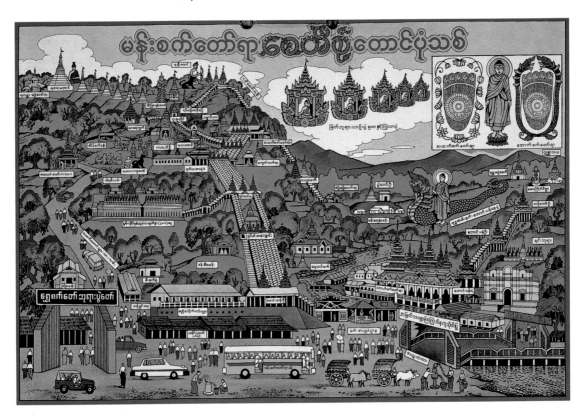

106 Buddhist pilgrim poster
of sites associated with the
Buddha's foot (buddhapad).
Burmese. Twentieth century.
(See also pp. 62–4.) H. 25.5 cm,
W. 35.5 cm. Department of
Oriental Antiquities

had made the long and arduous journey from the Land of Snows to the most important
of all the sites of pilgrimage in Buddhism. To this example of pilgrim remembrance can
be added clay impressions bearing the text of invocations, clay votive plaques, and small
stone stelae, usually depicting the Eight Great Events of the Life of the Buddha. How-
ever, as John Guy points out, the abiding pilgrim souvenir was, and still is, a much-prized
leaf from the sacred *bodhi* tree itself.[13]

In this context, the Japanese approach to visiting religious sites, which in Japan are
either Buddhist or Shinto (or indeed Shinto sites which have become Buddhist),
deserves special attention. In contemporary Japan internal tourism is a huge busi-
ness. It is usually conducted in groups and, even if the sites visited are shrines or
temples, is only part pilgrimage. The other part merges readily into conventional
tourist behaviour. The merging of these two forms of travel can be traced histori-
cally to early pilgrimages undertaken against a background of dangerous and costly

travel. In these circumstances small groups of pilgrims visited distant shrines on behalf of their communities and were supported financially by the wider group they represented. They 'went for all of them, offered prayers for all of them, and brought back charms [omamori, ofuda] and gifts [omiyage] for all' (fig. 107).[14]

The islands of Japan are replete with sacred sites, both natural features of the landscape (such as mountains and caves), and temples or shrines. Many have a specific associated benefit which visitors seek: they may be curative of specific illnesses or disabilities, they may be appropriate to certain types of people (those looking for partners, newly-weds, examination candidates, car drivers, and so forth), and they may be associated with particular sects. These, like secular sites of tourism, each have their specific range of souvenirs and mementos. As in feudal times, travellers journey under moral obligations to those left behind. Even the tourist on a secular visit anticipates returning with an appropriate gift specific to the place or places visited, gifts intended for a potentially large group of those remaining at home. Indeed his or her journey is in a sense a surrogate for those whom they represent and the purchases are to a degree the products that the absent traveller would have bought had they not stayed behind. The ultimate extension of the philosophy is perhaps the practice on the Shinkansen, the high-speed 'bullet' trains which link major cities in Japan, of bringing round on trolleys the gifts passengers could have bought had the train not sped through particular stations without stopping. This is a world of surrogate memory, of mementos of visits not experienced but enjoyed vicariously through the gift. In one sense, these are souvenirs in the terms we have begun to encounter: over-elaborated, redundancy writ large. Yet, in another sense, this is experience expanded through artificially widening the memory of it. This is not absurd behaviour. After all, what is the visit to a museum exhibition but a surrogate for visiting and experiencing material in the context from which it ultimately derived?

107 Paper amulet with textile fragments. The amulet shows Kobo Dashi (Kukai) who founded the Shingon sect headquarters on Mount Koya. The textile fragments are said to be from the garments of Kukai himself and to offer continuing protection to pilgrims. Japanese. Nineteenth century. H. 8.5 cm, w. 16.3 cm. Department of Japanese Antiquities.

For the first-hand traveller in Japan the means of authenticating the memory of visits are numerous, and to a significant extent they are site-specific. We have referred above to the taking of photographs of travellers, often with the date on which they visited a particular site on a placard in front of the group or traveller, and with the site itself visible behind. It is important that the traveller appear in the picture. A photograph of the site is not itself sufficient. There are other indisputable authentications of presence at a particular site that are available. Originally pilgrims to sacred sites would have had their pilgrim's clothing marked in a distinctive fashion as proof that they had visited a specific place. This then developed into a kind of passport, the goshuincho or 'special red stamp book'. From the end of the nineteenth century, a practice developed of providing such stamps at tourist as well as at religious sites. The souvenirs available at each site include a range of possible natural products from the area, and might include charms, silk, pottery, calligraphic brushes, wooden bears and so forth.[15]

In addition to these various *kinen* taken away as memorabilia, visitors to shrines and temples also leave behind small votive plaques and pieces of white paper which predict future fortune. Thus the whole act of memorialising the visit includes leaving something behind, taking something away, and sharing it in the form of gifts with those who did not visit in the first place. Japanese culture thus provides perhaps the most complete distribution of memory we have encountered.

To end this section on a more iconoclastic note, however, it is interesting to recall the number of people who leave 'I was here' inscriptions on even the most important of monuments, and some who even arrange for it to be done on their behalf. Thus, for example when the great recorder of ancient Egypt, Giuseppi Belzoni, entered through a tunnel into the central chamber of one of the pyramids at Giza, he inscribed 'in the Italian language, in large letters, which extend from one end to the other, his name and the date of his discovery'.[16] Later that day one of Belzoni's party climbed to the top of the Great Pyramid. Feeling nauseous he nearly gave up the ascent, but persevered to the very top where 'he found the names of the Belmores and the ubiquitous Captain Cory inscribed, along with that of the Countess's lapdog, Rosa'.[17] We also learn that carved there was the name of the French writer and diplomat Chateaubriand, together with an inscription beneath saying 'Il n'était pas ici'. Having visited Egypt, Chateaubriand found he had no opportunity to do justice to the pyramids, so he requested a countryman to inscribe his name there 'according to the custom of these prodigious tombs, for I like to fulfil all the little duties of a pious traveller'.[18]

Souvenirs

The pious traveller, however, is not a pilgrim. We turn shortly to consider in more detail the Grand Tour of the Mediterranean sites of antiquity from the eighteenth century; but we begin in earlier centuries of European voyaging where the journey is not one of discovering the roots of one's own faith, but an encounter with other people's.

The mnemonics we have considered in Chapter 3 all imply a reduction of some kind, a condensed expression of the essential. They are shorthand, and as such they cannot contain elaborate narrative. Indeed, they often act to generate oral accounts, stories, history and memory. Their task is to aid recollection of a great deal more than they immediately express. And what they contain in this boiled-down medium is often fundamental knowledge, things that should not be forgotten, whether technical information about the individual's place in space or time, ancestral origins or other historical detail crucial to affirming identity; or they may serve to suggest moral lessons that need to be remembered and acted upon. In all this they are largely vehicles of an unsentimental form of memory.

The comparison of these mnemonics with the souvenir is revealing. It too is certainly a condensed

108–9 *Top* Commemorative porcelain plate by Veniamin Pavlovich Belkin, with painted decoration celebrating the second anniversary of the Russian Revolution. The Classical temple and the red star symbolise the old order giving way to the new Soviet State indicated by factory buildings billowing with smoke. Designed 1919, produced 1920. Russian. D. 23.5 cm.
Bottom Earthenware plate designed by Charles Murphy to celebrate the New York World's Fair, decorated with the exhibition buildings and central structures. An inscription on the back records that the Fair commemorates the 150th anniversary of the inauguration of George Washington as First President of the United States. American. 1940. D. 25.8 cm. Department of Medieval and Modern Europe.

version of reality; it is generally about the world in reduced form. Indeed, since most are acquired in the course of travel, there is an obvious practical reason for this: they must be miniatures if they are to be portable, unless the traveller is on the grandest of Grand Tours and scale and cost are no objection. When the British Museum opened a gift shop at Heathrow Terminal 4, a special kind of problem was created for the marketing department since, by the time passengers had gone through customs to reach the duty free shopping area, they had already deposited their baggage. They were limited in what could be bought by the size of the overhead lockers or the space underneath the seat in front. New ranges needed to be developed to meet these condensed requirements.

However, there are several other aspects to the contrast between souvenir and aide-memoire. Firstly, most souvenirs are without any deep reference or practical application (though Swiss army knives and the like provide ready exceptions to any overgeneralised statement). In Micronesia, Marshall Island versions of navigation charts are now sold as tourist objects; but in becoming souvenirs they have none of the precision that a mariner would ensure if it were for his own use. Secondly, souvenirs also come from somewhere else – clearly there is no need to recollect what is already all around you – and they are usually copies of (or parts of) something that is somewhere else. Given this, souvenirs have about them a strong whiff of the inauthentic which, for commercial reasons, it may sometimes be necessary to counter – an 'official' copy may not be an acceptable description for those in search of genuine antiquity, but is

110 Bronze lamp made for the TOC H Christian charity in the form of a late Roman lamp and introduced in 1922 as a focus of remembrance and guidance. This example was bestowed on the Stepney branch in London in 1929, and commemorates a member, Roland Phillips, killed in the First World War. British. 1929. H. 35 cm. Department of Medieval and Modern Antiquities.

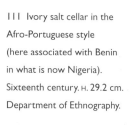

111 Ivory salt cellar in the Afro-Portuguese style (here associated with Benin in what is now Nigeria). Sixteenth century. H. 29.2 cm. Department of Ethnography.

thought to give some reassurance of authenticity in the case of the souvenir. So finally, souvenirs are sentimental in a way that other aides-memoires are not: they are memorabilia, tokens, rather than a concretisation of memory.

Another aspect of souvenirs, shared with other memorabilia such as the heirloom, is the fact that their significance is potentially independent of any exegesis. They are silent witnesses to a past they do not directly record or document, and their meaning is exclusive to those who are able to construct their semantic context from their own experience. The jolt or frisson of nostalgia that heirlooms may

engender in those who recognise in them a certain sentimental value is highly personal. Verbalisation, explanation, does not effect the same linkage that the object in itself exercises on those to whom it has an immediate importance. To anyone else they are, like a joke explained, inert, unfunny, impersonal. In Freudian terms they might be described as connecting to the world of the unconscious. Without the immediate physical presence of the object, they lack the power to evoke.

Such objects act as stimuli which produce responses discussed by Susan Stewart as 'longing' or nostalgia.[19] Nostalgia, in the hackneyed phrase 'ain't what it used to be'. It is about a past which is recollected through rose-tinted glasses as better than it probably was, and certainly better than the present. The sources of such evocative emotion have a psychological dimension. In Rowlands' interesting observation, the reason souvenirs, heirlooms and indeed photographs have a particular power to bring on nostalgic sentiment is 'because, as a material symbol rather than a verbalised meaning, they provide a special form of access to both individual and group unconscious processes'.[20] Memory itself, it hardly needs saying, he sees as lurking in the background stalking the unconscious, ready to be retrieved into consciousness. Some objects, we might go on to say, have a special power to evoke nostalgia because they lack an exegesis; indeed they are strongly personalised precisely because they have no burden of formal exposition of their significance. It remains for the individual to fill the gap, to invest them with meaning based on their own experience and recollection.

Amongst the most celebrated of early 'souvenirs' are the so-called Afro-Portuguese ivories. They are dated to a period from the late fifteenth to the middle sixteenth centuries, that is from the earliest years of the Portuguese exploration of the African coastlines.[21] They comprise a group of objects carved in a highly decorative manner, often with a complex composition of sculpted figurative elements. The objects include salt cellars, oliphants or trumpets, the handles of daggers or knives, spoons and forks (fig. 111). The emphasis on tableware is one indication that the objects were destined for courtly European contexts, though they are likely to have been more ornamental than functional, as was true of many decorative Renaissance objects. If these are accurately described as a precursor of the souvenir, they were far from trinkets.

The ivories are in two distinctive styles suggestive of two separate sources. These are now identified with the so-called Sapi of what is now Sierra Leone and artists in southern Nigeria who may have been Yoruba or Edo. They represent fusions of African and European elements, a scenario evidenced in one of the rare sources which documents the creation of the objects. In a report dating to 1506–10, Valentin Fernandes reports that the inhabitants of Sierra Leone 'are black and very talented in manual art, that is [they] create] ivory saltcellars and spoons. They create in ivory any work which we draw for them.'[22] The Afro-Portuguese

112 Ivory tusk carved with images derived from contemporary Belgian cartoons for a European market. From the Loango coast of west Central Africa. Early twentieth century. L. 85 cm. Department of Ethnography.

ivories are sometimes referred to as the first airport art, airport art before there were airports. However, this first-hand account suggests that the tag 'souvenir' may be somewhat misleading. The ivories would certainly have strongly evoked the exotic – not least because of the source of the material from which they were made. However, they were not carved as a memory of a visit, but as tribute to those in Europe who had sponsored the voyages of exploration – an exploration itself motivated both by a missionising zeal and a desire to extend trade links and find sources of rare materials, of which ivory was already one. The use of heraldic devices often referring to the court of Lisbon – the arms of the ruling house of Aviz, for instance – are one indication of the intended destination of some of these luxury wares.

So the Afro-Portuguese ivories are not perhaps totally souvenirs in the terms we have just described them, for all that they share a taste for the exotic, and work in the rare material of ivory. Later examples include very elaborate ivories carved for export in the Lower Congo area of west Central Africa, and often identified with the Loango coast and the ivory carving centre at Chiluango in Cabinda. These date from about the 1830s and were produced until the end of the nineteenth century. They were often complete tusks usually showing chains of figures in profile (sometimes literally shackled together in a slave chain) and often wearing a hybrid assemblage of clothing including wraparound skirts, European jackets and traditional raffia skull caps. Europeans are identifiable in the imagery by their kepi (a French-style military cap), suits, shoes, umbrellas and sometimes by the furniture on which they are seated. Some later tusks include imagery copied from Belgian satirical cartoons (fig. 112). Such ivories are clearly intended to exploit what was seen as appropriate to European taste. But, whilst the Afro-Portuguese ivories of the sixteenth century were often, if not practical tableware, at least display pieces for incorporation into table settings, those of the Loango coast had by the nineteenth century become functionless. Paradoxically they are more readily equated with what we would now think of as souvenir work because they have more completely endorsed redundancy.

The Grand Tour

Those who took the Grand Tour to Italy in its heyday – the decades between the end of the Seven Years War in 1763 and the outbreak of the Napoleonic Wars in 1796 – were inspired by motives other than extending Christianity or trade, which gave a different character to their journeying. The Tour, though undertaken in varying degrees by other European travellers, was a largely British institution, indeed an aspiration principally of the aristocracy and the wealthier classes who were familiar with Roman antiquity from reading the Latin texts. Their ambitions were to discover for themselves the grandeur of the Italian Renaissance and the baroque, but even more so to visit the remaining monuments of imperial Rome. The purpose was broadly educational – indeed academically informed governors, travelling companions and guides were ready to help make the most of the experience. And the

113 The so-called 'Townley sphinx', a marble sphinx with a female head, a canine body and a lion's tail. Excavated in Italy and sold to Charles Townley in 1780, at the height of the Grand Tour. The sphinx is of second century AD date and is mounted on a Roman well-head. H. 73 cm. Department of Greek and Roman Antiquities.

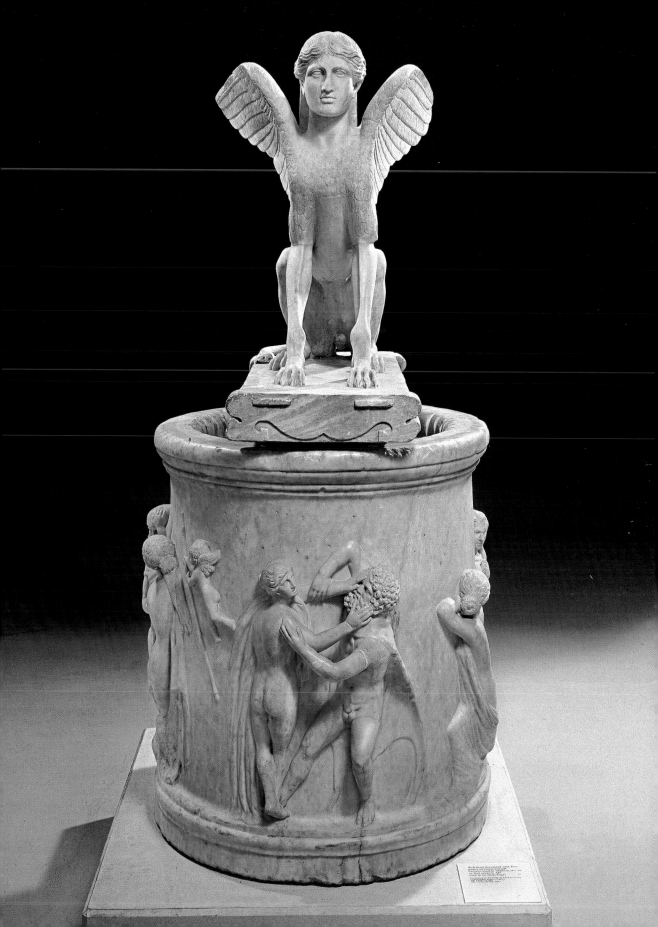

114 Drawing by Giovanni Battista Piranesi showing the ancient intersection of the Via Appia and the Via Ardentine in Rome. For the frontispiece of the *Antichita Romane*, volume II, 1756. H. 63.5 cm, W. 39.9 cm. Department of Prints and Drawings.

objects and artworks acquired conformed to this sophisticated motivation. Piranesi, in his print shop in Rome, was extensively patronised by British clients appreciative of his distinctive portrayals of the major imperial remains (fig. 114); Canaletto's views of Venice were almost exclusively produced for a British market; whilst Pompeo Batoni, already an established 'history painter', turned his hand to painting portraits of British visitors with, as required, appropriate antiquities in the background.[23]

Supplying the insatiable demands of the monied visitors for objects and paintings to take home led to a lucrative sideline for various British representatives in the major Italian destinations, especially in Rome and Venice. Paintings and prints were one thing; however, the search for antiquities which could decently be brought back was an equally energetic obsession, though frustrated by their comparative rarity and difficulty of transport. As early as 1730, Edward Wright commented on an observation current among cultured Italians to the effect that 'were our ampitheatre portable, the English would carry it off'.[24] There were, however, considerable and effective restrictions on what could in fact be 'carried off'. Much was under the control of the Papacy or already incorporated into major collections of antiquity where its status was relatively secure. Some marbles certainly were considered exportable, and many which are now in British Museum collections, or (like the so-called Jennings dog, fig. 115) still coming legitimately onto the British market over 200 years later, derive from the activities of this small group of enthusiastic Grand

115 Marble dog, copied from a Greek bronze original, and acquired in 1750 by Henry Constantine Jennings. This copy dates from the second century BC. H. 105 cm. National Art Collections Fund. Department of Greek and Roman Antiquities.

Tourists. Much was also still under the ground and amongst the more persistent of treasure hunters the best chances of acquisition lay in sponsoring excavations. After all, this was the era when, apart from the statuary at scattered villas in the Italian countryside, major sites of ancient renown were being uncovered: Herculaneum in 1738 and Pompeii in 1748.

Clearly there is more to this than we might normally associate with souvenir-hunting. There is, firstly, the engagement of the tourist with Classical sources and an acknowledgement of their importance in wider Western culture. The objects were often large and there was a heavy emphasis on authenticity. Indeed, so much so that by the end of the century little was left that could be legitimately exported and dodgy practice was daily visited 'upon poor John Bull'. Rome had been 'exhausted of

every valuable relic, that it is become necessary to institute a manufactory for the fabrication of such rubbish as half the English nation come in search of every year', as one visitor remarked.[25] Hogarth duly lampooned the extent to which the passion for the acquisition of antiquities and old master pictures had overriden the exercise of judgement by showing Time artificially aging fake works of art for this inexpert market (fig. 116). The objects brought back are at one level souvenirs. At another, however, the returning graduates of the Grand Tour, who displayed their acquisitions on the walls and in the niches of innumerable grand houses in Britain, put on display a moral sophistication which was seen to be one of the more desirable outcomes of

116 William Hogarth,
'Time Smoking a Picture'.
Etching and mezzotint. British.
1761. H. 26.3 cm, W. 18.5 cm.
Department of Prints and Drawings.

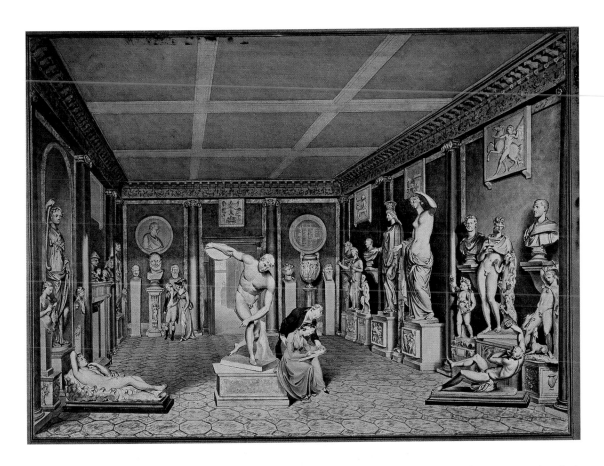

117 Charles Townley (1737–1805) travelled to Italy on three Grand Tours. His resulting collections of antiquities and old master drawings are an important part of the British Museum's collection. In this watercolour by W.A. Chambers, the Townley collection is pictured as shown in his dining room at Park Street, Westminster, London. British. 1794–5. H. 54 cm, W. 39 cm. Department of Prints and Drawings.

the experience (fig. 117). They had not just visited another country; they had immersed themselves in the grandeur of another time and in the perfection of the intellectual and artistic achievements of Classical traditions.

Photograph Albums

The Grand Tour gave rise to paintings and prints recording the sites of antiquity visited. The most ubiquitous item of the material culture of modern travel is, however, surely the camera. Arguably the greatest innovation in the making of memory is the invention of photography in 1839, and the most widely disseminated of modern memorabilia is the photograph album. Photographs capture and retain a fleeting moment and from the instance of their realisation on the surface of the film they have accrued a special potential to trigger recollection. Time has moved on, the image has become the stuff of memory. It has in that instance become past, in a way that moving film or video cannot because of its own internal temporality and the resulting sense of participation in the passage of time.[26] But because it is an exact replica of what was in the real world at that moment it has an aura of authenticity which most other duplicate imagery of the material world cannot achieve. It is also, like conscious memory, fragmentary.

Photography in the British Museum has a long history.[27] One of the great

118 View of the front of the British Museum and the forecourt by the photographer Roger Fenton. It has been suggested that the figures are Fenton's wife and family. c. 1857. British Museum Archives.

pioneers of early photography, Roger Fenton, became the Museum's first official photographer in 1852 (fig. 118). He subsequently went on to earn an enviable reputation in the Crimea as the first war photographer, before returning to the Museum again in 1856 to reoccupy his position. Eventually, Fenton fell out with the Director of the day, the formidable Antonio Panizzi, and ultimately returned to a legal career. Fenton's photographs of the Museum and of its collections are retained in the archives, where his pictures of the Greek and Roman sculpture collections remain a great achievement. Many objects were carried to the roof on sunny days and photographed there with the benefit of natural light.

But, in truth, the potential of the new and wondrous technology to act as a touchstone of memory was hardly acknowledged at the moment of its earliest entrance into the Museum. The first photographs in or of the Museum appear to be those taken as an experiment in late July 1843 by the innovative figure Fox Talbot. The experiment was hardly a success: the weather was warm, the chemicals did not respond as was intended and the result was a 'calotype' of the outline of Montagu House (the original British Museum building) which is atmospheric by its very indistinctness, in the manner of the first photographs ever – those taken of the Parisian skyline (fig. 119). Talbot wrote to excuse himself on account of the 'extreme haste' and the 'consequent imperfections' of the results.[28] The reply, interestingly, came from Charles Fellows, then on the point of departing for a third season of work at Xanthus, the capital of Lycia. His response acknowledges the value of photography to his enterprise but worries about whether he could realistically make use of it at

144

119 The earliest known photograph of the British Museum showing the original Montagu House. It is thought to have been taken by Henry Fox Talbot in 1843. British Museum Archives.

its present state of development – given that the circumstances of his archaeological work obliged him to adopt the role of a 'rough traveller'. Thus, it seems that the Museum's first experiments with photography were connected with the ambition to use photography on archaeological expeditions, with creating records of the archaeological process and its immediate context – that is, with scholarly and documentary purposes and not with indulging a taste for enhanced memorialising.

There is other evidence also that photography was regarded as a superior form of recording. Date and Hamber draw attention to the convergence of interest in making casts of objects and taking photographs of them. The practice of creating casts from Classical sculpture in particular already had a history in European Museums generally, as in the British Museum.[29] By 1835, in one of the periodic Parliamentary Select Committee enquiries into Museum affairs, it was remarked that, whilst the British Museum had been making and receiving casts for some time, there was nothing like the systematic provision the Louvre was able to offer through having a dedicated cast service. The purposes of providing casts were several, but one was certainly to engage in exchange so that various institutions should have the possibility of putting their collections into chronological sequences more meaningfully. By 1867 Henry Cole, Director of the South Kensington Museum (later the Victoria and Albert), succeeded in concluding an international convention 'for promoting universally Reproductions of Works of Art . . . which can easily be reproduced by Casts, Electrotypes, photographs, and other processes, without the slightest damage to the originals'.[30] Photographs of people or of events document what was there, then, and

has since faded, changed, or even died; photographs of objects record or, in the case of casts, duplicate in different materials what is there and what – unless museum processes go wildly astray – will always be there in that form.

Yet, where time does alter appearance, today's record readily translates into tomorrow's touchstone of memory. An institutional example of this is the so-called Cowtan Album. This is an album put together from the late 1850s by Robert Cowtan, who, from 1830, was on the staff of the Museum's Department of Printed Books. The contents are portraits in the form of *cartes de visite* incorporating photographic portraits. The use of photographic visiting cards was popularised in Paris in 1859 by

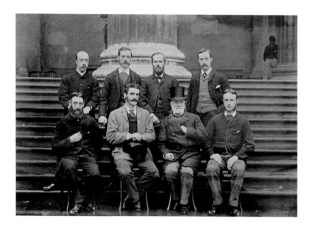

Andre Disdéri and for several years thereafter a fad for having them made, exchanging and collecting them spread to Britain.[31] They were avidly put together in volumes in the manner of modern-day autograph hunters. Cowtan, in this vein, acquired photographic cards from fellow members of staff of the day, outside scholars and an international group of celebrities, not all of whom will necessarily have been visitors to the Museum, but whose images were in circulation. It is hard to imagine, for instance, that all the royal princesses, or the emperor of Russia, were visitors, let alone that their inclusion complied with the description of the volume in the records where it is called an 'Album of Photographs of British Museum Officials'.

120 Photograph of members of the Department of Antiquities. At the back are '2nd class attendants' and at the front '1st class attendants' and (in the top hat) Samuel Birch, Keeper of Oriental Antiquities. *c.* 1881–5. British Museum Archives.

These are, for all that, an evocative record – no doubt all the more so to the original collector. Indeed some of the juxtapositions suggest that Cowtan was rather playfully constructing his own remembrance for posterity of some of his impressions of his colleagues. The first pages contain impressions of the irascible Director and Principal Librarian of Cowtan's day, Antonio Panizzi. It can be no accident that on one of the later openings two further views of Panizzi's bust are placed above the *cartes de visite* of Giuseppi Garibaldi and Napoleon III (fig. 121). Frederic Madden, a member of staff who kept a colourful journal, compared Panizzi's photographic image to 'a gorilla made sick by a surfeit of pumpkins'. A more agreeable colleague, the equally distinguished Richard Owen (the Superintendent of the Natural History Collections), for instance, has as his companions on the album page a trio with impeccable credentials: Cardinal Manning, Cardinal Newman and Austen Layard, the excavator of Nineveh.

In the mis-titling of the album, and in the likelihood that a significant number of the photographic cards did come from actual visitors to the Museum, the volume is suggestive of the 'family' of the Museum of the day. It lacks, however, the more directly personal evocation of the true family album whose popularity from the later nineteenth century onwards has contributed to a step change in the available means of remembrance. The ease with which studio photographs could be made arguably altered the range and depth of memorialising in the Victorian era. Assembling photographs in albums, often adding other mementos in the form of locks of hair, pressed

flowers, significant quotations or poems, was a favourite Victorian pastime. The creation of such intimate family archives mixes the photograph with the relic to create an artefact which goes beyond mere recollection. It is an act of remembrance.

Where such albums or imagery is viewed may also give a context to the remembrance implied. In the context of Renaissance painting Evelyn Welch tells us that when Beatrice de'Contrai sat down to eat in the late fifteenth century she placed a portrait of an absent friend Isabella d'Este at another chair so that 'by looking at it I seem to be at table with your ladyship'[32] – an exemplary instance of the practical application of Alberti's principle that the purpose of portraiture is to make absent people present. Yet remembrance can go further. On the Isle of Wight is Osborne House, the home of Queen Victoria and her favourite retreat from the courtly life of London. Her bedroom is preserved as it was. Adjacent to the pillow where she slept is placed a framed photograph of her husband Prince

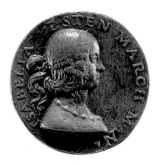

122 Cast bronze medal of Isabella d'Este, Marchioness of Mantua, by Gian Cristoforo Romano. Isabella d'Este was a leading Renaissance collector of both Classical antiquities and contemporary works. She regarded herself worthy of commemoration in her lifetime and gave versions of this medal to many contemporaries. Italian. 1498. D. 38.5 mm. Department of Coins and Medals.

121 Page of the Cowtan Album showing Sir Anthony Panizzi together with Garibaldi and Napoleon III. Compiled from the late 1850s and the late 1870s. H. 30 cm, W. 24 cm. Department of Prints and Drawings.

Albert whose mourning preoccupied the latter part of her lengthy reign. Her last view at night and her first in the morning was of her beloved consort. The placing of the photograph in this case does not just enable a daily act of remembrance, it has about it the sense of needing to ensure something or someone is not lost. Time has been stilled, but memory continues to keep the image ever present. This is less about remembrance and has become a form of vigil. In this case the photograph is as much about the repercussions of forgetting as about the activity of recollection.

Yet, it is not only the Victorians whose photographic albums turned the new recording technology into a sentimental instrument. An equivalent situation is associated with the Yoruba peoples of Nigeria, and in particular with the death of one of a pair of twin children. Twins (*ibeji*) are regarded as sacred children who can enhance fortune one way or the other – they bring either twice the luck or twice the trouble. Women with twin children would traditionally dance with them at markets or in more recent times at places like bus stations, receiving alms in return for the blessings of their children. It follows that the death of a twin threatens further misfortune. Thus, should one die early, a memorial figure may be commissioned by the parents to demonstrate their continuing affection for the deceased twin. The sculpted figure has

affection lavished upon it. It may be 'dressed' in a small beaded gown and decorated with jewellery, it will be oiled and rubbed, and, as a surrogate for the departed, may be fed, rocked to sleep at night and awoken in the morning. It may be sung to and danced with. This is remembrance with an edge. The acts of affection are undertaken in the knowledge that a propitious future may be thereby assured – or at least that a less than propitious one may not ensue through the act of forgetting. The *ibeji*, whilst a substitute for the lost child, is not an attempt at portraiture. Interestingly, though, the carving of *ibeji* figures has in recent decades begun to give ground and other images, including in some recorded cases plastic dolls, have begun to be used. So too have photographic images, in these cases not taken of the deceased child but of the survivor. The photograph is then put on the wall with a table beneath where weekly offerings of food are placed.[33] What is lost in forfeiting a three-dimensional image treated as if it were the departed loved one, is regained by having a real likeness, albeit of the spirit double, the survivor, in photographic form.

In India a practice of post-mortem photography has also developed. This is partly because there may not otherwise be photographic images of the deceased and this is the last opportunity with near relatives assembling together to create memory and to do so in a form that can be duplicated from the same negative. In Hindu belief the deceased retains the spirit until cremation and the post-mortem photograph records an individual who yet is possessed of vital qualities. Photographs are also sometimes over-painted to create an effect which is, if anything, a heightened form of reality. The staring eyes become more intense and the presence of the absent subject more imaginable. Pinney reports that such memorial photographs are hung prominently in a family home where incense sticks are burnt at the beginning and end of the day to honour the deceased.[34] On the lunar day which corresponds to the death more elaborate worship is prescribed. Here memory has got entangled with death. The photograph stills time, just as death robs the living of feeling, sensation and memory itself. And those who remain are left to wrestle with the issues of absence implied in converting the lived experience of others into remembrance.

In Victorian Britain a tradition of taking post-mortem photographs of the deceased developed and the resulting images were often displayed in domestic settings. The propaganda for early photography described the new invention as 'a mirror with a memory'. *Punch* took up the theme in 1862 with a ditty on photographs of people:

The portrait as it will last
And when some twice ten years have passed,
Will show you what you were:
How elegant, how fresh and fair.
I wonder what the mirror will,
Compared with it, exhibit still!

For the deceased it was all a little too late.

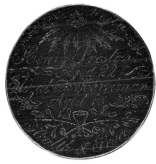

123–4 Coins rubbed down and inscribed by British prisoners about to be transported to Australia. Tokens of this sort were given to loved ones whom they were unlikely ever to see again. First half of the nineteenth century. British. D. 28 mm (both). Department of Coins and Medals.

Conclusion

It is appropriate to end a book on memory with the subject of photography. The photograph has become by far the most ubiquitous and most potent of the modern artefacts of memory. Neighbours who were burgled recently woed the loss of money and credit cards, regretted that electronic equipment and passports had gone, but grieved over the loss of their family photographs, stolen it was presumed for their frames. What had been taken, however, was a reminder of their children growing up, of relatives long gone, of the enchantment of family recollection.

Yet the photograph is not just another touchstone of memory. Memory has never been overly concerned with 'authenticity'; it does not engage us in any slavish search for an objective independent witness to events. Memory does not bother to search the archives for confirmation of its assertions. It is only in the creation of more technical objects, in the mnemonics of various kinds that we looked at in Chapter 3, that a concern with accuracy is paramount: the accurate repetition of trains of thought or patterns of speech, the ability to identify the times and seasons of the year in which appropriate ritual events must occur, or the remembrance of the route on potentially perilous journeys. Otherwise, whether in portraits or in panoramic reviews of historical events, we see not documentary records, but a representation of how people want to be remembered, or of how artists think they and the events in which they have been engaged should be remembered. These objects are already involved in the process of giving a gloss to the past, even the recent past, of creating nostalgia. As we have seen, their very creation is itself part of that refashioning of the past which is the work of memory and of remembrancers. The objects of memory discussed in the body of this book are from that perspective already interpretations.

Photography has seemed to be an innovation which breaks this association between objects and the construction of memory. We have seen in Chapter 2 that a consistent metaphor for the laying down of memory in the mind is that of a 'trace', of marks stencilled onto paper, or in Freud's phrase a 'mystic writing pad'. The photograph likewise is not an imitation of its subject; it is a literal trace of it. Few other objects illustrated in this book are similar – perhaps only the *imago* of the Romans, the death masks, or in Burmese belief the large footprint of the Buddha left at Shwe Settaw pagoda. To that extent the photograph is like memory itself.

Yet, in the end, this may only be a technical distinction. Its origins may not be interpretative, but, once the film is developed and the captive image rendered as a physical entity, the photographic print is subject to the same processes as other objects. The photograph may freeze time, but once it becomes a subject of reflection it melts back into the flow of remembered events. It has been a consistent theme of this book that objects stir recollection, that they inspire stories whose retelling constitutes memory. As memory itself is constantly on the move, so too are the narratives, in which the meaning of objects is embedded, forever evolving, reshaped in order to make our sense of the present lead coherently towards a desired future. Photographs too cannot escape this inevitability. The museum of the memory is not a static place, but a gallery under constant refurbishment.

Notes

Chapter 1

1 Crook, 1972; Miller, 1973; Caygill, 1981; Wilson, 2002.
2 As quoted in Sacks, 1985, 22.
3 Mordaunt Crook, as quoted in Caygill, 1981, 32–4.
4 Raphael Samuel (1994, 1998) has analysed this from the perspective of British identity in his two-volume study, *Theatres of Memory*.
5 Glaser, 2002.
6 As quoted in Yates, 1966, 131; and more generally on Camillo's theatre, see Chapter VI.
7 Findlen, 1989, 62.
8 Haskell, 1993, 45.
9 Mack, 1997, 43ff.
10 Jenkins, 1985, 179–81.
11 Parshall, 1999, 456.
12 As quoted in Haskell, 1993, 252.
13 To quote Kavanagh, 2000.
14 Sacks, 1985, 105.
15 *One Hundred Years of Solitude*, 46.
16 Kavanagh, 2000, 10.
17 Werbner, 1998, 77ff.
18 Ibid.
19 Beard, 2002.
20 Ibid., 13.
21 Jenkins, 1994.
22 Coleman and Elsner, 1995, 10ff.
23 Beard, 2002, 45.
24 Ibid., 70.

Chapter 2

1 Audu, 2000, 28.
2 Personal communication.
3 Audu, 2000, 28.
4 Meadows and Williams, 2001.
5 Ibid., 37.
6 Johnson 1759; reprinted in Bate, 1968, 304.
7 Hendry, 1993, 35ff.
8 Nooter Roberts and Roberts, 1996, 31–3.
9 Mack, 1995, 134.
10 Vansina, 1978, 17.
11 Vansina, 1978.
12 Ong, 1982, 34.
13 Ong, 1982.
14 Carruthers, 1990, 11.
15 Goody, 1968.
16 Küchler, 1987; Connerton, 1989; Whitehouse, 1992; Rowlands, 1993.
17 Welch, 1993, 426.
18 Ong, 1982, 65–6.
19 As quoted in Carruthers, 1990, 18–19.

20 Yates, 1966, 70.
21 Young, 1970.
22 Samuel, 2000, 58–9.
23 Carruthers, 1990, 8.
24 Vansina, 1978, 17.
25 Yates, 1966, Chapter XV.
26 Ibid., 62–4.
27 Spence, 1985.
28 As quoted in Binski, 1996, 152.
29 Canby, 1993, 9.

Chapter 3

1 Shamashang, 2000, 137.
2 Cornet, 1982, 73–124.
3 Reefe, 1981.
4 Starzecka, 1996, 31; Hakiwai, 1996, 50–1.
5 Vansina, 1978, 24.
6 Biebuyck, 1973, 1986.
7 Biebuyck, 1975, 74–81.
8 Ascher and Ascher, 1997.
9 Ackermann, 1999, 50.
10 Ackermann, 2000, to which the interpretation below, and the detail in the preceding paragraphs is due.
11 Though Davenport, 1964, illustrates an octagonal example.
12 Ibid., 11; Joyce, 1908, 147–8, summing up earlier reports, concurs.
13 MacGaffey, 1988, 1991.
14 Thompson, 1986; Mack, 1995, 56–62.

Chapter 4

1 Gschwantler, 1997, 15.
2 Johnson, 1989, 37.
3 Strathearn, 1997, 259–60.
4 Welch, 1998, 91.
5 Coleman and Elsner, 1995, 123–4.
6 Cormack, 1997, 25.
7 Ibid.
8 Ibid., 28.
9 Ibid., 62.
10 U Mya, 1936, 320–1.
11 Ibid., 323.
12 Cheesman and Williams, 2000, Chapter 1.
13 Walker, 1995, 14–15.
14 Ibid., 57.
15 Wang, 2002.
16 Haskell, 1993, 26–36.
17 Zanker, 1995, 32ff.
18 Ibid., 39.
19 Rogers, 1993, 16 and Chapter 4.
20 Ibid., 50.

21 Ibid., 90–1.

22 Skelton, 1994, 34.

23 Canby, 1994, especially the essay by Seyller, 49–80.

24 Seyller, 1994, 60.

25 Haskell, 1993, 74.

26 Griffiths, 1998, 178–81; and discussed in detail by Layard, 1922, under the title 'The Headless Horseman'.

27 Borgatti, 1990, 35.

Chapter 5

1 Mack, 1986.

2 Bloch, 1971, Chapter 5.

3 As quoted in Carmichael and Sayer, 1991, 11.

4 Ibid., 68–9.

5 Borg, 1997.

6 Walker, 1985, 10–11.

7 Carmichael and Sayer, 1991.

8 Walker, 1985, 105.

9 Ibid., 121.

10 Binski, 1996, Chapter 3.

11 Ibid., 139ff.

12 Ibid., 140.

13 Ibid., 142.

14 Cherry, 1994, 212–13.

15 Llewellyn, 1991, 74–7.

16 Binski, 1996, 153ff; Llewellyn, 1991, Chapter IV.

17 Rothenstein, 1989; Gretton, 1992.

18 See, for example, Bradley, 1998.

19 Last, 1998.

20 Ibid., 45.

21 Taylor, 1997.

22 Parkinson, 1991, 148–9.

23 Walker, 1997, 23.

24 Ibid.

25 Secretan, 1994.

26 Barley, 2000, 123.

27 Walker, 1985, 16.

28 Ibid., 18ff.

29 Ibid., 34–5.

30 Ibid., 36ff.

31 Ibid., 62.

32 Walker, 1995, 16.

33 Danto, 1986; Rowlands, 1999.

34 Briggs, 1988, 144–5.

35 Lewis, 1969; Küchler, 1987, 1999; Strathearn 2001; Gell, 1998, 223ff.

36 Strathearn, 2001, 14.

37 Johnson, 1750; reprinted in Bate, 1968, 89.

Chapter 6

1 Hale, 1993, Chapter V.

2 Schele and Miller, 1992.

3 McEwan, 1994, 44–5.

4 Ibid., 45.

5 Schele and Miller, 1992, 179.

6 Reade, 1983, 29.

7 Curtis, 2000, 78ff.

8 King, 1999, 266–7.

9 As quoted in Walker, 1995, 61.

10 Forty, 1999, 11.

11 Curtis, 2000, 40–1.

12 Reade, 1983, 40–1.

Chapter 7

1 For an accessible cross-cultural description, see Coleman and Elsner, 1995.

2 Ibid., 81ff.

3 Biddle, 1999.

4 Coleman and Elsner, 1995, 106.

5 Ibid., 109.

6 Cherry, 2001, 163–4.

7 Reinberg, 1995.

8 Ajmar and Sheffield, 1994.

9 Ibid., 38.

10 Eck, 1983.

11 Bhardwaj, 1973.

12 Blurton, 1992, 57.

13 Guy, 1993, 356.

14 Graburn, 1983, 46.

15 Ibid., 46ff.

16 Manley and Rie, 2001, 149.

17 Manley and Rie, 2001.

18 Ibid., 287.

19 Stewart, 1984, 132ff.

20 Rowlands, 1993, 144.

21 Bassani and Fagg, 1988.

22 As quoted by Bassani, in Phillips (ed.), 1996, 467.

23 Haskell, 1996, 11.

24 As quoted in Ingamells, 1996, 27.

25 Ibid., 29.

26 Edwards, 1999, 225–6.

27 Hamber, 1996; Date and Hamber, 1990; Date, 1989.

28 Hamber, 1996, 368.

29 Jenkins, 1992, 34ff.

30 Date and Hamber, 1990, 310.

31 Briggs, 1988, 133.

32 Welch, 1998, 93.

33 Houlberg, 1973, 27.

34 Pinney, 1997, 138ff.

Bibliography

Ackermann, Silke. 1999. 'The Principles and Uses of Calendars: Political and Social Implications'. In Kirsten Lippincott, *The Story of Time*. Merrel Holberton in association with National Maritime Museum, pp. 48–51.

Ackermann, Silke. 2000. 'Medals and Memory: The Secrets of Perpetual Calendars'. Unpublished text of a lecture to the Royal Numismatic Society, 18 January.

Ajmar, Marta and Catherine Sheffield. 1994. 'The Miraculous Medal: An Immaculate Conception Or Not'. *The Medal*, 24, pp. 37–51.

al-Khalil, Samir. 1991. *The Monument: Art, Vulgarity and Responsibility in Iraq*. University of California Press.

Ascher, M. and R. 1997. *Code of the Quipu; a Study in Media, Mathematics and Culture*. Dover Publications.

Audu, Osi. 2000. 'Monoprint ("Juju")'. In John Mack (ed.), *Africa: Arts and Cultures*. British Museum Press, pp. 28–9.

Barley, Nigel. 2000. 'West Africa'. In John Mack (ed.), *Africa: Arts and Cultures*. British Museum Press, pp. 84–123.

Bassani, Ezio and William Fagg. 1988. *Africa and the Renaissance*. Museum for African Art, New York.

Bate, W.J. (ed.). 1968. *Essays from the Rambler, Adventurer, and Idler*. Yale University Press.

Beard, Mary. 1992. 'Souvenirs of Culture: Deciphering (in) the Museum'. *Art History*, 15 (4), pp. 505–32.

Beard, Mary. 2002. *The Parthenon*. Profile Books.

Bhardwaj, S.M. 1973. *Hindu Places of Pilgrimage in India*. University of California Press.

Biddle, Martin. 1999. *The Tomb of Christ*. Sutton Publishing.

Biebuyck, Daniel. 1973. *Lega Culture: Art, Initiation and Moral Philosophy among a Central African People*. University of California Press.

Biebuyck, Daniel. 1986. *The Arts of Zaire: Volume II Eastern Zaire. The Ritual and Artistic Context of Voluntary Associations*. University of California Press.

Bierbrier, M.L. (ed.). 1997. *Portraits and Masks: Burial Customs in Roman Egypt*. British Museum Press.

Binski, Paul. 1996. *Medieval Death, Ritual and Representation*. British Museum Press.

Bloch, Maurice. 1971. *Placing the Dead: Tombs, Ancestral Villages, and Kinship Organisation in Madagascar*. Seminar Press.

Blurton, T. Richard. 1992. *Hindu Art*. British Museum Press.

Borg, Barbara. 1997. 'The Dead as a Guest at Table? Continuity and Change in the Egyptian Cult of the Dead'. In M.L. Bierbrier (ed.), *Portraits and Masks: Burial Customs in Roman Egypt*. British Museum Press, pp. 26–32.

Borgatti, Jean M. and Richard Brilliant. 1990. *Likeness and Beyond: Portraits from Africa and the World*. The Center for African Art, New York.

Bradley, Richard. 1998. *The Significance of Monuments: On the shaping of human experience in neolithic and Bronze Age Europe*. Routledge.

Briggs, Asa. 1988. *Victorian Things*. Batsford.

Brilliant, Richard. 1991. *Portraiture*. Reaktion Books.

Callet, R.P. 1873. *Tantaran ny Andraiana eto Madagascar*. 3 volumes. Editions de la Libraire de Madagascar.

Canby, Sheila R. 1993. *Persian Painting*. British Museum Press.

Canby, Sheila R. (ed.). 1994. *Humayun's Garden Party, Princes of the House of Timur and Early Mughal Painting*. Marg Publications.

Carmichael, Elizabeth and Chloe Sayer. 1991. *The Skeleton at the Feast: The Day of the Dead in Mexico*. British Museum Press.

Carruthers, Mary J. 1990. *The Book of Memory. A Study of Memory in Medieval Culture*. Cambridge University Press.

Caygill, Marjorie. 1981. *The Story of the British Museum*. British Museum Press.

Cheeseman, Clive and Jonathan Williams. 2000. *Rebels, Pretenders and Imposters*. British Museum Press.

Cherry, John. 1994. 'Medieval and Later Antiquities'. In Arthur MacGregor (ed.), *Sir Hans Sloane. Collector, Scientist, Antiquary Founding Father of the British Museum*. British Museum Press in association with Alistair McAlpine, pp. 198–221.

Cherry, John. 2001. 'Healing through faith: the continuation of medieval attitudes to jewellery into the Renaissance'. *Renaissance Studies*, 15 (2), pp. 154–71.

Coleman, Simon and John Elsner. 1995. *Pilgrimage, Past and Present in the World Religions*. British Museum Press.

Connerton, Paul. 1989. *How Societies Remember*. Cambridge University Press.

Cormack, Robin. 1997. *Painting the Soul. Icons, Death Masks, and Shrouds*. Reaktion Books.

Cornet, Joseph. 1982. *Art Royal Kuba*. Edizoni Sipiel Milano.

Crook, J. Mordaunt. 1972. *The British Museum: A Case Study in Architectural Politics*. Harmondsworth.

Curtis, John. 2000. *Ancient Persia*. British Museum Press.

Danto, Arthur. 1986. 'The Vietnam Veterans' Memorial'. *The Nation*, 31 August, p. 152.

Date, Christopher. 1989. 'Photographer on the roof'. *British Museum Society Bulletin*, 61, pp. 10–12.

Date, Christopher and Anthony Hamber. 1990. 'The Origins of Photography at the British Museum, 1839–1860'. *History of Photography*, 14 (4), pp. 309–25.

Davenport, W. 1964. 'Marshall Islands cartography'. *The Bulletin of the University of Pennsylvania*, 6 (4), pp. 10–13.

Eck, D.L. 1983. *Benares: City of Light*. Routledge and Kegan Paul.

Edwards, Elizabeth. 1999. 'Photographs as Objects of Memory'. In Marius Kwint Christopher Breward and Jeremy Aynsley (eds), *Material Memories*. Berg, pp. 221–36.

Findlen, Paula. 1989. 'The Museum: its Classical etymology and Renaissance genealogy'. *Journal of the History of Collections*, 1 (1), pp. 59–78.

Forty, Adrian and Susanne Kuchler (eds). 1999. *The Art of Forgetting*. Berg.

Freedberg, David. 1989. *The Power of Images, Studies in the History and Theory of Response*. The University of Chicago Press.

Gell, Alfred. 1998. *Art and Agency: An Anthropological Theory*. Clarendon Press.

Glaser, Karen. 2002. 'Running Debate'. In *Building Design*, 12 July, p. 14.

Goody, Jack. 1968. *Literacy in Traditional Societies*. Cambridge University Press.

Graburn, Nelson. 1983. *To Pray, Pay and Play: The Cultural Structure of Japanese Domestic Tourism*. Université de Droit, d'Economie et des Sciences, Centre des Hautes Etudes Touristiques, Serie B, no. 26.

Gretton, Thomas. 1992. 'Posada's Prints as Photomechanical Artefacts'. *Print Quarterly*, IX (4), pp. 335–56.

Griffiths, Antony. 1998. *The Print in Stuart Britain, 1603–1689*. British Museum Press.

Gschwantler, Kurt. 1997. 'Graeco-Roman Portraiture'. In Susan Walker (ed.), *Ancient Faces: Mummy Portraits from Roman Egypt*. British Museum Press, pp. 14–22.

Guy, John. 1991. 'The Mahabodhi temple: pilgrim souvenirs of Buddhist India'. *The Burlington Magazine*, CXXXIII, pp. 346–67.

Hakiwai, A.T. 1996. 'Maori Society Today: Welcome to our World'. In D.C. Starzecka (ed.), *Maori Art and Culture*. British Museum Press, pp 50–68.

Hale, John. 1993. *The Civilization of Europe in the Renaissance*. MacMillan.

Hamber, Anthony J. 1996. *'A Higher branch of the Art'. Photographing the Fine Arts in England, 1839–80*. Gordon and Breach Publishers.

Haskell, Francis. 1993. *History And Its Images: Art And The Interpretation Of The Past*. Yale University Press.

Haskell, Francis. 1996. 'Preface'. In Andrew Wilton and Ilaria Bignamini (eds), *Grand Tour: The Lure of Italy in the Eighteenth Century*. Tate Gallery Publications, pp. 10–12.

Hendry, Joy. 1993. *Wrapping Culture: Politeness, Presentation and Power in Japan and Other Cultures*. Clarendon Press, Oxford.

Houlberg, Marilyn Hammersley. 1973.
'Ibeji Images of the Yoruba'. *African Arts*, 7 (1),
pp. 20–7.

Ingamells, John. 1996. 'Discovering Italy:
British Travellers in the Eighteenth Century'.
In Andrew Wilton and Ilaria Bignamini (eds),
*Grand Tour: The Lure of Italy in the Eighteenth
Century*. Tate Gallery Publications, pp. 21–30.

Jenkins, Ian. 1985. 'James Stephanoff and the
British Museum'. *Apollo*, 121, pp. 174–81.

Jenkins, Ian. 1992. *Archaeologists & Aesthetes
in the Sculpture Galleries of the British Museum
1800–1939*. British Museum Press.

Jenkins, Ian. 1994. *The Parthenon Frieze*.
British Museum Press.

Jha, Makhan (ed.). 1985. *Dimensions
of Pilgrimage: An Anthropological Appraisal*.
Inter-India Publications, New Delhi.

Johnson, Barry C. 1989. *Tea and Anarchy! The
Bloomsbury Diary of Olive Garnett 1890–1893*.
Bartletts Press.

Johnson, Samuel. 1968 (various dates in the
mid-eighteenth century). In W.J. Bate (ed.),
Essays from the Rambler, Adventurer, and Idler.
Yale University Press.

Joyce, T.A. 1908. 'Note on a Native Chart
from the Marshall Islands, in the British
Museum'. *Man*, 8, no. 81, pp. 146–9.

Kavanagh, Gaynor. 2000. *Dream Spaces:
Memory and the Museum*. Leicester
University Press.

King, J.C.H. 1999. *First Peoples First Contacts,
Native Peoples of North America*. British
Museum Press.

Küchler, Susanne. 1987. 'Malanggan: Art and
Memory in a Melanesian Society'. *Man*, 1987,
22 (2), pp. 238–55.

Küchler, Susanne. 1999. 'The Place of Memory'.
In Adrian Forty and Susanne Küchler (eds),
The Art of Forgetting. Berg, pp. 53–72.

Küchler, Susanne and Walter Melion (eds).
1991. *Images of Memory: On Remembering
and Representation*. Smithsonian Institution
Press.

Kwint, Marius, Christopher Breward
and Jeremy Aynsley (eds). 1999. *Material
Memories*. Berg.

Last, Jonathan. 1998. 'Books of Life: Biography
and Memory in a Bronze Age Barrow'. *Oxford
Journal of Archaeology*, 17 (1), pp. 43–53.

Layard, G.S. 1922. *The Headless Horseman*.
Phillip Allen and Co.

Lewis, Phillip. 1969. 'The Social Context
of Art in Northern New Ireland'. *Fieldiana:
Anthropology* 58, Field Museum of Natural
History.

Lippincott, Kristen. 1999. *The Story of Time*.
Merrell Holberton in association with
National Maritime Museum.

Llewelyn, Nigel. 1991. *The Art of Death.
Visual Culture in the English Death Ritual
c. 1500–c. 1800*. Reaktion Books in association
with the Victoria and Albert Museum.

Lowenthal, David. 1985. *The Past is a Foreign
Country*. Cambridge University Press.

McEwan, Colin. 1994. *Ancient Mexico in the
British Museum*. British Museum Press.

MacGaffey, Wyatt. 1988. 'Complexity,
Astonishment and Power: The Visual
Vocabulary of Kongo Minkisi'. *Journal of
Southern African Studies*, 14 (2), pp. 188–203.

MacGaffey, Wyatt. 1991. *Art and Healing
of the Bakongo Commented by Themselves:
Minkisi from the Laman Collection*. Folkens
museum-etnografiska, Stockholm.

MacGregor, Arthur (ed.). 1994. *Sir Hans
Sloane. Collector, Scientist: Antiquary Founding
Father of the British Museum*. British Museum
Press in association with Alistair McAlpine.

Mack, John. 1986. *Madagascar, Island of the
Ancestors*. British Museum Press.

Mack, John. 1995. 'Fetish? Magic Figures
in Central Africa'. In Anthony Shelton (ed.),
Fetishism: Visualising Power and Desire. Lund
Humphries, pp. 52–65.

Mack, John. 1995. 'Islamic influences: The
view from Madagascar'. In Karin Ådahl and
Berit Sahlström (eds), *Islamic Art and Cultures
in sub-Saharan Africa*. Acta Universitatis
Upsaliensis, N.S. 27, pp. 123–37.

Mack, John. 1997. 'Antiquities and the Public:
the Expanding Museum, 1851–96'. In Marjorie
Caygill and John Cherry (eds), *A.W. Franks:
Nineteenth-century Collecting and the British
Museum*. British Museum Press, pp. 34–50.

Mack, John (ed.). 2000. *Africa: Arts and Cultures*. British Museum Press.

Manley, Deborah and Peta Rie. 2001. *Henry Salt: Artist, Traveller, Diplomat, Egyptologist*. Libri Publications.

Mann, Nicholas and Luke Syson. 1998. *The Image of the Individual: Portraits in the Renaissance*. British Museum Press.

Meadows, Andrew and Jonathan Williams. 2001. 'Moneta and the Monuments, Coinage and Politics in Republican Rome'. *The Journal of Roman Studies*. XCI, pp. 27–49.

Netzer, Nancy and Virginia Reinburg (eds). 1995. *Memory and the Middle Ages*. Boston College Museum of Art.

Nooter Roberts, Mary and Allen Roberts. 1996. *Memory: Luba Art and the Making of History*. The Museum for African Art, New York and Prestel.

Ong, Walter. 1982. *Orality and Literacy: The Technologizing of the World*. Methuen.

Parkinson, Richard. 1991. *Voices from Ancient Egypt: An Anthology of Middle Kingdom Writings*. British Museum Press.

Parshall, Peter. 1999. 'The Art of Memory and the Passion'. *Art Bulletin*, LXXXI (3), pp. 456–72.

Phillips, Tom (ed.). 1995. *Africa: The Art of a Continent*. Royal Academy of Arts, London and Prestel.

Pinney, Christopher. 1997. *Camera Indica: The Social Life of Indian Photographs*. Reaktion Books.

Proust, Marcel. 1941. *In Search of Lost Times*. 12 vols. Translated by C.K. Scott Moncrieff. Chatto and Windus.

Rabelais, François. (1564) 1970. *The Histories of Gargantua and Pantagruel*. Translated and with an introduction by J.M. Cohen. Penguin Books.

Reade, Julian. 1983. *Assyrian Sculpture*. British Museum Press.

Reefe, T. 1977. 'Lukasa: A Luba Memory Device'. *African Arts*, 10 (4), pp. 48–50.

Reinberg, Virginia. 1995. 'Remembering the Saints'. In Nancy Netzer and Virginia Reinburg (eds), *Memory and the Middle Ages*. Boston College Museum of Art, pp. 17–32.

Richardson, J. 1885. *A new Malagasy–English Dictionary*. London Missionary Society, Antanarivo.

Rogers, J.M. 1993. *Mughal Miniatures*. British Museum Press.

Rothenstein, Julian. 1989. *J.G. Posada: Messenger of Mortality*. Redstone Press in association with The South Bank Centre.

Rowlands, Michael. 1993. 'The role of memory in the transmission of culture'. *World Archaeology*, 25 (2), pp. 141–51.

Rowlands, Michael. 1999. 'Remembering to Forget: Sublimation as Sacrifice in War Memorials'. In Adrian Forty and Susanne Küchler (eds), *The Art of Forgetting*. Berg, pp. 129–45.

Sacks, Oliver. 1985. *The Man Who Mistook His Wife for a Hat*. Picador.

Samuel, David. 2000. *Memory: How we use it, lose it and can improve it*. Phoenix.

Samuel, Raphael. 1994 and 1998. *Theatres of Memory, Volume 1: Past and Present in Contemporary Culture; Volume 2: Island Stories: Unravelling Britain*. Alison Light (ed.) with Sally Alexander and Gareth Stedman Jones, Verso.

Schama, Simon, 1996. *Landscape and Memory*. Fontana Press.

Schele, Linda and Mary Ellen Miller. 1992. *The Blood of Kings, Dynasty and Ritual in Maya Art*. Thames and Hudson.

Secretan, Thierry. 1994. *Going into Darkness. Fantastic Coffins from Africa*. Thames and Hudson.

Seyller, John. 1994. 'Recycled Images: Overpainting in Early Mughal Art'. In Sheila Canby (ed.), *Humayun's Garden Party, Princes of the House of Timur and Early Mughal Painting*. Marg Publications, pp. 49–80.

Shamashang, Benjamin. 2000. 'Royal Statue (*ndop*)'. In John Mack (ed.), *Africa: Arts and Cultures*. British Museum Press, pp. 136–7.

Skelton, Robert. 1994. 'Iranian Artists in the Service of Humayan'. In Sheila Canby (ed.), *Humayun's Garden Party, Princes of the House of Timur and Early Mughal Painting*. Marg Publications, pp. 33–48.

Spence, Jonathan D. 1985. *The Memory Palace of Matteo Ricci.* Faber and Faber.

Starzecka, D.C. (ed.). 1996. *Maori Art and Culture.* British Museum Press.

Stewart, Susan. 1984. *On Longing: Narratives of the Miniature, the Gigantic, the Souvenir, the Collection.* The Johns Hopkins University Press.

Strathern, Marilyn. 1997. 'Pre-figured features: a view from Papua New Guinea highlands. In Joanna Woodall (ed.), *Portraiture, Facing the Subject.* Manchester University Press, pp. 259–68.

Strathern, Marilyn. 2001. 'The Patent and the Malanggan'. In *Theory, Culture and Society,* 18 (4), pp. 1–26.

Taylor, John. 1997. 'Beyond the Portraits: Burial Practices in Pharaonic Egypt'. In Susan Walker (ed.), *Ancient Faces: Mummy Portraits from Roman Egypt.* British Museum Press, pp. 9–13.

Thompson, Robert Farris. 1986. 'Zinkondi: Moral Philosophy Coded in Blades and Nails'. *Bulletin du Musée Barbier-Mueller,* 31.

U Mya. 1936 (1930–40). 'A Note on the Buddha's foot-prints in Burma'. *Archaeological Survey of India.* Annual Report, Delhi, pp. 320–31.

Vansina, Jan. 1978. *The Children of Woot: A History of the Kuba Peoples.* The University of Wisconsin Press.

Walker, Susan. 1985. *Memorial to the Roman Dead.* British Museum Press.

Walker, Susan. 1995. *Greek and Roman Portraits.* British Museum Press.

Walker, Susan (ed.). 1997. *Ancient Faces: Mummy Portraits from Roman Egypt.* British Museum Press.

Wang, Helen. Forthcoming. 'Mao on Money'.

Welch, Evelyn. 1998. 'Naming Names: The Transience of Individual Identity in Fifteenth-Century Italian Portraiture'. In Nicholas Mann and Luke Syson (eds), *The Image of the Individual, Portraits in the Renaissance.* British Museum Press, pp. 91–104.

Werbner, Richard (ed). 1998. *Memory and the Postcolony: African anthropology and the critique of power.* Zed Books. Including 'Beyond Oblivion: Confronting Memory Crisis', pp. 1–20; and 'Smoke from the Barrel of a Gun: Postwars of the Dead, Memory and Reinscription in Zimbabwe', pp. 71–104.

Whitehouse, H. 1992. 'Memorable Religions: Transmission, Codification and Change in Divergent Melanesian Contexts'. *Man* (N.S.) 27, pp. 777–97.

Wilson, David M. 2002. *The British Museum: A History.* British Museum Press.

Woodall, Joanna (ed.). 1997. *Portraiture: Facing the Subject.* Manchester University Press.

Yates, Frances. 1966, 1999. *The Art of Memory. (Selected Works, Volume III).* Routledge.

Young, Robert M. 1970. *Mind, Brain and Adaptation in the Nineteenth Century: Cerebral localization and its biological context from Gall to Ferrier.* Clarendon Press.

Zanker, Paul. 1995. *The Mask of Socrates: The image of the Intellectual in Antiquity.* Translated by Alan Shapiro. University of California Press.

Index

(Italics indicates an illustration)